RUDOLF WITTKOWER

SCULPTURE

PROCESSES AND PRINCIPLES

ALLEN LANE

ALLEN LANE

PENGUIN BOOKS LTD

17 GROSVENOR GARDENS, LONDON SW1W 0BD

FIRST PUBLISHED IN 1977

ISBN 0 7139 0878 5

SET IN MONOPHOTO EHRHARDT

PRINTED IN GREAT BRITAIN BY

BUTLER & TANNER LTD

FROME AND LONDON

DESIGNED BY GERALD CINAMON

CONTENTS

FOREWORD

In 1968 the Electors of the University of Cambridge invited Rudolf Witt-
kower to be the Slade Professor of Fine Arts for the academical year 1970–
71, an invitation which he accepted with the greatest pleasure. According
to the statutes the Slade Professor's duty is to give twelve lectures 'on
the History, Theory, and Practice of the Fine Arts, or some section or
sections of them'. Since these lectures are open free of charge to all
members of the University a broader rather than a specialized subject
seemed indicated. Rudolf Wittkower chose one which, as he explained
in a letter, 'would aim at both undergraduates and at more advanced
students'. And he added: 'In actual fact, time permitting, I would like
to turn these lectures into a little book.'

Time did not permit. What form the book would have taken I do not
know, but I do know that it, too, would have aimed at a readership beyond
the confines of specialists. I do hope I did not do a disservice to my hus-
band's intentions by publishing the lectures in their original form, with-
out footnotes, but with as full a bibliography as I was able to put together
from the notes and lists of titles on file.

Some editorial adjustments were unavoidable. The Cambridge
audience was not the captive one of a prescribed course. It was hardly
to be expected that everyone would attend all lectures, so in order to
make certain points understandable to those who had missed one or the
other, the gist of what had been said in previous talks was often reiterated
as the course progressed. Such repetitions are eliminated in the printed
text. The greater difficulty was the reduction of some 480 slides to a
manageable number of illustrations. This, too, called for occasional slight
adaptations of the original manuscript.

The question of how to turn a live talk into cold print has, of course,
been much discussed. I am glad to say that the editors of Allen Lane
agreed with me to accept Sir John Summerson's verdict, stated in the

Preface to his published BBC talks: 'a lecture is a lecture and it is a mistake to turn it into something else.'

I should like to put it on record that my husband was truly happy at Cambridge during his term of office. I am sure he would have wished to express his gratitude to the Electors and the Vice-President of the University for his appointment; to the Master and Fellows of Christ's College for their extraordinarily kind hospitality, and to Michael Jaffé for the infinite care he took of all practical arrangements.

My personal thanks go to Professor Howard Hibbard, the first to read the manuscript, for his encouragement and valuable suggestions. To Jacob Bean, Lucas M. Collins, Richard Dorment, Miss Karen Horn, C. Douglas Lewis Jr, Mrs Carla Lord, Mrs Cynthia MacCabe, Miss Jennifer Montagu and Professor John White for help with procuring photographs; to the editors at Allen Lane for their untiring patience and aid in the preparation of this book which necessitated a veritable stream of letters to and fro across the ocean.

<div align="right">

Margot Wittkower
New York, 1976

</div>

INTRODUCTION

I hope you will forgive me for starting with a few controversial remarks. Let's face it, a great deal of nonsense is being said and written about Art, especially by those who are writing on modern art who are often victims of meaningless professional rhetoric. I have to confess that, despite decades of training in reading art-historical prose, I have not often managed to get through a book on modern art from cover to cover.

Obviously, I cannot guarantee that I myself won't fall prey to rhetorical pitfalls, but I am aware of them, and I hope to be able to offer a few serious and historically valid interpretations even when turning to the art of the twentieth century – my criteria will be derived from facts to which a few thousand years of history bear witness. I shall be down to earth. I shall deal to a large extent with sculptural techniques and thought processes linked to them or derived from them and hope to present at least some conclusions drawn from unchallengeable visual evidence. Wherever and whenever possible I shall base my interpretations on the opinions of the sculptors themselves and the opinions of their contemporaries.

My title makes it quite clear that I have no intention of offering a survey of sculpture from the ancients to Henry Moore and beyond. I shall of course deal with many important works of art and, I hope, at the end you may find that we have unlocked a few closed doors and that you can approach with open eyes and a fresh mind a vast panorama of artistic events in the history of sculpture.

My object will be a double one: by studying sculptors' working methods, I want to discover their artistic ideas and convictions and implicitly open up avenues for the beholder's approach to sculpture. Although a great number of studies – and many good ones – exist that give an account of working processes of such artists as Michelangelo and Rodin, no comprehensive study is known to me that would tell us what unites

and what separates sculptors across the centuries. So, these lectures should fill a gap and focus attention on some strange lacunae in the history of art.

1

ANTIQUITY

In the past sculptors have made use virtually of any material that lends itself to being shaped in three dimensions. Even such materials as sand, shells, rock crystal and glass have their place in the history of sculpture. Modern sculptors have extended the range of materials enormously: new metals, steel, artificial materials such as nylon and plastics have been pounced upon continuing the old tradition of exploration and experimentation.

Nevertheless, throughout history and around the globe two materials have been prevalent: wood and stone. Bronze may be added as a third in some parts of the world such as China, Africa, Greece, Rome and Europe. In Europe wood-carving has always been at home in northern countries, especially France and Germany. When stone was used in these countries, as it was to a considerable extent, it was often a variety of the locally quarried soft stone, such as limestone and sandstone rather than the harder stones such as marble or even harder materials such as granite and porphyry, quarried in Mediterranean countries.

The working of stone is of incalculable antiquity: you all know primitive flint implements which are found all over the world. They must be regarded as the first powerful extension of the human hand and consequently ushered in the dawn of human civilization. These implements furnish the first examples of human craftsmanship; they were produced by flaking or 'knapping'; they provided power, as primitive man constantly discovered. And thus they were the harbingers of stone deities and stone images, receptacles of magic power.

In the course of time flaked implements no longer satisfied men. Two new techniques of working stone were developed, both immensely laborious and slow. First, by rubbing an implement with sand, its shape could be improved and so abrasive processes originated. In addition, cop-

per, bronze, and later, iron tools were invented and with their help stone could be shaped. Once such tools existed, we witness the birth of the history of sculpture. This takes us back in history well over six thousand years, to the beginnings of the Egyptian and Babylonian civilizations. The Greeks, the heirs to the Oriental civilizations, and after them the Romans and Italians proudly nursed the traditions of immemorial age and it was within the orbit of these Mediterranean civilizations that the notion developed that the carving of stone and specifically of marble was the highest aim and the greatest achievement of sculptors. This southern notion was completely assimilated throughout Europe and not even today has it lost its validity. In accordance with this tradition much of what I have to say here will be concerned with stone sculpture.

Let me make some general remarks about marble sculpture before turning to my first major topic, namely the way the early Greeks prepared their marble statuary. It is clear that the carving of marble requires long training and extraordinary experience. The sculptor's work actually begins before the carving – it begins with the choice of the marble block. A first-rate sculptor knows exactly what he will need. Michelangelo trusted no one: he spent years of his life in the quarries of and near Carrara, in the vicinity of Florence. They are still today the principal repository of fine Italian marble.

When it was impossible for Michelangelo to go himself to the quarries, he provided guidance to the stonemasons on the spot by letting them have drawings with accurate sketches (including measurements of the blocks he required). Miraculously, a few such drawings have survived. The inscriptions are in Michelangelo's unmistakable hand. Across one of the blocks he wrote, 'largo braccie due e mezzo', i.e. the block had to be $2\frac{1}{2}$ braccie or about 5 feet long.

A great deal depended on the quality of the marble. To a certain extent the quality that was available even determined what tools could or could not be used. Naturally, it is not often that workshop deliberations on such matters are documented for the benefit of art historians. In one historical case we can gain a remarkable amount of information on these matters owing to the survival of a contemporary diary. When Bernini, during his visit to Paris in 1665, was commissioned to carve a marble portrait of King Louis XIV [1] time was too short to have suitable marble shipped from Carrara. He had to use a block of French marble. We know that he ordered three different blocks and actually started work on all three simultaneously so that he might quickly decide which one was most suitable for his purpose. Even the block he finally chose was too brittle for the technically dazzling performance he had planned. He wanted to show the King in his splendid royal wig that surrounds the head like

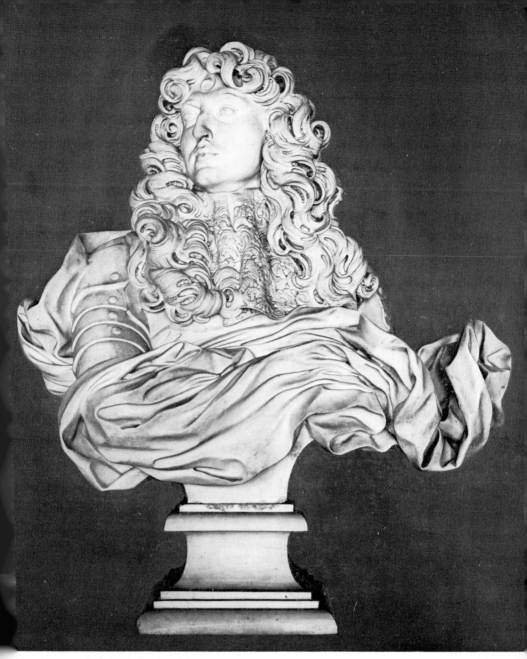

1. *Louis XIV*, 1665. Bernini

an aureole. Professional pride required that he render the locks realistic-
ally and free-flowing. But Bernini feared that the marble would splinter
if he used a chisel for the undercutting. Hence, he had to use the drill
more extensively than in any of his other marble works, and the drill-
holes are easily traceable everywhere.

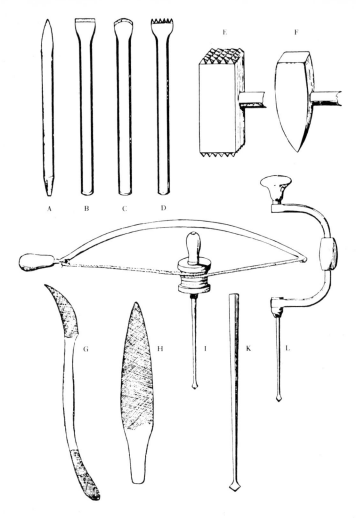

2. Sculptors' tools: (A) point or punch, (B) flat chisel, (C) bull-nosed chisel, (D) claw-chisel, (E) *boucharde*, (F) pointed hammer, or trimming hammer, (G, H) rasps, (I) running-drill, (K) drill, (L) auger

Let me say a word about these and other tools used by sculptors. Figure 2 illustrates all the important tools assembled. I mention specifically the square hammer (or *boucharde*) which nowadays has a steel head covered with pyramidal points; the point or punch which is used with a mallet to knock off relatively large chips of stone; various types of chisels: the flat chisel, the bull-nosed chisel, the claw or toothed chisel; in addition, the drill, here represented in two early forms used by the Greeks; files and rasps which were used to smooth down the surface; and abrasives (not shown here) which served to polish off the rasp marks.

Many of these tools were known to the Egyptians and have been in use for well over three thousand years; hardly any new ones have been added to the old arsenal. As abrasives the Greeks used emery which is chiefly found in the island of Naxos and in Asia Minor. Elsewhere sand or pumice stone (a porous kind of lava) served the purpose (nowadays sculptors use mechanically produced carborundum).

Not all the tools were used simultaneously through history. Different periods gave preference to different tools. I have little doubt that to a certain extent the continuity of a style depended on the set of tools handed down in the workshops from one generation to another. There have been periods when sculptors used mainly or even exclusively abrasive processes (I have even known modern sculptors who swore by them). At certain periods the drill was heavily used – no wonder that results differ widely. But the principal tools always were and still are the punch, flat and claw or toothed chisels and the drill. These tools will play a very considerable part in what follows.

Our knowledge of working methods and traditions in antiquity and the Middle Ages is more considerable than is often realized. Representations of sculptors' tools, sculptors' workshops and sculptors at work are not at all rare – admittedly, this kind of material is much more common in the Middle Ages than in Greece and Rome. Yet a fair number of unfinished ancient marbles have survived and they give us an excellent chance of checking up on working conventions in antiquity.

In Greek vase painting one can occasionally see sculptors' tools in operation. Figure 3 shows a woodworker using the running drill. The quick movement of the bow (to and fro) sets the handle with the drill

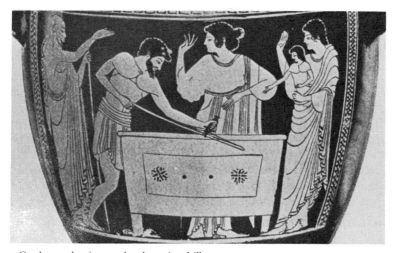

3. Greek vase showing woodworker using drill, *c.* 500 BC

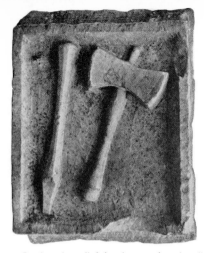

4. Greek votive relief showing punch and mallet

in rapid motion. Equally interesting is a Greek votive relief [4] representing a punch (or point) and a mallet. Figure 5 shows the punch applied at right angles to the block. Obviously, this stroke produces indentations rather than furrows. Nowadays the more common practice is to apply the punch obliquely to the surface. This procedure is usually called 'mason's stroke' and results in long grooves. The differentiation between these two strokes is most important. You will immediately discover this in an unfinished Greek figure of the sixth century BC which was found on the island of Naxos [6]. The front, back and also both sides of the figure show exactly the same state of preparation: the marble is dotted with little holes. It is evident that the sculptor had applied the punch at right angles to the block and never chose a different stroke.

We have to assume an initial preparatory stage, before the stage of execution found in the unfinished archaic statue. First, the sculptor had to trim down the marble block to an approximately regular shape. This accomplished, he probably drew the front, the back, and the two sides on the planes of the rectangular block. There is an intrinsic likelihood of this, for he needed guiding lines that made it possible for him to interpret his figure coherently. Moreover, we know from many later examples that it was always found necessary to draw outlines on the block wherever and whenever artists worked directly in stone.

Following his drawn outlines, the sculptor began work with the heavy punch. At this stage the execution was abandoned. But the appearance of the unfinished figure is sufficiently revealing to allow us to reconstruct the entire working procedure. The sculptor laid, as it were, his cards on the table. It is clear that he did not work into the depth of the stone from one side only at a time. He regarded it as necessary to hew off the marble simultaneously on the four faces of the block. He would have

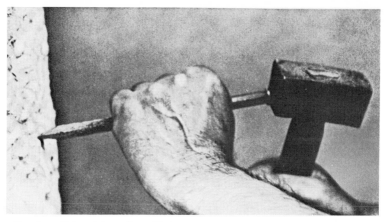

5. Punch applied at right angles to block

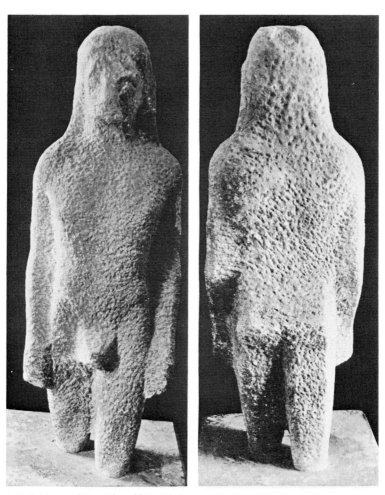

6. Unfinished male torso from Naxos, sixth century BC

ntinued the way he began: in going on he would have taken off slowly and steadily one layer of marble after another all around the figure. For the next stage or stages he would have used finer punches and, finally, the uneven surfaces would have been smoothed down by abrasive processes.

Recently, a Belgian sculptor, H. J. Etienne, patiently experimented with Greek working methods. He had bronze tools made whose alloy probably corresponded to that known to the Greeks before 500 BC. It appeared that when he tried to use the oblique stroke with such tools, the punch or chisel glided over the marble. But it was possible to work with the punch at right angles to the surface. However, such tools must have been most cumbersome, for they are soon blunted by hammering and must be constantly resharpened. About 500 BC the situation changed: much harder iron or steel tools became available; they made possible the oblique stroke and other advances in sculptural techniques.

We now understand why the sculptor of our statue used only (and in all likelihood, could only use) the stroke at right angles. This sculptor's free method of working in marble is, of course, immensely strenuous. Long practice, great skill, and an even, gentle stroke were the vital preconditions of success. Nevertheless, he needed certain controlling factors. One was to stick as closely as possible to the block shape: neither arms nor legs were allowed to move freely, and hair, for instance, had to be firmly connected with the neck.

We may now look at a finished figure of this type [7]. Many such figures of archaic Greek youths survive. In archaeological parlance they are called *kouroi*. My example, the earliest of the completed marble *kouroi*, dating from the time of our unfinished example, *c.* 600 BC – is in the Metropolitan Museum in New York.

The silhouettes of such a figure clearly disclose the original block form. In front of the finished piece one feels doubly sure that, while working on the front, the back, and the sides, the sculptor must always have taken his bearings from the early outline drawings: as he faced each side of his figures he thought in draughtsmanlike terms. (Incidentally, the artist still followed the Egyptian canon of proportion.)

As a result of this, the finished figure must have four distinct views. The truth of this statement can easily be checked in the Metropolitan Museum *kouros* [7]. The four sides of such a figure consist of four planes, meeting one another at right angles with only the corners chamfered. We may call this figure as well as many others prepared in the same way (always like the unfinished figure from Naxos) pluri – or multifacial, for they have four clearly separate or rather, separable faces, and consequently offer four different views to the beholder.

7. *Kouros*, *c.* 600 BC

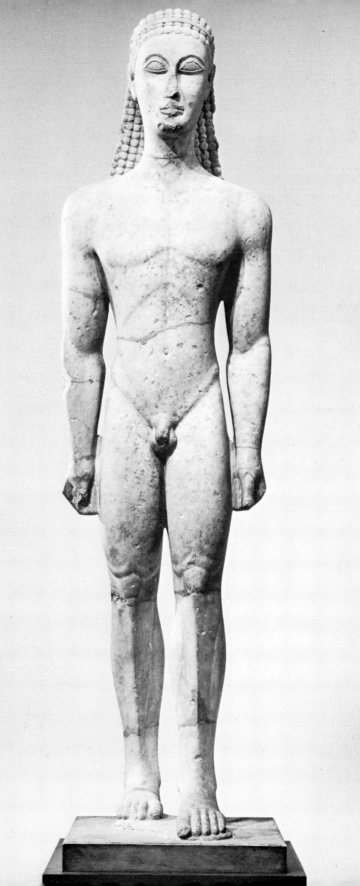

8. Detail of 7 showing punch marks

Such a figure is, of course, far from realistic (if we apply the term according to modern usage), but it has tremendous vitality; it is bursting with energetic life. Moreover, it has a warm and soft, almost velvety surface quality. This does not simply result from the nature of the porous and warm Greek marble, but above all from the working process I have briefly described. The infinite number of indentations produced by the punch, though smoothed over by abrasives, create – as it were – vibrations under the surface that evoke the sensation of breathing skin. It is owing to the patient, intelligent punch work that went into the making of such figures, that we perceive their tremendous sculptural qualities rather than the essential flatness of each face of the figure.

Early Greek figures – roughly from the mid-seventh to almost the mid-fifth century BC – were to a large extent executed by punch work. I am here following the judgement of Carl Bluemel, the first modern archaeologist to investigate – most perceptively – Greek working methods in marble, though the distinguished Oxford archaeologist John Boardman, in his review of the last edition of Bluemel's book, says, 'We now know that from the beginning the sculptor was free and dexterous in his use of the flat chisel and that it was not all a matter of punch and abrasive. We can see that the claw chisel was used to remove layers of stone ...' These views are derived from the work of another British scholar, Sheila Adam, whose remarkably knowledgeable and carefully argued book, *The Technique of Greek Sculpture* is basically a critique of Bluemel. Even so, personally, I still feel convinced that, subject to some slight adjustments, Bluemel's observations are fundamentally sound.

In any case, there cannot be any doubt that the unfinished marble from Naxos as well as many *kouroi* statues were executed with the punch. A detail of the head of the Metropolitan Museum *kouros* [8] may give you a clearer idea of the possibilities and limitations afforded by this tool. The hair had to be completely stylized – it has been represented as clusters of knob-like protuberances. Such bobbles are about all you can do with the punch. Careful inspection reveals that each bobble is separated from the others by a small hole made by the punch, and the diamond-shaped point of the tool is everywhere apparent. It is clear that this tool does not allow any undercutting or any free-floating hair. The stylized hair we see here has, however, nothing mechanical about it. Each little protuberance has, as it were, an individuality of its own, is different from its neighbours, and partakes in an uninterrupted creative process.

The most famous *kouros* of the type we have studied is the so-called *Apollo of Tenea*, now in Munich [9]. It dates a little later than the Metropolitan Museum piece, maybe about 550 BC. I am showing you only the well preserved, splendidly modelled upper part with a head of con-

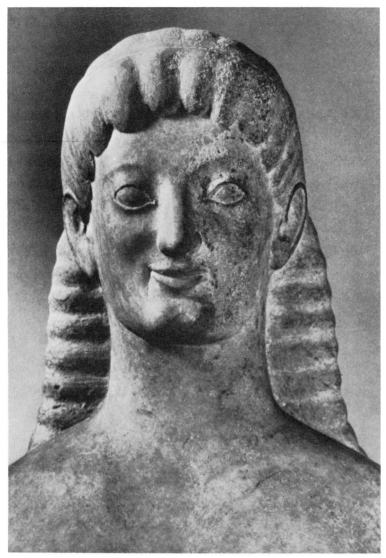

9. *Apollo of Tenea, c.* 550 BC

centrated energy (despite the stereotyped archaic smile) and a hair style
that is different from the one we have studied.

The female statue from Miletus in Asia Minor [10] dates from the
period of the Apollo of Tenea, i.e. about 550 BC. These female counter-
parts to the *kouroi* are called *korai*. I discuss this particular one for a spe-
cific reason: there was an archaic tradition according to which dressed

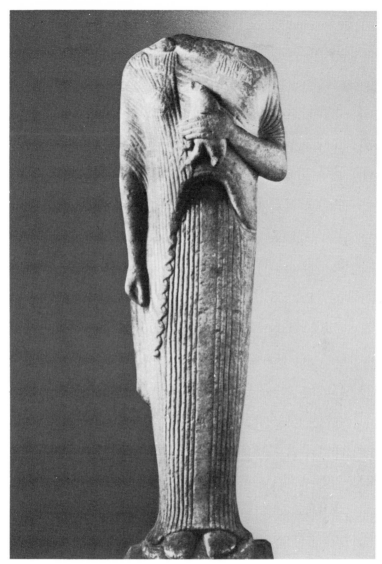

10. *Korai* with partridge, *c.* 550 BC

female figures were sometimes carved from a cylindrical rather than from a rectangular block. In spite of this the figure does not present an infinite number of viewpoints. The side views show that the problem here was similar to that of the male figures we have studied: the figure presents only four clearly marked views. This statue also reveals that, after the punch work had ended, the sculptor used other tools for the long furrows

of the dress. We may look at yet another piece of the same period, the so-called *Aristion Stele* from the end of the sixth century [11], for further enlightenment. This famous gravestone bears the name of the man in

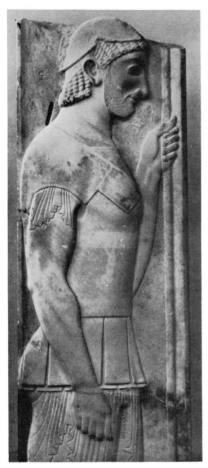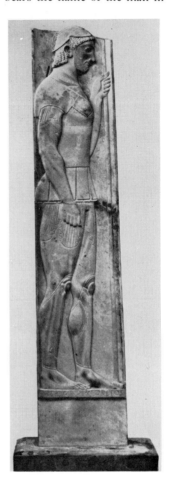

11. Grave relief of Aristion, *c.* 600 BC

memory of whom it was set up. It is also one of the rare cases where the artist signed his name, *Aristokles*. The deceased is seen walking; he is bearded, clad in helmet and armour and is holding a spear in his left hand. This low relief was carefully analysed by Sheila Adam, who convincingly differentiated a number of tools used by the artist. For instance, the curving folds of the skirt under the right hand were cut with a flat chisel with a broad blade (called a 'drove'). The rounded channels indicating muscles around the knees were perhaps carved by a curved chisel. The drill was used in the nostril and ear. Thus, as we approach the year 500, the situation begins to change. When this stele was found it still

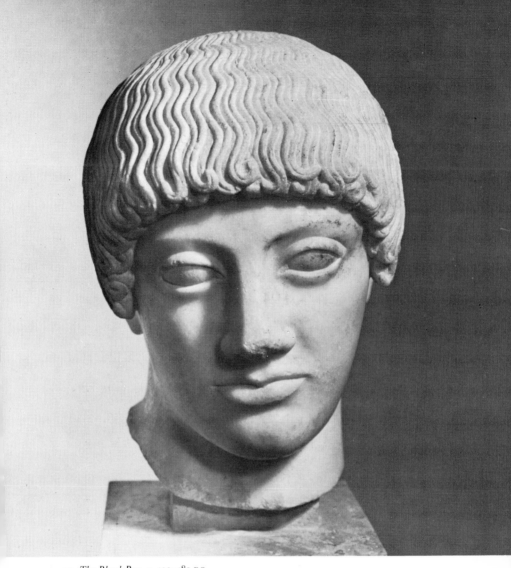

12. *The Blond Boy*, c. 490–480 BC

had many traces of colour. This opens up the question of polychromy to which I propose to return later. I may, however, mention an early fifth-century (490–80) head in the Acropolis Museum at Athens [12] which goes under the name of *The Blond Boy* because of the colour of his hair. In this case the paint on the eyeballs is still fairly well preserved, and there is no reason to doubt that all Greek works were enlivened in this way. The head also marks an immense step away from archaic formalism, in the direction of the freedom and humanity of the classical style of the mid-fifth century. It is worth looking at the fashionable hair style of this youth. The punch can have played only a minor part here; much

of the hair, such as the long wavy furrows, was probably done with the flat chisel. We witness the expansion of technical possibilities.

By the middle of the fifth century the punch had ceased to be the primary tool of Greek sculptors. The flat chisel, the claw chisel and the drill came into their own. Although drill work is found from the earliest beginnings of Greek sculpture, the potentialities of the drill were fully exploited only at a much later period. The story of the use of the drill in European sculpture has not yet been written, although it should be fascinating. When it was found that the drill made it possible not only to bore deep into marble or stone, but also to undercut the hard material in a most daring manner and to produce both realistic and picturesque

13. *Virgin and Child*, c: 1330. Tino di Camaino

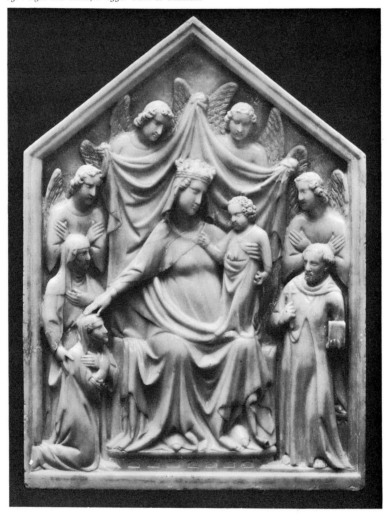

effects, it became a great stand-by in realistic periods of the history of
art, such as in Hellenistic art and in much of Roman art, and later in
the art of the seventeenth century. Even in the intervening period,
between the fall of Rome and the rise of Renaissance art, the drill was
never wholly abandoned.

I want to jump chronological barriers for a moment to discuss a little
alabaster relief by the great Tuscan sculptor Tino di Camaino [13]. It
represents the Virgin and Child enthroned with Queen Sancia, second
wife of Robert the Wise of Anjou, King of Naples, kneeling, and recom-
mended to the Virgin by Santa Clara; on the right is St Francis. This
little relief dating from *c.* 1330 contains some judicious and very interest-

14. Detail of 13

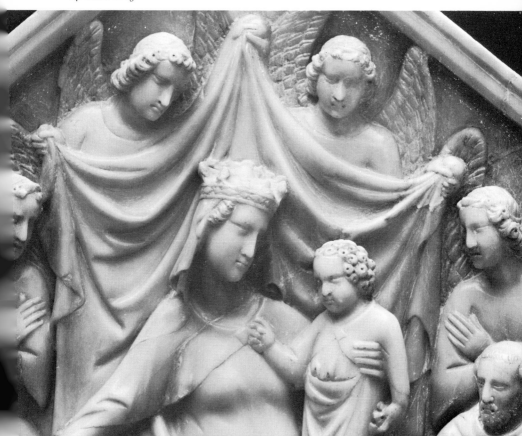

ing drill work. The hair of the Christ Child curls up and the centre of
each curl shows a drill hole [14]. I was attracted by this, because (un-
known to himself) Tino was doing here precisely what long before him
the Greek artist of the East Pediment of the Temple at Olympia had

done between 468 and 457 BC. It is worth observing that Tino used the drill elsewhere, for instance in the corners of the mouths of all the figures – thus creating small areas of emphatic shadows, and thereby enhancing the expression of liveliness in the figures.

But the drill was not always a blessing; it could become a curse; many modern sculptors loathed it and would never touch it. Before explaining the negative aspect of this tool, let me say a few more words about the flat chisel and the claw chisel. To a certain extent the flat chisel replaced the punch even in antiquity. It was extensively used by Roman sculptors and during long periods of the later history of sculpture.

I think it is significant that Andrea Pisano in a fourteenth-century allegorical relief representing Sculpture on the Campanile of Florence Cathedral [15] shows a statue being worked with a flat chisel. The chisel, incidentally, is correctly held, and we can even recognize the oblique stroke. In contrast to the punch applied at right angles, this produces a comparatively flat surface. Why then was the flat chisel, obliquely applied, so much used? Flat chisel work is much more rapid than work with the punch. With one stroke you can remove many times the quantity of marble that you remove with a stroke of the punch. Moreover, the tool is safer than the punch, and it (possibly) requires less skill. With the flat

15. Allegory of Sculpture, Florence Campanile, fourteenth century. Andrea Pisano

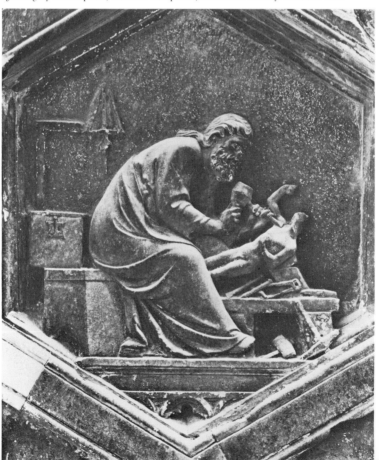

chisel the sculptor acquires greater ease of execution at the expense of vigour and perhaps even of quality.

The claw chisel is probably the most versatile sculptor's tool. The teeth may vary in size and number; they may be pointed or blunt. Accordingly one can work this tool like a many-pointed punch or like a flat chisel with a number of small edges. Sculptors often employed the claw chisel in conjunction with the flat chisel. After initial punch work, many prepared their figures with the relatively speedy and safe flat chisel and then used the claw chisel for subtleties of modelling. The teeth of the claw chisel produce, of course, parallel grooves on the surface, and they can easily be detected before abrasives have been applied.

Let's now look at a slab of marble [16] prepared by a sculptor to demonstrate the different textures produced by various tools:

4. Indentations produced by the square hammer, *boucharde* – similar to punch work at right angles.
5. Deep long furrows produced by the punch (mason's stroke).
6. Parallel, slightly uneven grooves produced by a flat chisel with broad blade (drove).
7. Even, parallel grooves produced by the claw or tooth chisel.
9. Striations produced by a flat chisel.

16. Different textures produced by various tools

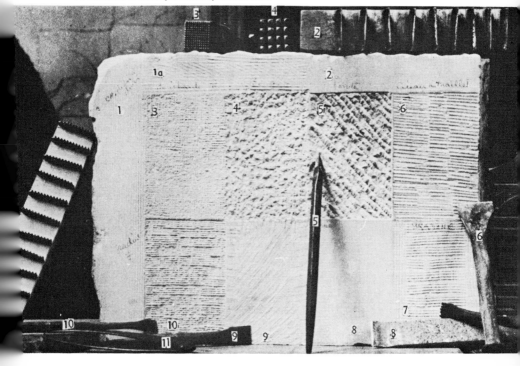

ıere was only one sculptor in the history of art who was entirely dedi-
ted to claw chisel work and that was Michelangelo. We shall have ample
occasion to explore how his technique – or rather his ideas expressed
through his technique – led to results at variance with Greek and Roman
antiquity.

Finally, I want to open up a problem that will occupy us again and
again, namely that of the transfer of a design or a model on to the marble.
So far we have been concerned with direct carving, mainly during the
archaic period – carving without previous studies on paper and without
the preparatory models from which sculptors worked in many periods
of the history of art. Preparatory stages must have been considered at
a comparatively early period in Greece, and in any case during the fifth
century BC. For the extensive sculptural programmes on Greek temples
of the classical period, such as Olympia and the Parthenon, one has to
assume the careful planning of a master-mind who would then direct
the coordinated execution by many hands. We may presume that much
could be done by word of mouth and by direct, constant supervision.
But I have doubts that this was sufficient. We have to assume that even
at that period clay or terracotta models were made; first, in order to clarify
the general planning, and then for the guidance of the executing hands.
This method must have been in use for some time before attempts were
made to secure faithful transfer from the model to the marble.

When Pliny was writing his *Natural History* in the first century AD,
the book which contains most of the information we have about Greek
artists, we encounter a triple division of the plastic arts, called in antiquity
fusoria, *plastica* and *scultura*. *Fusoria* is the art of founding metal; *plastica*
the art of working in clay or wax; and *scultura* the art of working in stone.
This division probably had a long ancestry and shows in any case that
the modellers in soft materials had assumed considerable importance. An
older generation of archaeologists believed that a mechanical technique
of transferring the design of the model into marble was not developed
until the first century BC by Pasiteles. But it is now believed that the
Greeks had developed such a method much earlier. This method, usually
called pointing, consisted in establishing with the greatest precision
parallel points on the model and the marble block. The contraptions you
see in figure 17 make the principle quite clear. In antiquity the pointing
machine would have been similar, though, of course, much simpler. This
technique leads us back to the drill. Only with the drill could the correct
points at the correct depth be established on the marble block.

In late antiquity this method was used in a most discreet way, mainly
to fix a few essential points on the surface of the marble. Figures 18 and
19 show two small marbles, both Roman and both unfinished. The statue

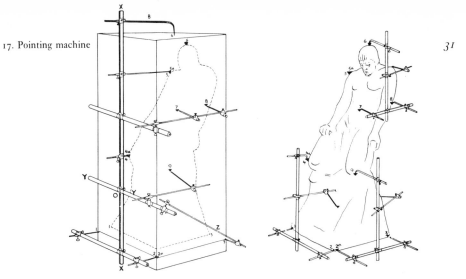

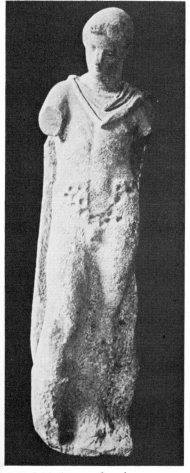

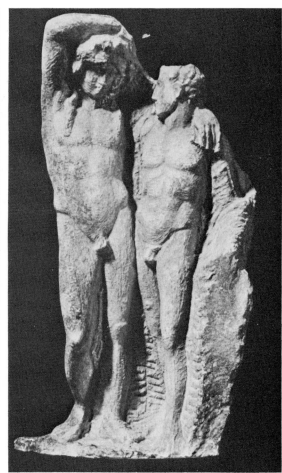

18. Unfinished statue of youth
from Rheneia

19. *Dionysus and Satyr*

of the youth shows a number of pointing holes in the stomach area. The group of *Dionysus and Satyr* has a few elevated pointing knobs on its surface. This group is also interesting for the various tool marks it reveals: the punch, flat chisel and claw chisel can easily be discerned.

The mechanical problem of transfer from model to marble never ceased to occupy sculptors' minds and we will come across it again and again. It was however not until the nineteenth century that the problem took on gigantic proportions – as we will see. It was then that the misuse of the drill reached its climax. The recovery of sculpture in the twentieth century was closely linked with contempt for the drill, and for any mechanical methods of transfer, with a return to direct carving.

In the following chapters some or most of the themes begun here will be continued and, I hope, be further clarified. At the end (I venture to predict) we will find that the problems about which sculptors meditate and around which their dreams revolve are comparatively few and have hardly changed in the long course of the history of western man.

THE
MIDDLE
AGES

THEORETICAL FOUNDATION;

CHARTRES WEST

So far I have mainly dealt with archaic Greek practices of executing stone figures. My discussion of the later periods of classical antiquity has had to be brief: you may recall that I suggested that after 500 BC or there-abouts, the early punch work was supplanted or supplemented by work with other tools such as the flat chisel, the claw chisel, and the drill; and we found that even the introduction of mechanical methods of transfer (the so-called pointing method) can be traced back to antiquity.

Moving on to the Middle Ages, we shall often have occasion to look back to classical antiquity, for the umbilical cord with the ancients was never severed. If I say move on to the Middle Ages, I mean a considerable chronological jump, for there is very little monumental sculpture before the twelfth century. This remains true although there survive a great many attractive sculptural works of high quality from the so-called Dark Ages, from Charlemagne's period as well as from the tenth and eleventh centuries. But with few exceptions these works are small – ivories, book-covers, seals, and such like.

Among the memorable exceptions, there are the works of the North-umbrian Renaissance, mainly the monumental Bewcastle and Ruthwell Crosses. I illustrate one scene (probably the grandest) from the Ruthwell

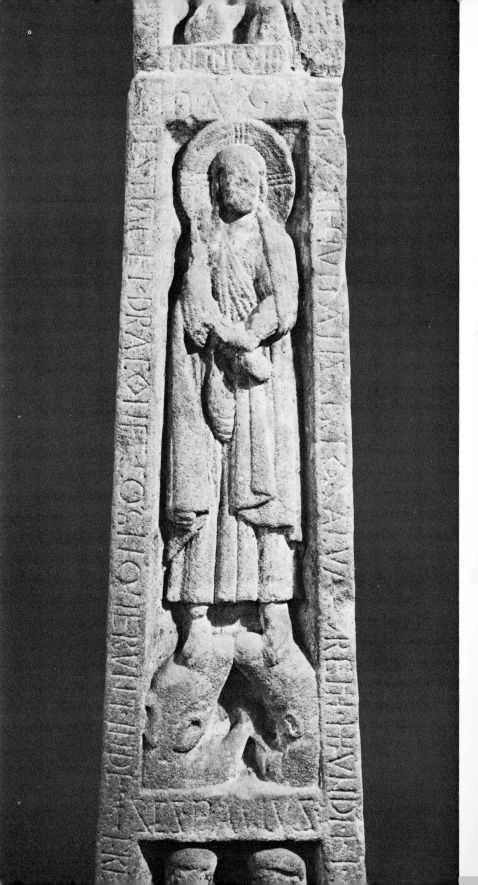

Cross [1], representing Christ treading the Beasts. This Cross is usually
dated between 750 and 850 AD. Recently, John Beckwith has argued that
these great crosses, which seem to express the religious emotions of a
United Northumbrian Church, look back to Romano-British works
rather than forward to the period of Carolingian renewal.

For enlightenment on the problems I am concerned with – the techni-
cal processes and principles of monumental sculpture in the Middle
Ages – we have to turn to the emergence of the great Gothic cathedrals
of the period when, in France above all, but also in England, Germany
and Italy, a new monumental sculpture arose for the first time on a broad
foundation after the collapse of the classical world.

But before turning to some of the works of that period I would like
to settle two questions. First, what kind of written statements, documents
or treatises survive that would help clarify our problem? And secondly,
what can be learned from representations (dating back to the Middle
Ages) which show sculptors at work?

The first question is comparatively easy to answer. Before the Renais-
sance of the fifteenth century we know of only one treatise that tells us
something about sculpture. This is Theophilus' *De Diversis Artibus* (On
the Various Arts), of which seven manuscripts survive, and which has
always been known. An excellent critical edition with an English transla-
tion by C. R. Dodwell appeared in 1961. Dodwell, I think, resolved once
and for all the chronological problem of this work, which had previously
been dated at any time between the ninth and thirteenth centuries. He
claims that it was written between 1110 and 1140 in north-west Germany
by a Benedictine monk who must have been a versatile artist in his own
right (Theophilus is a pseudonym). The work consists of three books.
The first deals with the materials and the art of painting; the second with
glass; and the third and longest with metalwork. Unfortunately, there
is no reference to stone-carving. Theophilus himself seems to have been
a metal-worker; his discussion discloses that he is talking from personal
experience. The third book contains the most revealing information.
After a God-fearing introduction, the author begins with recommenda-
tions for the construction of the workshop and then runs through its
equipment at considerable length. Among others, he informs us how to
make chisels, rasps and files. The descriptions and recommendations are
very detailed and one is astonished to find how well equipped an early
medieval workshop was. (I give one example: 'Files', he says 'are also
made of pure steel – large, medium, four-sided, three-sided and round.')

I suppose one does not get answers to the question of how monumental
stone sculpture was made, because at the time of writing the problem
hardly existed. Theophilus supplies, however, competent information on

all the techniques current in his day, such as work in silver, gold, bronze and copper, niello and enamel techniques, and even the founding of bells. Almost at the end he turns to bone-carving and here we get the only piece of information of direct interest to us. 'When carving bone', he says, 'first trim a piece of it to the size that you want, and then spread chalk over it. Draw the figures with lead [we would now say pencil] according to your wishes, and score the outlines with a sharp tracer so that they are quite clear. Then, with various chisels, cut the grounds as deeply as you wish ...' Here we find what indeed we would have expected: there is no talk of a preparatory sketch or design; his procedure corresponds to that we thought the archaic Greek sculptor adopted, namely to make the design directly on the block. In view of what we shall see later, it is important to realize that the procedure as described in the early twelfth century was still, or rather again, that of the archaic sculptor.

The ancients themselves had changed their approach, in my view, as early as the mid-fifth century BC, when preparatory planning stages became necessary; and the fact that unfinished Roman figures reveal that they had been pointed, proves that work from models had then become the rule. Now, owing to the lack of paper it would not have been so easy in the twelfth century to plan a figure beforehand, be it in bone or stone. Paper was extremely scarce until the sixteenth century (incidentally, Theophilus contains the first reference to paper in the western world) and parchment was much too expensive for this kind of exercise. But there would always have been such materials as chalk and slate, and Theophilus might have told us something like this: 'Before starting to carve in bone try out the design you wish to make on a piece of slate and when you are satisfied transfer it on to the bone ...'

Although there are no other texts before the fifteenth century to help us, there is some revealing visual evidence. Before turning to it, I must mention a unique work, the Album of Villard de Honnecourt, which he compiled over a number of years during the first half of the thirteenth century, a hundred years after Theophilus wrote his book. Villard, who was born near Cambrai in northern France, worked and studied in France, Switzerland, Germany and Hungary and his voluminous sketchbook gives us an extraordinary insight into the mind of a medieval architect on his wanderings. The sketchbook is immensely rich and suggestive and I can only mention two aspects of it. It contains a number of didactic drawings with geometric schemata to facilitate the representation of man and animal [2].

The vast majority of Villard's drawings are records, jotted down because they interested him. Ultimately, all these designs were meant

to be a storehouse of motifs to be used as the occasion arose. He is equally
concerned with architecture and sculpture. These drawings are very re-
markable and in front of them one has, in the words of the French scholar,
Pierre Du Colombier, to pose the question that was debated by medieval
philosophers: 'What comes first, the chicken or the egg?' In other words,

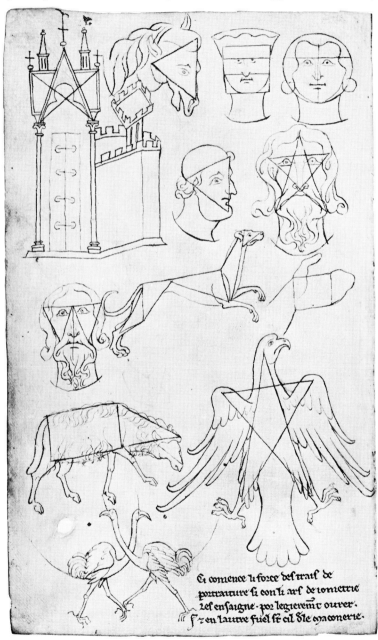

2. Drawings with geometric schemata, thirteenth century. Villard de Honnecourt

was it draughtsmen such as Villard who opened the sculptors' eyes or, alternatively, was it the sculptors who were followed by the draughtsmen? The answer is not too difficult: I believe that all scholars agree that Villard depended on the sculptors and in many cases modern scholarship has traced the models he copied.

In one case, incidentally, Villard proudly states that he had drawn from nature. The sheet shows a lion, which is, however, more stylized and conventional than most of his copies after works of art. The fresh breeze of life that we encounter in the sculpture of the cathedrals did not come from this kind of tradition. In fact, with one or two exceptions drawings by sculptors for sculpture do not appear until the early fifteenth century – and even then are immensely rare.

The position with regard to architecture is different. There is the famous palimpsest of Rheims of about 1250 and a façade design of the Cathedral of Strasbourg of *c*. 1275. In England there existed so-called 'tracing houses' from 1324 onwards where the architects and their assistants executed drawings.

In Toulouse the first *known* French construction after a design on parchment dates from 1381. Two drawings for the façade of Orvieto Cathedral, dating from the early fourteenth century, have survived, and all this material allows us to conclude that Villard's Album was a rarity in the thirteenth century, and it was not until the fourteenth century that drawings assumed a growing importance in works of art, above all for the great cathedrals and churches of the period.

Our second source of information comes from contemporary representations of artists at work. I mentioned that the surviving material is comparatively rich and that I could have made a different selection. Our first two examples date relatively early. Figure 3 is a scene from the twelfth-century tomb of St Vincent at Avila in Castile. We see through an arcade three simple stone sarcophagi, one behind the other. A mason or sculptor, apparently working at the cover of the second sarcophagus, is holding a chisel in his right hand and a hammer in his left. This is, of course, incorrect: no one could work like this; the tools should be exchanged, chisel in left, hammer in right hand. This may be a minor defect, hardly worth mention. What is interesting, however, is the fact that such a subordinate sculptural activity was regarded worth representing.

Figure 4 shows two stained-glass windows from Chartres Cathedral, dating about 1225. A sculptor with two assistants is shown carving figures of kings (they are wearing crowns) from blocks placed at an oblique angle. The sculptor (on the left) is working with only a chisel, while one assistant, resting his left hand on a hammer is looking attentively at what his master is doing. The other assistant (on the right) is less engaged – in

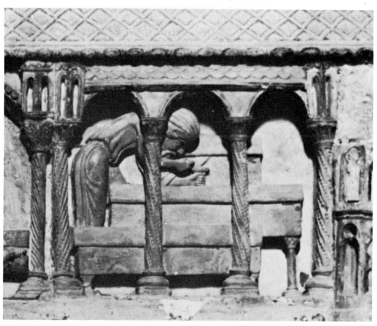

3. Tomb of St Vincent at Avila, Castile, twelfth century, detail

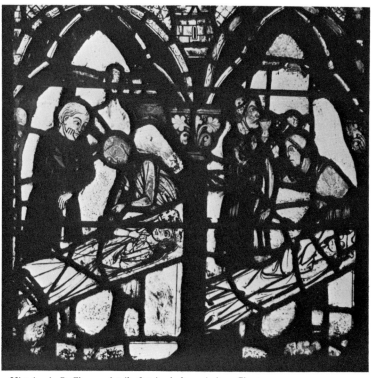

4. Histoire de St Cheron, detail of stained glass window, Chartres, *c.* 1225

fact, he is drinking from a cup unconcerned about the master's progress. The sculptor is swinging the mallet high above his head, aiming a stroke at the chisel that he is holding at right angles to the stone, under the chest of the figure. Like the Castilian master, these French sculptors are working directly in stone and this, surely, corresponded to reality. I don't think we have any reason not to accept the evidence of these images: thus we learn something about the oblique position in which the stone was kept during execution, and we also seem to be able to deduce that the stroke at right angles was used.

The term *sculptor* denoting an artist, and only an artist who works in three dimensions, was almost unknown in the Middle Ages. Medieval terminology was quite different from ours and, moreover, a differentiation between various professional groups developed very slowly. For a long time there was no distinction between architect, mason, stonecutter, and so forth. The Latin term *artifex* (which may be translated as 'artist' or 'sculptor') and *operarius* (meaning workman) were interchangeably used. So the Castilian mason [3] and the French sculptors [4] belonged to the same class and were equally worthy of being represented. The great Italian sculptor Nicolo Pisano appeared in a document of 1266 as *magister lapidum* which at that moment denoted both architect and sculptor. Even more than two hundred years later, in a posthumous document of 1483 (i.e. in mid-Renaissance), Donatello was still called *scarpellator*, i.e. stonemason.

But it would be mistaken to generalize too dogmatically. We can only go wrong if we lump together a time-span of over three hundred years and events that took place in widely separate areas. For instance, the documents of Prague Cathedral, which had one of the most important medieval cathedral workshops, show that the masons who carved decorative pieces received higher pay than the average stonemason; in other words, greater skill was financially rewarded. In the great Milan Cathedral workshop we find a differentiation between *scarpellini* or stonemasons and *muratori* or bricklayers. In medieval England one can differentiate between the following categories: the rough-mason, who laid the stones and hewed them with axe and hammer. Secondly the free-masons, who worked with axe, chisel and mallet on the mouldings for doors and windows, and carved capitals and other decorative features. These two types are very well represented in some Munich manuscripts: the workman in figure 5 is doing the work of the rough-mason, the one in figure 6 that of the free-mason.

The third English category are the workers in hard stone, alabaster, and marble who executed commissions for tombs, etc. or who worked for stock. Finally, there were the master-masons, who were expected to

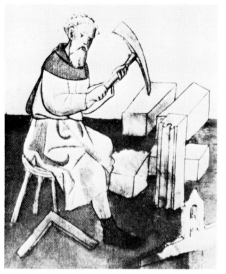

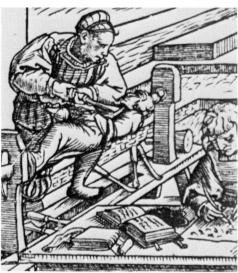

5. Rough-mason at work, German
manuscript, early fifteenth century

6. Free-mason at work,
early sixteenth century. Hans Burgkmair

produce plans and even models, to pilot a work through all its stages
and to whom also belonged the task of engaging workmen and paying
out wages.

In spite of such differentiations, it was only in the sixteenth century
in Italy that artists insisted on a clear distinction between art and craft.
The ever memorable case of Michelangelo must be mentioned in this
connection. When, as a young man, he declared at home that he wanted
to become a sculptor, his father put his foot down and closed the discus-
sion by telling him that never would he allow a son of his to become
a stonecutter. It was only owing to the entreaties of the enlightened
Medici prince, Lorenzo the Magnificent, that the father changed his
mind. If one would want to isolate a symbolic event that marks the separa-
tion of the history of modern sculpture from that of the Middle Ages
and the Early Renaissance, one would have to point to this momentous
encounter at the end of the 1480s.

To return to the illustrations: a drawing after one of the thirteenth-
century stained-glass windows in Rouen Cathedral shows bricklayers,
stonemasons and decorative sculptors busily at work building a church
[7]. Of particular interest is the mason who is seen working with a chisel
at a capital. Once again the capital is propped up in an oblique position.

Similar building conventions continued throughout the fourteenth and
fifteenth centuries. In figure 8 you see a miniature from a mid-fifteenth-
century manuscript in the Royal Library in Brussels representing in
fairly realistic terms the construction of the church of the Madeleine at

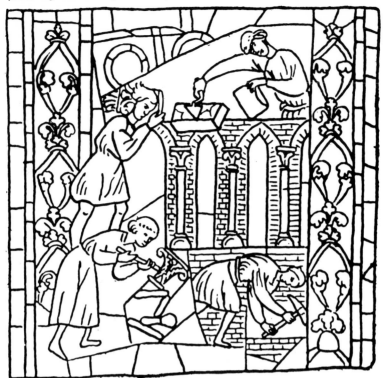

8. Construction of the church of the Madeleine at Vézelay, miniature from a fifteenth-century manuscript

Vézelay in Burgundy (the woman who directs the work represents Bertha of Roussillon). In the background, protected by a roof, we see the stone-masons at work in a kind of shed called a 'lodge'. In the foreground,

workmen transport pieces of stone with carved mouldings to the building, where they will be fitted on to parts already standing. It is rather important to note that the stonemasons were so skilful that they managed to fit moulding on moulding as the building went up.

The last two illustrations in this series only confirm what we have learned. Figure 9 reproduces a beautiful miniature from the so-called Bedford Hours in the British Museum dating from the 1430s. The building in progress is, of course, the Tower of Babel. Here one can follow in very great detail the entire process of erecting a late medieval building.

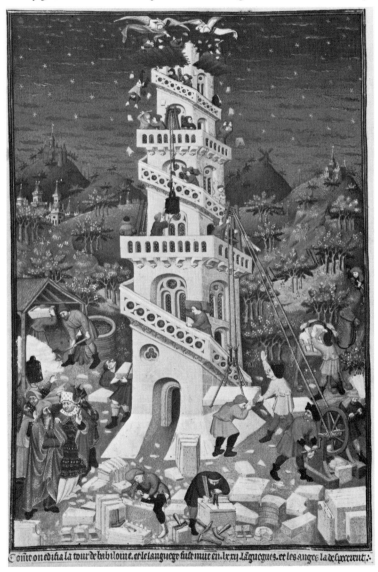

9. Construction of the Tower of Babel, miniature, Bedford Hours, *c.* 1430s

10. Building of the Temple of Jerusalem, miniature, fifteenth century. Jean Fouquet

From our point of view the stonemasons working in the foreground and
the assembly of stone are of particular interest. One of the masons most
attentively handles callipers, by the use of which identity of size is
assured. We also see stones of equal size, carved work-pieces and brackets
assembled on the ground. So, one made sure beforehand that what went
up would fit.

Figure 10 is a miniature of the highest quality. It comes from a Jose-
phus manuscript in the Bibliothèque Nationale in Paris illuminated by
Jean Fouquet at the end of the fifteenth century. The cathedral that you
see going up represents the Temple of Jerusalem. The lower tiers of the
building are finished and the masons are concerned with the erection of
the last tier. Masons in the foreground are shown trimming blocks of
stone and carving mouldings, and this time there appears also a sculptor,
who seems to be measuring a figure that is slightly propped up by means
of a large stone. At the sculptor's feet lies a hammer and a couple of rasps.
So, here, at the end of the fifteenth century, the sculptor of a large stone
figure mingles as an anonymous equal with stonemasons and stone-
cutters.

Let us now look at a few illustrations of artists represented alone. My
earliest example dates from 1285 [11]. It comes from a choir stall that
is now in the Museum at Hanover. The monk here represented is working
with mallet and chisel at a piece of a stall with a crocket. This, therefore,

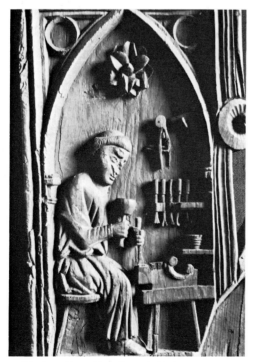

11. Monk working with mallet and chisel,
detail from choir stall, 1285

might well be an attempt at a self-portrait by the master who executed the choir stall. On the wall of his workshop there hang in a row six different chisels for wood-carving, and above them there are callipers and a carpenter's square. Here for the first time one gets a feeling that the artist regarded himself as a kind of elect person – hence the prerogative of creating in solitude. There *was* a self-awareness among artists at this early date and this I have to mention to counter-balance what I have said before. This self-awareness also found expression in self-laudatory inscriptions, mainly of architects, dating back to the eleventh century and even earlier. From the twelfth century onwards we also have some sculptors' signatures and some laudatory inscriptions put up by the sculptors themselves or by their friends. For instance, at the beginning of the twelfth century a Latin distich was placed on the richly sculpted façade of Modena Cathedral, that may be translated as follows:

> How worthy you are of the honour, Wiligelmus
> To be famed among sculptors for your sculpture!

Figures 12 and 13 make known the exceptional power of the artist-creator. Both represent Pygmalion, who according to the Greek legend fell in love with an ivory statue he had made; he invoked Venus, who granted life to the statue. Figure 12 comes from a London manuscript of about 1380, the text of which is the late medieval *Roman de la Rose* (the Pygmalion story had been incorporated from Ovid's *Metamorphoses*). We see the artist carving apparently a wooden statue with mallet and chisel; other chisels, callipers and a hammer are lying around. The scene in figure 13 comes from an Ovid manuscript of the fifteenth century in Florence. We see Pygmalion holding his finished statuette in his left hand; he is obviously attempting to communicate with it. Again, there is the workbench of a wood-carver and it is not unlike that of the early piece at Hanover.

Finally, some other problems: in figure 14 we see a monk painting a statue of the Virgin and Child. This is the frontispiece miniature of a late thirteenth-century Apocalypse manuscript in the Lambeth Palace Library in London. I have selected this illustration in order to bring up again the question of polychromy. We see here that the painting of figures may well have been a specialized job as early as the thirteenth century.

In figure 15 we see a sculptor working on a tomb figure after a model which, as the inscription informs us, is the body of a deceased royal personage. The illumination belongs to a German manuscript of the second quarter of the fifteenth century at Munich. What is interesting here and worth remembering is that the sculptor copies freely without any mechanical aid.

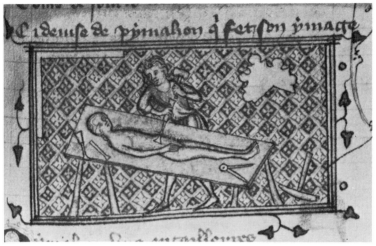

12. Pygmalion as sculptor, manuscript, *c.* 1380

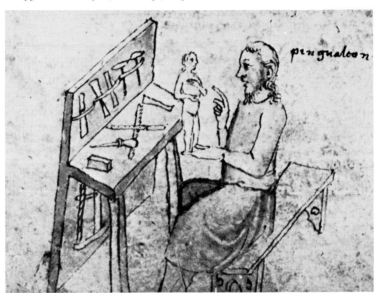

13. Pygmalion, Ovid manuscript, fifteenth century

At last we are ready to turn to the monuments themselves. Wilhelm Vöge, a great art historian and teacher of Erwin Panofsky, published in 1894 a book with a title which I would translate as *The Beginnings of the Monumental Style of the Middle Ages*. This book is almost exclusively concerned with the sculptures of Chartres, where one finds – in Vöge's words – the first liberating ascent of the French spirit. I am referring to Vöge's book here, because in spite of the vast amount of art-historical

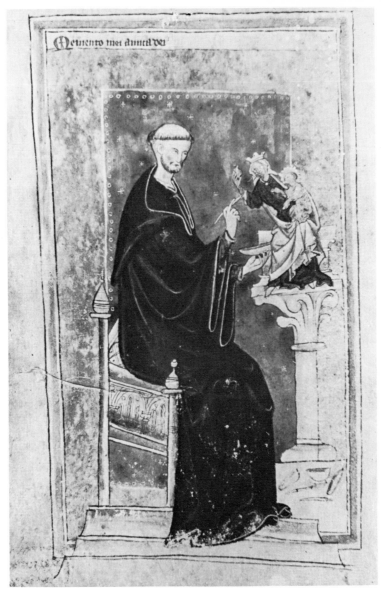

14. Monk painting statue of Virgin and Child, miniature, thirteenth century

work that has been done in the more than seventy-five years since the book appeared, it has never been equalled. Moreover, Vöge pays considerable attention to the conventions that existed or rather developed in the cathedral workshop of Chartres. In fact, so far as I can see, no one has superseded his penetrating observations and I too am indebted to him. We cannot discuss the history of the erection of

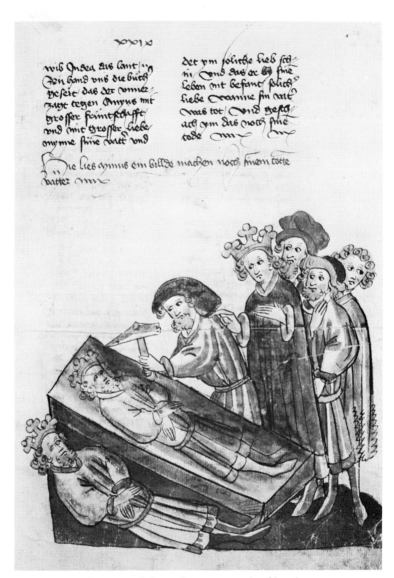

15. Sculptor working on a tomb figure, German manuscript, fifteenth century

Chartres. Medieval cathedrals took long periods of time to be completed and you can see that the towers of the west front of Chartres belong to different periods. Our interest is focused on the triple portal of the west front, already called in the thirteenth century the 'Royal Portal' and especially on the central one. These portals were planned by a master mind in the 1140s and were probably finished between 1145 and 1155.

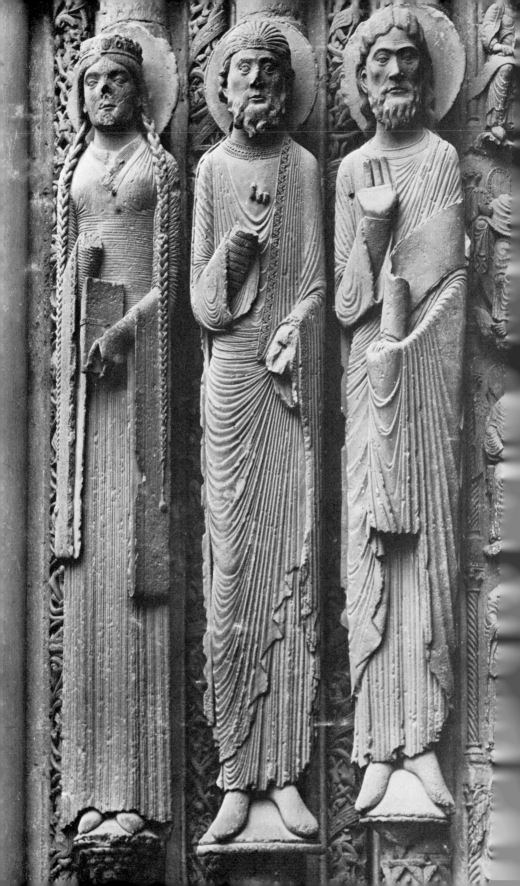

Since the quality of the tympanum and of the jamb figures of the central porch is considerably superior to that of the figures of the side portals, the central porch is always attributed to the great master himself and most of the rest is given to his workshop.

Let us look at the left-hand jamb figures of the central porch [16]. A few things are evident at first glance: each figure lives, as it were, in its own world. The figures are not related to each other or to the beholder. Their expression seems to be thoughtful, mysteriously removed, and we may even discover the faintest archaic smile. Their whole appearance is entirely coordinated with the jamb columns before which they stand or hover. Their heads are looking straight forward, their arms and hands are close to their bodies holding a book or a scroll and their bodies are scarcely discernible under the long parallel folds of their draperies. They are in the true sense of the word 'column figures', but they have no architectural function and one could take them away without interfering with the architecture. French scholars of the nineteenth century and even of our own day have often discussed the problem of how such Gothic portals with their army of figures were carried out. Were the figures carved, as the French put it, *avant la pose* (before having been set up) or *après la pose* (i.e. *in situ*)?

One encounters cases of unfinished capitals and even of unfinished statuary in position and that would seem to favour the theory that this was common practice. However, it is far from true. I illustrated contemporary representations of work-in-progress with a purpose. Nowhere did we find workmen or sculptors hewing or carving stones or blocks in position. Even if we doubled or tripled the number of examples, we would not encounter a single such case. In other words, I believe that what we have seen in those contemporary illustrations was by and large the rule: blocks of stone were worked *avant la pose* in the cathedral workshop, i.e. often simply in the open or maybe under cover (as we have seen) quite close to the building site. In any case it can be shown – and I believe everyone agrees – that the Chartes sculptures were worked *avant la pose*. Each of the Chartres figures consists of a whole block; none of the figures is put together from two or more stones. In cases where a joint goes through a piece of decorative or figure sculpture it may be assumed that the work was executed *après la pose* (incidentally, it has been argued, perhaps a trifle too ingeniously, that to find unfinished capitals in a church is not a proof of *après la pose* work – it may just prove the opposite, namely that at a hurried job one had to use capitals that had not been completed and that, therefore, their unfinished condition might well be an indication of the fact that one did not continue work *après la pose*).

16. Three of the left-hand jamb figures,
west façade, Chartres Cathedral, thirteenth century

But what is more interesting is the probability that the Chartres workshop started a new tradition. The sculptural decoration of the early Middle Ages was probably often worked *après la pose*, for – as Vöge and others have argued – early polychrome sculpture was so close to painting and was so obviously derived from painting, that it must also have been handled like painting, i.e. have been executed on the wall within the finished structure. The monumental sculpture of Chartres by contrast is worlds removed from painting – it is three-dimensional in the first place, it has a kind of primitive plastic force and in this respect it is essentially similar to Greek archaic sculpture.

These figures yield some of their secrets if they are carefully studied. As we have seen, each of them was made of one block. What is more, as a detail from one of the side-portals shows [17], figure and column were made of the same block; the halo seen against the joint of column shows that the figure filled the entire height of the block. The blocks of the figures were about 7 feet high; they were square, with sides of about one foot. These squares were always placed diagonally, i.e. one corner of the square is sticking out, confronting the beholder. The sculptor was most careful not to sacrifice anything of the block. Figures 16 and 17, but particularly the detail, reveal quite clearly the diamond-shaped sides of the block. The flat face of the falling drapery on one side of each figure represents almost the skin of the block. The sculptor submitted himself to an iron discipline: he followed the dictate or the logic of the block; consequently elbows are held close to the bodies, arms are kept along the sides of the block and the spines of the books touch the foremost angle of the lozenge.

I think the detail [17] shows better than the whole figures of the Royal Portal at Chartres that the lozenge-shaped block form is clearly visible in the finished figures, that they are all subservient to the same method of procedure, that the sculptor must have drawn the outlines of each figure on the faces of the block (paralleling the procedure of the archaic Greek artist), but that we have to assume clarifying preparatory work for the vast and complex sculptural programme, even though the individual figures were probably created independent of preparatory designs or models since they all follow the same basic pattern. How were these figures worked? From the information we have gathered before, in a shed – the lodge – quite close to the building. Here the blocks were propped up in an oblique position and the sculptor would attack the block directly – with what? My guess is, with a punch. When you look at the detail of a head it presents that bursting, pulsating life despite the attitude of eternal tranquillity, that we can associate with the effect of creative punch work. But the surfaces of these figures are, of course, badly

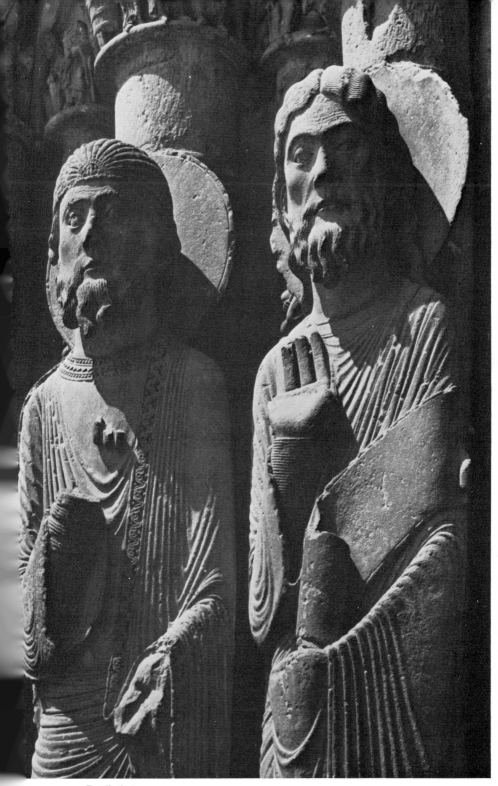

17. Detail of 16

weathered and I would not like to be too insistent. On the other hand, it is certain that other tools were also used. Theophilus and the early visual material have taught us that the tools were available and in the beard of the head on the left in figure 17 and in the ornament of his dress, we may discover claw and flat chisel work. Such tools must also have been used in the long pleats of dresses. In any case, there is no doubt that the figures of the Royal Portal were carved directly in stone.

I have to conclude with some observations and queries. First, I would not like to leave you with the notion that the great artist of the Royal Portal was a slave to the block-form he had chosen. He chose, of course, the lozenge-shaped or diagonally-placed block, because it would give him a chance to express the tectonic and immobile qualities he was seeking for these column figures. His attitude to the block was probably not much different from that of Michelangelo. But Michelangelo could verbalize his ideas and put them on record for all time, while (for many reasons) the Chartres master may have been incapable of explaining them, even to his workmates.

The task this master was facing was not less difficult than that of the great Greek enterprises from the mid-fifth century on. Theological advisers would probably have requested, as they almost invariably did, some kind of assurance that their wishes were carried out. Moreover, the master was responsible for the work of a number of assistants who all needed guidance. Surely, like the archaic artist, these artists, too, must have drawn their figures on the faces of the block.

But that cannot have been all. What kind of general planning, what kind of preparatory work do we have to postulate? As I have said at the beginning of this lecture, one cannot easily agree to the planning on paper or on parchment nor, indeed, to the existence of models. And yet it cannot all have been done by word of mouth. How can the master have assimilated the programme with its infinite details, how can he have kept everything in mind during long years of execution? I have not got the answer and no one has it. But there is no saying when and where hitherto untapped sources may begin to flow.

3

THE MIDDLE AGES

CHARTRES, RHEIMS, BAMBERG, ORVIETO

In the approximately eighty years between the sculptures of the west porch of Chartres and the sculptures of the north and south porches much had happened. Briefly, a great process of Gothic humanization is noticeable: it can be followed through a number of intermediary stages of the second half of the twelfth century at Senlis, Nantes and Laon, and even from the earlier north porch of Chartres to the later south porch, although there were perhaps only fifteen years or even less between the jamb figures of the one and those of the other (the execution of the jamb figures in both portals lies between approximately 1220 and 1235).

The stylistic changes between the west porch and the north and south porches have often been described; I can therefore concentrate on a few features of special interest in our context. All the jamb figures are still addorsed to columns, but they no longer form an integral unit with the column; they have lost their elongated columnar shape; they have gained in volume, naturalness, individuality. Heads turn here and there, arms and hands are shown in many different positions. Some of the figures even turn to, and communicate with, each other. Among the latest figures on the south porch we find such splendid statues as the St George [1], who displays a firm stance and a natural balance and looks like a knight of the age of the Troubadours.

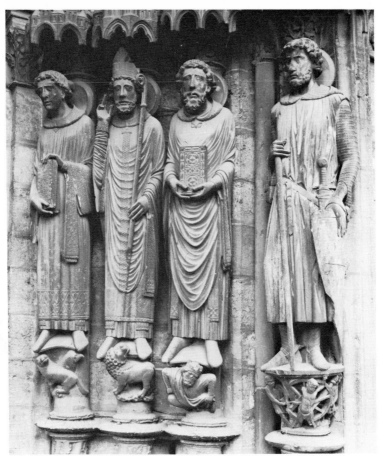

1. *St George* (right), south porch,
Chartres Cathedral, *c.* 1220–35

Clearly, there was no longer here a towering personality such as the
great master of Chartres West, a disciplinarian who had taught the
masters working under him in the cathedral workshop how to carve
sculpture of monumental size and who could not help enforcing an
archaic law of stylization. From such figures as the Visitation of the left
portal of Chartres North, showing St Elizabeth and the Virgin turned
to each other in mute dialogue, a way opens to the celebrated An-
nunciation and Visitation of the central porch of the west front of
Rheims [2], a climax of French mid-thirteenth-century Gothic sculpture.
The freedom of these figures, their diversity of movement, their dif-
ferentiated expressions, the richness and variety of dresses with their con-
trasts of simple, broad, vertical folds and dense, crumpled, partly hori-
zontally arranged pleats – all this shows that there was more than one

2. *Visitation*, central porch, west front
Rheims Cathedral, thirteenth century

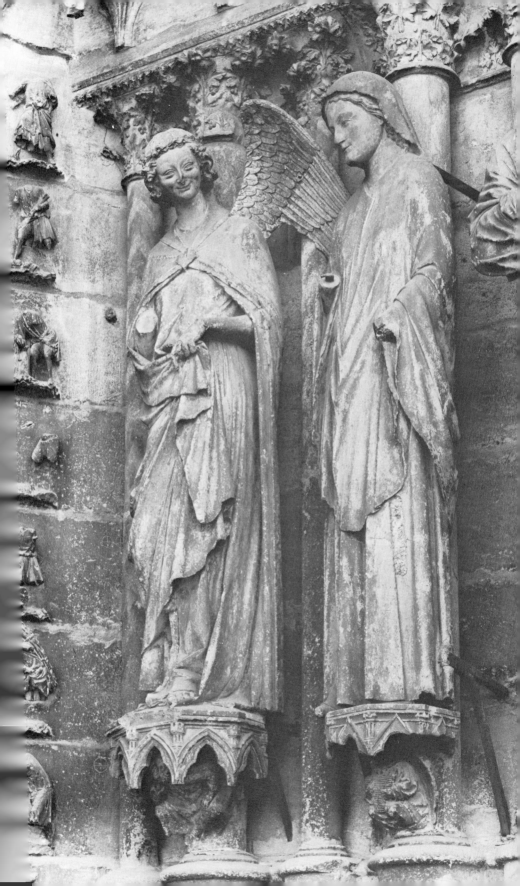

hand at work, and moreover, it shows that most careful preparatory studies must have preceded the execution. These figures date from the period when Villard de Honnecourt compiled his sketchbook. It seems reasonable to assume that the Rheims master of the Visitation made use of sketches he had drawn during his itinerant years. How else could one explain the classical features of the Virgin. Her Juno-like head has always amazed beholders to such an extent that some older critics considered these statues Renaissance or even eighteenth-century restorations.

If we have to agree that the artist of the Visitation had recourse to a storehouse of designs and exemplars he had accumulated, we also have to agree to the next step, namely the preparation of the actual figures by way of drawings. Not long after the date of these works, preparatory designs begin to appear – as I explained before, first in connection with architecture, some time later to be followed by drawings related to sculpture. It is my contention that an important change in the preparation of monumental sculpture came about between Chartres West and Chartres North and South. These early thirteenth-century portals must have been as carefully prepared in designs as the portals of Rheims. On the whole I would agree with Marcel Aubert's general assessment of the thirteenth-century position. He wrote:

> The master who is in command of the lodge, distributes the work, supplies the guiding ideas to the sculptors, and hands on to them the details of the iconographic programme that he has received from the clerical adviser. He furnishes sketches, maybe rather detailed ones, which would contain the measurements, the silhouette, the pose, and the main features of the figure. He watches over the execution and on occasions takes up chisel and mallet himself ... He is responsible both for the details of the sculptural work and for the architectural construction.

I think one can buttress these remarks by tangible facts. For this purpose I shall first switch over from France to thirteenth-century Germany, then to early fourteenth-century Italy and at the end I shall return to fifteenth- and even early sixteenth-century Germany again. First I want you to follow me to Bamberg in Franconia in central Germany.

Bamberg's Cathedral is a repository of exquisite mid-thirteenth-century sculpture. In fact, discriminating study has established that there were two workshops in succession, an older one beginning to work about 1220 and a younger one, the activity of which seems to lie just after the middle of the century. The great master of the younger generation was closely dependent on Rheims, so close in fact that the Virgin of his Visitation [3] must be regarded as a free (somewhat Teutonic) version of the Rheims Virgin. The older liberal German art history noted and described this dependence, while younger and more nationalistically oriented German art historians refuse to acknowledge any connection.

3. *Visitation*, Bamberg Cathedral, *c.* 1230-40

This matter is not without some importance. I cannot afford to go into this affair in any detail and can only state my firm conviction that the Bamberg master must have spent some time at Rheims during his *Wanderjahre*. And together with the style of Rheims he probably also transmitted working conventions he had encountered there. The most important and also the most enigmatic work conceived by this master is an

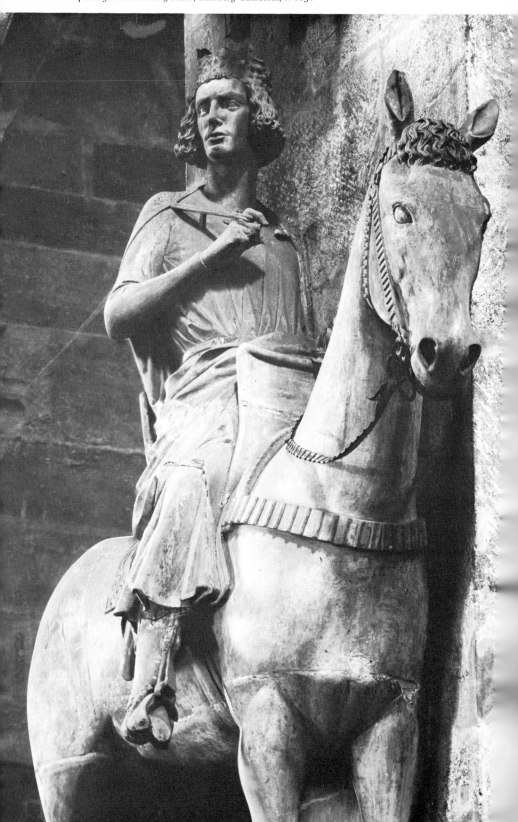

equestrian statue in stone, *The Bamberg Rider* [4], placed high against
a pillar in the church. The height of the whole group (horse and rider)
is just under 8 feet. This is the first almost life-size equestrian statue
after the fall of Rome, and it is a work of the highest quality. You may
not be satisfied with the wooden appearance of the horse. But look at
the masterly way the figure is sitting in the saddle: there is a mixture
of royal bearing and nonchalance. This can be seen very well in a view
from the back [5] and you will also notice how splendid the horse looks
in this view. In fact, both the head and the hind legs are remarkably well

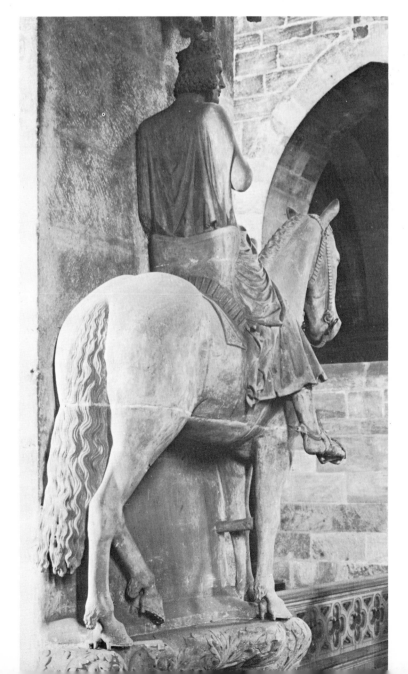

understood. I want you to notice other things in this work. First there is a joint going through the back of the saddle, about half-way up. I shall come back to this. Secondly, you can see very well that the rider has no left arm – an indication that the work was conceived for positioning against a wall and those who have more recently examined it agree that it has always been in the position in which it is now.

I called this work enigmatic, because one does not know who is represented. People have tried to attach every conceivable name to the rider, from St George to King Stephen of Hungary, the Emperor Henry II of Germany, and Constantine the Great. Thirty years ago a book of 550 pages appeared entitled *The Bamberg Rider and his Secret* – this problem endears, of course, the work to the public. Careful investigation has shown that it consists not of one stone, but of seven different pieces. This investigation was carried out in 1924 and I show the diagrammatic drawing published on that occasion [6]. The largest block [I] served for the

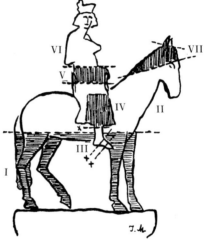

6. *The Bamberg Rider,*
diagrammatic drawing

legs and the belly of the horse. In figure 5 you can easily see the joint which has been filled in with plaster. The second large block [II], was used for the body, neck and part of the head of the horse and also some of the lower part of the rider's body. The middle and upper portion of the rider's body, a part of the mantle with the right knee and the upper section of the horse's head were all made of small individual blocks. The joints, by the way, would not have been visible at the time the monument was put up, for originally rider and horse were colourfully painted. Remains of colour have been found in the mouth and nostrils of the horse, the mantle of the rider, and elsewhere; the crown was gilded. In the seventeenth century the polychromy of the group was replaced by off-

white paint; only the crown remained gilded. At the beginning of the nineteenth century chemicals were used to remove three layers: the seventeenth-century white, the original colour, and the grounding, in order to expose the naked natural stone we see today.

It is obvious that the Bamberg Rider was made in the cathedral workshop and not *après la pose* (as was believed by some). Incidentally, despite the great care taken in fitting the various pieces together, the wavy strands of hair forming the horse's tail do not carry over exactly from one block to the other across the joint. No better proof of a separate working of the blocks in the workshop is needed. But if the blocks were worked singly and perhaps even by different hands under the master's supervision, we have to postulate a rather detailed design or even a model to which constant reference could be made. I think this case does not allow of any other explanation. My suggestion that the master may have brought such a working technique along with him from Rheims cannot be confirmed with equal assurance. It might be argued that the new challenge of creating an equestrian monument (for which there was no tradition) forced the master to experiment with clay models until he had found a satisfactory solution.

In contrast to France, Germany and England, Italy had few great cathedral workshops with extensive sculpture yards. But among them there is at least one that can help us. For the west front of Orvieto Cathedral a theological programme was requested that could compare with the cathedral programmes of the north. And it is at Orvieto that we can learn a great deal about the working of such a lodge – mainly owing to an exemplary investigation carried out by Professor John White. We are moving, as I have mentioned, into the early years of the fourteenth century.

First, a few basic data. The foundation stone of the new cathedral was laid in 1290. In 1310 Lorenzo Maitani (a Sienese who had already been in Orvieto at the beginning of the century) was confirmed as *capomastro* of the Cathedral of Orvieto and remained in this position until his death in the summer of 1330. Whether he himself was or was not a sculptor is a point still discussed among specialists. In any case, the lower half of the façade which contains the bulk of the sculptural decoration was executed during his tenure of office. The work we are concerned with is the four broad piers with their sculptural decoration. The decoration consists of a carpet-like layer of splendid reliefs which illustrates the history of mankind under the aspect of Christian Revelation. The first pier on the left relates in more than a dozen scenes the story of the Creation and Fall. Even in figure 9 you may notice how the pier is covered by a jigsaw of marble slabs. The second pier contains reliefs illustrating

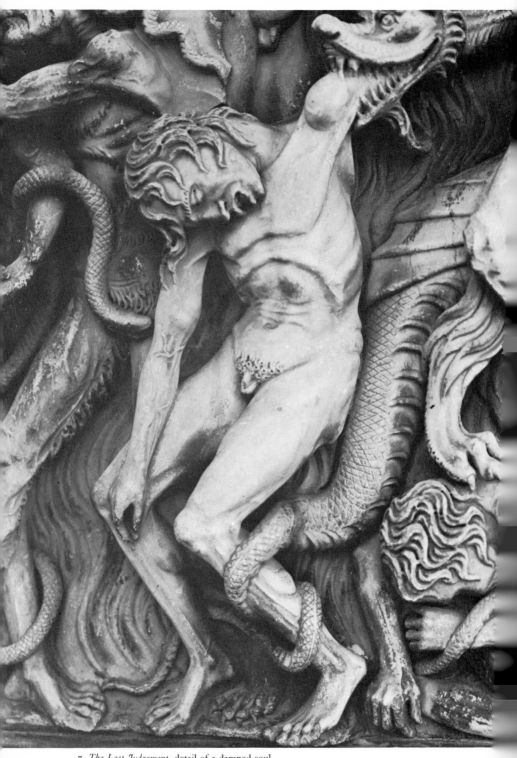

7. *The Last Judgement*, detail of a damned soul,
west front, Orvieto Cathedral, early fourteenth century

the Prophecies of Christ. The third pier contains the Life of Christ and the fourth the Last Judgement.

In our context, the specific interest in these reliefs has two interrelated reasons. First, only the reliefs of the lower half of each pier are completely finished. The upper halves appear throughout in various stages of execution. Secondly, all in all, 163 marble blocks of various sizes were used and put together in what would seem an entirely haphazard way. What can we learn from these facts about the organization of the workshop?

Figures 7 and 8 are two scenes from the finished lower portions.

Figure 7 shows a damned soul from the Last Judgement pier; it gives you an idea of the perfection of the execution (there is scarcely any weathering to be seen here). You also get a pretty good idea of the high quality of this work. One senses the hot breath of the style of Giovanni Pisano whose Pisa pulpit was executed between 1302 and 1310.

Figure 8 illustrates the relief showing the Fall (first pier). This relief can teach us something important, a lesson that could be repeated in many cases. The scene is fitted into the space of a single marble slab. The sculptor carefully confined the figures to this area. Adam's feet, Eve's elbow touch the borders of the block. Nevertheless, there are subordinate links to adjoining blocks: to the right of Eve's legs there is a bush, one half

8. *The Fall*, west front, Orvieto Cathedral, early fourteenth century

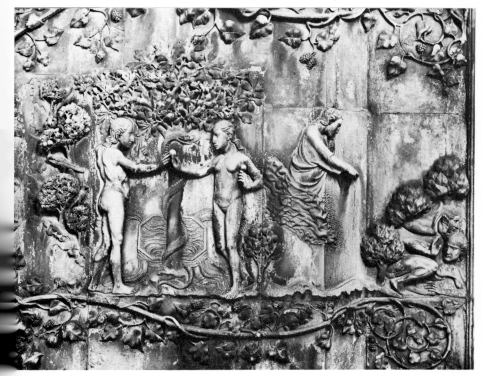

of which extends across the joint. The fit is perfect and one realizes that the final adjustment, in any case, could only have been done *après la pose*. But now look at the upper edge of the block: here the tree also spreads over on to the next block, but the leaves do not join [9]. The only explanation is, of course, that the blocks were worked in the workshop by different hands and when they were put up in position it was found that this little discrepancy was beyond repair and so nothing was done about it. I cannot forgo directing your attention to a little detail: what we see

9. Detail of 8

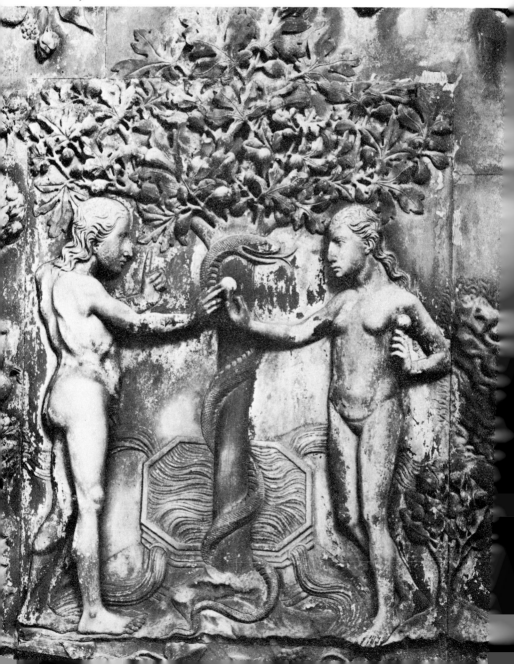

here is not an apple tree (as it should be) but a fig tree. The sculptor
of the upper block knew it too. So, these sculptors must have had before
them detailed designs to work from.

This conclusion can be supported by other similar observations. Not
far from the relief of the Fall is that of the Creation of Eve [10]. Once
again the composition is carefully fitted into one block of stone. To the
right of the scene, on another block, there are two attending angels. The
one on the left points out, as it were, the miraculous event by raising

10. *The Creation of Eve*, west front, Orvieto Cathedral, early fourteenth century

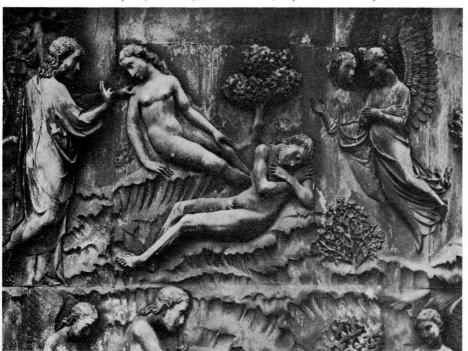

his hand. From a distance it looks as if this hand was carved on the Crea-
tion block. But in actual fact the joint runs round rather than through
the outstretched hand. Thus, we have another indication of how carefully
the design must have been followed in the workshop.

Our assumption that preliminary drawings must have existed is con-
firmed in this case by a document of 16 September 1310 according to
which Lorenzo Maitani was appointed *universalis caput-magister* of the
whole enterprise. Here it is expressly stated that Maitani may retain dis-
ciples for the purpose of 'drawing, forming, and executing the sculpture'.

The fact that the lower registers of all four piers are finished and the
reliefs higher up are not quite finished shows that work proceeded, step

by step, from the lower to the upper parts. In figure 11 we see Tubalcain, the biblical inventor of music, a relief in the topmost zone of the first pier. Although the relief has suffered from the weather, the granular appearance of the human body is not due to deterioration alone. The body presents the stippled or pitted surface characteristic of punch work. By contrast the figure's hair is carefully finished and so is the complicated bell-tower which still presents a perfectly preserved smooth surface treated with abrasives.

There are many similar cases. I will only show you one more, the Prophecy of the Crucifixion on the second pier [12]. The body and loincloth of Christ and the faces of sun and moon show once again the pitted condition typical of punch work with the right-angle stroke. In the arms of the cross and the surrounding area one finds the parallel striations of claw chisel work. The hair of Christ, the crescent of the moon, and the rays of sun and moon were worked with the flat chisel, and the rays were completely finished with abrasives.

12. *Prophecy of the Crucifixion*, detail of the Crucifixion,
west front, Orvieto Cathedral, early fourteenth century

I think we can now make some valid statements, even without further examples. It is certain that most of the carving was carried out *avant la pose*. But most of the blocks, if not all, went into position before they were completely finished. The finishing touches, the smoothing of surfaces, and perhaps some subordinate details were left to the last moment when one saw how the blocks fitted. We noted a strange insensibility towards a simple organization of identical marble blocks. The approximately contemporaneous delivery of 163 marble slabs of different sizes must have caused havoc in the workshop. But the leading artist had apparently decided to have the blocks cut to fit the scenes and such an approach required an immense amount of correct preliminary planning.

It would seem that specialists, minor craftsmen, were used for the less important parts of the reliefs, such as hair, plants and trees, and architectural features. All these are usually finished, while human bodies, the work of the most renowned masters, appear in various stages of punch work. So, we have to acknowledge a mastermind, evidently Maitani, who designed with the help of assistants the entire job and probably had the 163 marble slabs blocked out with the punch by a group of leading artists.

I mentioned in my last lecture that there are in existence two early fourteenth-century designs on parchment for the façade of the Cathedral of Orvieto. They are the first such designs in the history of Italian architecture known to us. It has always been acknowledged that one of these designs was indebted to Notre Dame in Paris. So we see France, at this moment, still leading in artistic matters, influencing both Germany and Italy and, conversely, I think we are allowed to conclude that Gothic planning conventions which we have reconstructed in Bamberg and could confirm with some assurance in Orvieto, are ultimately derived from the area that must be regarded as the cradle of Gothic art, the Ile de France.

We now leave the cathedral workshops and return to Germany, where we encounter a most vigorous Late Gothic art in the fifteenth century, an art that led in the early sixteenth century to the great figures of Dürer, Holbein, Grünewald and Cranach but which came to an end with the victory of the Reformation. This art was Gothic in form and feeling, but it was no longer tied to the cathedral workshops. In fact, in the fifteenth century these workshops had seen their day. The focus had shifted from the cathedrals with their anonymous workshop practices to the cities and their professional organizations – the guilds. Within these organizations we soon begin to discern names of individuals, but what is perhaps more important in this context, we meet new conventions of workshop practice derived from, or expressive of, the new social ambiance created by private enterprise. The individual master and his patron (often the Church but not as near-exclusive as before) became the focus of artistic creation.

The second half of the fifteenth century also saw the rise and rapid spread of the woodcutter's and engraver's techniques – techniques much practised in Germany at an early date – and the many copies that could be made of a design and its cheap distribution contained previously un- dreamed-of possibilities. Graphic representations were collected by sculptors and as early as the fifteenth century belonged to the equipment of their workshops. A good many sheets by the Master E.S., by Schon- gauer and Dürer were used as exemplars by sculptors. There were even graphic artists who produced sheets for precisely that purpose. Thus we find an anonymous engraver (only identifiable by the letter W) producing in about 1470 an engraving that was meant to serve late Gothic carvers as a model for the framework of their altars.

In addition, as time goes on, there is an ever-growing number of draw- ings related to sculptors' works, but it is difficult to decide whether the sculptors used painters or draughtsmen for their designs or whether the

13. Design for the upper part of an altarpiece, fifteenth century

sculptors were also the designers. Moreover, one cannot say whether such drawings were meant to be shown to patrons to give them a precise idea of what to expect or whether they were merely exemplars to work from.

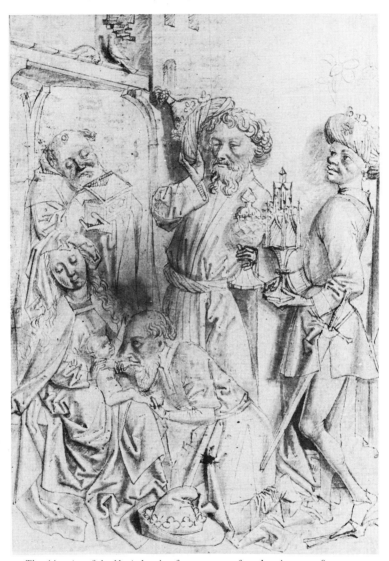

14. *The Adoration of the Magi*, drawing for one scene of an altarpiece, *c.* 1485

The same applies to a drawing in Munich [13]. It is a wonderfully accurate design on parchment, almost 20 inches high, showing the upper part of a sculpted altar, architecture and figures. Many more such examples could be given. But I have to limit myself to one more example of a somewhat different kind, a rather pictorial figure drawing from the

15. *The Adoration of the Magi*, centre of the altarpiece, *c.* 1485

end of the fifteenth century (in the collection of the Castle at Coburg), representing the Adoration of the Magi [14]. The drawing is an impressive study for one scene of a large sculptured altarpiece in the Germanisches Museum at Nuremberg [15]. A comparison of the two pieces quickly convinces us that the sculpted group has lost much of the in-

tensity of the drawing. For instance, the Virgin, who in the drawing follows with participating glances the encounter of the Child and the old King, is not at all engaged in this scene in the sculpted group, and so forth. In all likelihood, the sculptor was working from a painter's design. It is revealing for the Late Gothic workshop traditions that the same drawing was used by another sculptor for a group, now in the Bavarian National Museum in Munich. In this sculptural realization (without the figure of Joseph) the design has lost even more of its original warmth of feeling and stylistic subtleties.

The examples I have given throw a clear light on Late Gothic workshop procedure and leave no doubt that the sculptors worked from drawings, whether they were done by them, or for them, by painters or draughtsmen, or from commercially purchased engravings or woodcuts. The latter were accumulated in the workshop for the purpose of having a storehouse of models ready at hand which could be used without a moment's delay in case of need.

Although I have underlined the break between the cathedral lodges and the privately-run workshops, there was also a continuity. The private workshops surely inherited many of the earlier traditions, so that late medieval workshop practice also throws light on earlier conventions in the cathedral lodges. To a certain extent this would seem logical and one

16. Altarpiece, Bamberg Cathedral, fifteenth century. Veit Stoss

could enlarge on this topic almost *ad infinitum*. Let me only mention that in England monastic building had almost come to an end by 1500, and so parochial and capitular authorities had almost no need of masons. But the Crown did need them and at the end of Elizabeth's reign the Crown was to a large extent replaced by the nobility and gentry. This hint suffices to show that continuity never broke down.

Let us once more return to Bamberg for a final assessment of the Late Gothic position [16]. In the south aisle of the cathedral there is a huge wooden altarpiece consisting of a very large central scene of the Birth of Christ, and two wings, each with two scenes of His life of half the size of the central scene. The altar is the work of that extraordinary genius, Veit Stoss, who is now claimed both by the Germans and the Poles, for he worked for twenty years in Cracow (between 1477 and 1499),

17. St Wolfgang Altarpiece, central scene, 1471–81. Michael Pacher

but was born near Nuremberg and spent most of his long life in that city. He was always in trouble and was in and out of prison. The city fathers of Nuremberg called him 'a restless, wicked citizen' and 'a muddled and garrulous man'. After his death, in 1533, at the age of at least 86 years, litigations went on, for instance, about the price of the Bamberg Altar, which had originally been commissioned by Veit Stoss's own son, Dr Andreas Stoss, then Prior of the monastery of the Carmelites in Nuremberg.

The enormous dimensions of the Bamberg Altar are characteristic of a few Late Gothic altarpieces in southern Germany and Austria such as Michael Pacher's fabulous altar at St Wolfgang (near Salzburg) [17], executed between 1471 and 1481. Pacher was painter and sculptor and the St Wolfgang altar (which is about 28 feet high and 15 feet wide) consists of sculpted and painted scenes. There is a difference between the Pacher and Stoss altarpieces that immediately catches the eye. The Pacher altar sparkles and glows in its original Gothic colour, whereas the Stoss altar is not painted.

It has been argued that it should also have been painted, but that lack of money and other difficulties prevented its completion. But German specialists now tend to the opinion that, although the altar remained unfinished and never got its intended shrine, colour was not planned. For a memorandum in the Prior's hand states explicitly: 'No Prior should easily be persuaded to have the altar painted. All masters who are knowledgeable in these matters will supply the reason why colour should be omitted.' The altar was executed between 1520 and 1523 and at that time the anti-polychrome movement of the Italian Renaissance had evidently made an impact in the north.

As a matter of fact, there exists an earlier German altarpiece that was intentionally left unpainted – I believe it is the earliest – Tilman Riemenschneider's large altarpiece at Creglingen near Würzburg [18]. This altar, which with its Gothic shrine is over 35 feet high, is usually dated between 1505 and 1510. There is at least a hint at colouristic differentiation in the Riemenschneider altar: the architectural and decorative parts are carved from reddish pine and the figures are of much lighter linden wood. Riemenschneider was not a sworn enemy of colour. Most of his works are wholly or partly painted, such as the early Virgin and Child in Vienna, and his portraits, such as the splendid head from the tomb of Bishop Rudolf von Scherenberg in the Cathedral of Würzburg, are enlivened by the realistically painted eyes.

By a stroke of good luck Veit Stoss's design for the Bamberg Altar survives in the Archaeological Institute at Cracow [19]. The drawing is on parchment and almost 15 inches high. It is surely the drawing that

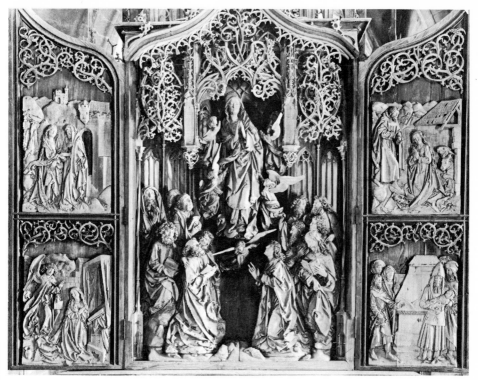

18. Altarpiece at Creglingen, 1505–10. Tilman Riemenschneider

was requested in the contract of 13 July 1520. Since its publication in 1912, the originality of this drawing has never been doubted. It is a unique piece; no such drawing by Pacher, Riemenschneider, or any other great German sculptor has come down to us. The drawing and the finished altar make an interesting comparison. We find that Veit Stoss followed his design in a general way. He had contractual obligations to do so. But he also felt free to vary the design and composition – an indication that he regarded the drawing as no more than a guiding document that would not however be permitted to impede his free and imaginative carving in wood. Incidentally, two sketches by his hand – not connected with this altar – have also survived; they give us an idea of his great skill as a draughtsman, and there can be little doubt that he worked a great deal in pen and ink.

The preparatory drawing for the Bamberg Altar is a piece of first-rate importance: for, in this case we have the contract, the drawing requested in it, and the final sculpted work. A happy coincidence at the end of a long era: hundreds upon hundreds of similar cases must have preceded this one.

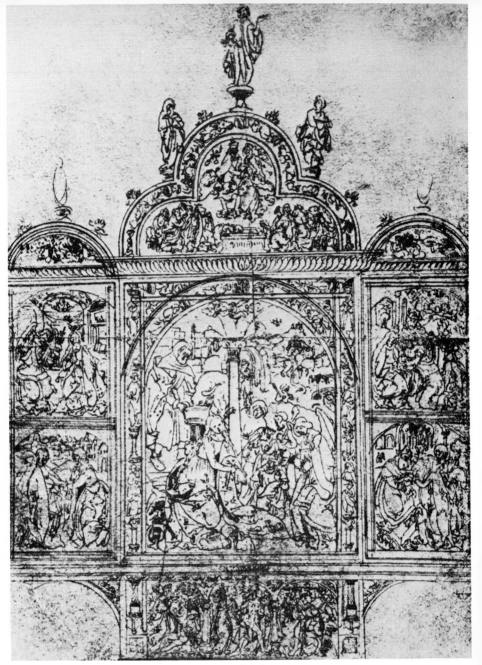

19. Design for Bamberg Altarpiece, *c.* 1520. Veit Stoss

We have indeed reached the end of an era. Look at the shrine Veit
Stoss designed for his altar. This is no longer the Late Gothic altar-shrine
with its ingenious filigree carving, but a simple Renaissance shrine with
plain segmental crowning features. From here we will have to turn to
the sculptor in the Renaissance.

4

THE
RENAISSANCE

ALBERTI, GAURICUS, LEONARDO

The changes that came to pass during the movement we call the Renaissance were of such a fundamental nature that they eventually brought about no less than a new species of man. I side with those scholars who regard the Renaissance movement as the dawn of modernity – even of modernity with some of its questionable blessings.

I can, of course, only hint here at some Renaissance problems of immediate concern to us. There is not a shadow of doubt that in the first decade of the fifteenth century a small circle of Florentine masters experienced a strange awakening. Among them the concept of a new type of artist was arising, one essentially different from the artisans and craftsmen of old. He became conscious of his intellectual and creative powers and regarded his special endowment as a gift from heaven granted to a few elect. The *locus classicus* for the new ideal of the artist is Leon Batista Alberti's treatise *On Painting*, written in 1435. Alberti tells us in great detail what kind of man the modern artist should be, and what moral and scholarly equipment was required of him. He insists on the necessity of placing the profession of art on a firm theoretical basis.

In the medieval order of things the visual arts ranked with the mechanical arts and not with the liberal arts, the cycle of which was then restricted to the linguistic and mathematical sciences. The new race of painters, sculptors, and architects strove to be admitted to the liberal arts and to rank as equals with rhetoricians, poets, and students of geometry. As a

liberal artist one had to acknowledge the scientific foundation of one's art, one had to be theoretically trained and, if possible, even contribute to the theory of art. Thus, from then onwards, theoretical considerations accompany the practice of art or, to be more correct, I think it became an article of faith of avant-garde artists that practice had to be based on theory. Henceforth we shall not only have to find out what sculptors *do*, but also what they think and say or, at least, what their literary spokesmen expressed in words.

It so happened that Alberti – himself writer, humanist, scholar, theorist, philosopher and original thinker, architect and sculptor – in a word, an early representative of the universal man of the Renaissance – set himself the task of laying the theoretical foundations of all three arts. Next to his treatise *On Painting*, his *Ten Books on Architecture* immediately come to mind. This bulky work, written over a long period of time and finished in the early 1450s (about fifteen years after *On Painting*) had an influence no less pervasive than his treatise on painting. His treatise on sculpture, entitled *De Statua*, is not in the class of the two other works. It is very brief and seems highly specialized. The modern reader may find much of it baffling and abstruse and so it is barely read or mentioned by art historians. There exists a 1568 Italian translation of the Latin original, an English translation of 1733, and a reliable German edition, published in 1877. About fifty years ago Panofsky commented briefly on some aspects of this work, and more recently interest in the work has grown. It has been shown that it was not the last of the three treatises (as had always been assumed), but the first one, dating from the early 1430s, and this fact may also explain some of its shortcomings.

Let us look at this treatise a little more closely. Alberti begins with a brief consideration of the motivation for the first attempts at the three-dimensional imitation of nature. From here he goes on to a definition of the plastic arts and immediately makes a differentiation of the greatest importance. Those who are working in wax or plaster, he says, proceed by adding material or taking it away; we call them modellers, while those who only take away and bring to light the human figure potentially hidden in a marble block, we call sculptors. Though guided by Pliny and Quintilian, no one before Alberti had ever expressed so clearly the difference between modeller and sculptor (or carver).

For about the next five hundred years this division has remained on sculptors' minds. It has plagued them, one might almost say it has persecuted them, and sculptors have rarely been capable of noting the difference between modellers and sculptors with Alberti's equipoise. Both modellers and carvers, so Alberti tells us, equally attempt to create likenesses of natural forms. And he goes on to say that they would be

less often mistaken in their works if they would follow his rules and his teaching. Each art and each science has its own rules and principles, Alberti says, and the sculptor who knows them will minimize the possibility of errors. Since the sculptor's aim is imitation of nature, he has to note that there exist two aspects to the problem of imitation: we have to acknowledge that there are universals and particulars. All humans look similar, but at the same time no two men are alike.

According to Alberti's own method, *dimensio* and *finitio* (which may roughly be translated as measurement and delineation) are the prerequisites for the realization of all likenesses. Measurement may be achieved by employing two instruments: the *exempeda*, a modular straight ruler to measure lengths, and a pair of movable carpenter's squares with which to measure diameters. With their help the sculptor can determine with mathematical precision the exact size of any part of his model. But although measurement guarantees reliable notations with regard to the relation of one part of the body to the other and to the whole, one can only determine universals in this way. In order to determine particulars, *finitio* or delineation is needed. Delineation is the method by which the outlines with all the cavities and proturberances of a figure in motion are determined and this is accomplished with the help of another tool, which Alberti calls *definitor*. The definitor consists of a circular disc to which is attached a pivoting rod from the end of which hangs a plumb line. With the use of the definitor one can determine any point on the model. Alberti selects as an example a statue encased by clay. The definitor will enable the sculptor to find any given point on this statue by way of drilling through the clay to the required depth. Alberti never talks explicitly about mechanical transfer from model to marble. But since the burden of his argument consists in submitting that scientifically reliable imitation of nature can only be achieved by the use of skilfully handled mechanical methods of checking and since, moreover, to all intents and purposes he is describing the pointing off method, I submit that he had mechanical methods of transfer in mind. As a matter of fact, a reconstruction of his definitor would come very close indeed to the modern pointing machine (see figure 17, page 31).

No one before had ever talked about sculpture the way Alberti did. It may be true that much of what he suggested was too cumbersome for simple practitioners, but let us not forget that he was close to sophisticated artists and sculptors, that he dedicated his *On Painting* to Brunelleschi, had high regard for Ghiberti and Luca della Robbia, and called Donatello his *amicissimo*, his very close friend. So we cannot doubt that his treatise was read and that it may have caused quite a stir among the coterie of avant-gardists. But to what extent did it influence current prac-

tices? It is impossible to give a conclusive answer, for – as I mentioned – art historians have neglected the treatise and have therefore also omitted discussing its influence. Yet a few observations of some relevance for our topic can be made. Leonardo knew Alberti's *De Statua*. He probably studied very closely every treatise by Alberti he could lay his hands on. In any case, Panofsky recognized that a drawing in the Codex Vallardi (Paris), evidently copied from Leonardo's original by one of his followers, was proportioned according to the system of Alberti's *exempeda* and thus one is not astonished to find Leonardo experimenting with a mechanical pointing method. His description in MS A of the Institut de France in Paris (dating from the early 1490s) is crystal-clear. Leonardo writes:

If you wish to make a figure in marble, first make one of clay, and when you have finished it, let it dry and place it in a case which should be large enough, after the clay figure is taken out of it, to receive the marble block from which you intend to carve the figure matching the one in clay. While the clay figure is in the case, slip little rods through holes in the walls of the case and thrust them so far in at each hole that each white rod may touch the figure in different parts of it. And colour black the portion of the rod that remains outside the case and mark each rod and each hole with a countersign so that each may fit into its place. Then take the clay figure out of this case and put in your piece of marble, taking off so much of the marble that all your rods may be hidden in the holes as far as their marks ...

The original text is accompanied by a tiny sketch which illustrates very cursorily the detailed written explanation.

Leonardo's 'box-and-rod' method is simpler than Alberti's definitor. In fact, it is so entirely mechanical that the dullest studio-hand should have been able to handle it. But was it practicable? Yes, it might have been workable for small, or very small pieces. I for one cannot quite see how Leonardo imagined that one could 'chisel the block with great ease' (these are his words concluding the passage) without repeating the game of lifting the block out of the case and putting it back again an infinite number of times.

For such men as Alberti and Leonardo mechanical methods of transfer presented a genuine scientific challenge. Though their reasoning differed (and we shall hear more about Leonardo), they were both dedicated to the concept of an art founded on objective and verifiable facts. Mechanical methods of transfer supplied an unassailably correct version or copy of another image. It seems unlikely that no other sculptors would have experimented with this problem in the sixty years between Alberti's and Leonardo's suggestive contraptions. Once the problem of mechanical control had been stated, it was in the air and could not be dismissed from people's minds again and sculptors might have been attracted to it for practical rather than philosophical reasons.

I would like to give you an example that has recently puzzled me a great deal. In the National Gallery in Washington there is a small relief representing *St Jerome in the Desert* by Desiderio da Settignano [1] that has always been the public's favourite piece in the sculpture collection of the Gallery. The relief has no old and revealing provenance. It was

1. and 2. *St Jerome in the Desert*, *c.* 1460. Desiderio da Settignano

found in Florence in the late 1880s and immediately attributed to Desiderio. Although there is no documentary evidence for this attribution, no other name will announce its claim as strongly as Desiderio's before the gentle devotional figure of the saint to whose prayer the figure on the cross seems to respond by curving towards him equally gently. It is only with Desiderio that one can associate the saint's naïvely sincere, wholly dedicated mood, the expression of which is inseparable from an extraordinary refinement of sculptural values. A delicate, almost dainty quality is characteristic for all the works we now recognize as his and separate them from the more robust works of his contemporaries. Desiderio died aged 35 or 36 in 1464 and there are good reasons to date this work shortly before his death.

Now a few years ago a second, absolutely identical marble relief appeared in Florence and was bought by a New York collector [2]. In the spring of 1970 it was possible to arrange for a confrontation of the two pieces. Both pieces measure 43 by 55 cm and both conform to such an extent that internal measurements taken at random with large callipers turned out to be practically identical. Although the design thus corresponds, there are differences that I must mention. The Washington version has a shimmering and glimmering surface, a mellowness and *sfumato* lacking in the slightly more robust and sharply defined second version. Moreover, a brownish patina which gives the piece in the National Gallery an alabaster-like appearance, adds to its appealing surface quality. The other piece by contrast has a whitish or rather light grey surface. Also, the second piece had some rust stains in the right lower half which were treated with acid and this led to an erosion of the surface in some areas.

How can we account for these two identical versions? Are they both modern fakes and will there be more identical versions on the Florentine art market from time to time? Or is the second version a modern marble reproduction? I feel fairly or even absolutely certain that we have to exclude fraud in this case. In trying to solve this problem I came across an old photograph taken in the 1890s of a cast that had been made from the National Gallery relief before it left Florence for its destination [3] – at that time the great country house of a Russo-Baltic aristocrat (the piece reached the USA after the Russian Revolution). The photograph reveals that the National Gallery piece must have had a different, much more sharply defined surface at the time the cast was made. The present softness and *sfumato* of the surface have to be regarded as relatively recent 'acquisitions' resulting from repeated cleaning and washing. Thus, originally the relief had a much crisper, more delineated, and less pictorial

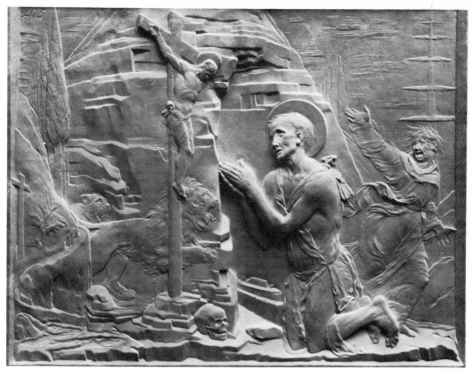

3. *St Jerome in the Desert*, cast after Desiderio da Settignano

aspect than it has today. This also means that the surfaces of the two versions were then much more alike than they are now.

We have also to consider another point. In contrast to urban living in previous centuries, there developed from the fourteenth century on in the advanced city-states of Italy, particularly in Florence, a steadily growing inclination for civilized and comfortable living. In the fifteenth century many Florentine upper-middle-class people were proud owners of attractive homes: colourful wedding-chests (*cassoni*), cabinet pictures, house-altars, statues, and reliefs increasingly belonged to the furnishing. The sculpture that was used for this purpose had to be reasonably priced and so there developed a special production (which Charles Seymour appropriately called shop-merchandise) of inexpensive casts in stucco, papier mâché and terracotta made from piece-moulds. As a rule such works reproduced a piece in marble by a recognized master and there were probably special workshops for this kind of reproduction. Although we know some pieces in perishable material of high or even very high quality, usually their derivative character is evident and the stages from the original down to the diluted forms of such reproductions are easily recognizable.

In a roundabout way we have come back to our reliefs. Surely, these two marbles cannot represent the original and a derivative piece: their equally high quality does not permit of such a conclusion. I can only find one sensible explanation, namely, that Desiderio had to satisfy two patrons, both eager to own a marble, a preparatory model of which they may have seen in his workshop. Chronologically we are halting just half-way between Alberti's and Leonardo's experiments, and I suggest that Desiderio himself experimented in this case with some pointing method – with a mechanical method of ensuring complete correspondence of the two pieces. Frankly, having spent a great deal of time attempting to solve this mystery, I am not entirely certain whether my conclusion is as convincing to you as it appears to me.

Another case that suggests the use of a mechanical method of transfer at exactly the same time, 1464, was recently discussed in a stimulating paper by Irving Lavin. Michelangelo's *David* [4] was carved from a large piece of marble that originally had served Agostino di Duccio for a giant figure commissioned by the Florentine Cathedral authority. As the documents inform us, Agostino's statue was to correspond to a model made of wax. Agostino's attempt at enlarging to giant size what must have been a small wax model failed: the marble block remained *male abozatum* (badly roughed out) in the cathedral workshop for almost forty years. It is likely that for the operation of enlarging the model to enormous size Agostino had used the mechanical method described and recommended by Alberti, or some similar mechanical device derived from it. Now in the margin of the document that recorded the handing over of the old block to Michelangelo, there is the following note: 'The said Michelangelo began to work on the said giant on the morning of 13 September 1501, although a few days earlier, 9 September, he had with one or two blows of the chisel removed a certain knot (or knob) that it had on its chest.' Lavin asks whether this *nodus* was not, in fact, a point, a knob of marble retained by Agostino as a fixed reference for measuring off his colossus from the model.

It may be difficult ever to arrive at absolutely conclusive results regarding the employment of mechanical processes in the fifteenth century. The passage I quoted from Leonardo's notebooks, however, showed that the matter was occupying men of his calibre at the end of the century. It is worth while looking back from this position to the beginning of the Florentine fifteenth century. The relief of Nanni di Banco [5] dates from shortly after 1410. Nanni was one of the founding fathers of Renaissance sculpture, a contemporary of Donatello, an enthusiastic votary of ancient sculpture, and he had an important share in decorating the niches of Or San Michele, the church of the Florentine Guilds. This relief is under

4. *David*, 1501. Michelange

5. Relief from Or San Michele, after 1410. Nanni di Banco

the niche belonging to the Stone- and Woodworkers' Guild. It is not unlike some of the late medieval material we have seen before. On the right you see a sculptor working on a *putto* that is leaning in the oblique position we know from many other examples. The sculptor is swinging a trimming hammer with which he is evidently removing the back of the block from which the *putto* (now almost finished) has been carved. To the left is a stonemason with a capital (the result of *his* work) before him. He is handling a carpenter's square. Both men are working directly in stone, both are clad in similar workman's overalls – indications that they have the same status as members of their guild.

Incidentally, by juxtaposing Leonardo's scholarly interest in mechanical transfer with such a representation, basically still tied to medieval conventions, I do not want to evoke the notion that the beginning and the end of the century were irrevocably separated by a gulf. Leonardo himself slipped back into traditional conceptions when he pronounced that 'Sculpture is not a science but a very mechanical art, because the sculptor has to toil under the sweat of his brow.'

In the well-known *Paragone*, the Comparison of the Arts which stimulated Renaissance artists for well over a hundred years, Leonardo unhesitatingly placed painting over sculpture. 'The sculptor's work', he said, 'entails greater physical effort and the painter's work greater mental effort ... The sculptor, in carving his statue out of marble or other stone wherein it is potentially contained, has to take off the superfluous and excessive parts with the strength of his arms and the strokes of the hammer – a very mechanical exercise ...' One imagines that Michelangelo's father talked exactly like that at the same moment. Surely, in Leonardo's

mind, the invention of a workable pointing method helped to reduce the
sculptor's manual labour, because subordinate hands could substitute for
him without any danger of spoiling the work. As time went on this sort
of reasoning appears more and more often.

The idea of mechanical transfer was closely tied to the existence of
a model; a preparatory model was a prerequisite. This is obvious, and
Alberti and Leonardo talk about models as a matter of course. Models
are now mentioned in contracts and documents, as happened in the case
of Agostino di Duccio's giant statue that we discussed. Some preparatory
models dating from the second half of the fifteenth century have even
survived. The terracotta model [6] is for Verrocchio's cenotaph of Cardi-
nal Niccolo Forteguerri in the Cathedral of Pistoia near Florence,

6. Terracotta model for Cardinal Niccolo Forteguerri's cenotaph, *c.* 1476. Verrocchio

commissioned in 1476. Verrocchio himself never finished the work and there are numerous later additions, but the model, now in the Victoria and Albert Museum, London, gives us a good idea of his intentions. In all likelihood, the model is not by Verrocchio's own hand but by the hand of a workshop assistant. Quite a literature has accrued around the question of authenticity. I am not concerned with this question, but rather with demonstrating the degree of finish we may find in, or can expect from, a Quattrocento model.

It can safely be said that, by and large, the use of three-dimensional models in the preparation of a piece of sculpture was a new departure; a new departure that cannot be separated from the establishment of individual workshops, of individual styles and working procedures, of a tendency to separate invention and execution; a shift in the emphasis of the creative process from the finished object to the first flashes of inspiration. In retrospect, all this would seem inevitable. But in the fifteenth century and even the first half of the sixteenth these were no more than potentialities, still embedded in traditional practices. In addition, it seems that the wish to pursue a new course was first largely restricted to Florence. We have seen that in Germany at the time of Donatello and Verrocchio, sculptural works were prepared only by drawings and often by drawings supplied by painters, draughtsmen and graphic artists. To a certain extent this may also have been true for Italy outside Florence,

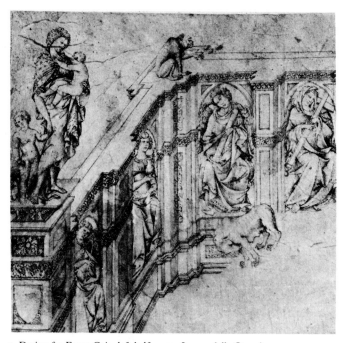

7. Design for Fonte Gaia, left half, 1409. Jacopo della Quercia

at least during the first half of the fifteenth century. Even when the sculp-
tor made his own design, the use of models was apparently unknown.

Let me give you an important, well-documented example. On 15
December 1408 Jacopo della Quercia was commissioned by the city of
Siena in the words of the contract 'to execute a fountain 28 feet long
and 8 feet wide with sculptures, figures, foliage, cornices, steps, pilasters,
and coats-of-arms and to make or cause to have made a drawing of said
fountain in the Council Hall of the Palazzo Pubblico'. It has been
assumed that this was a large design (perhaps nearly full-size) made on
the wall of the great hall for the benefit of the responsible committee.
A month later, on 22 January 1409, there was a new contract; the original
project was enlarged, the price was raised, and the contract was accom-
panied by 'a new design drawn on a certain sheet of vellum by the hand
of master Jacopo'–and this drawing was deposited with the notary who
had drafted the contract. After many difficulties the fountain was exe-
cuted and finished in 1419. Fragments of it are now in the Palazzo Pub-
blico, and a nineteenth-century copy was placed in the original position
in the great Piazza before the Palace. By an extraordinary piece of good
luck most of the drawing of 1409 on vellum has survived. The right half
[8] reached the Victoria and Albert Museum in the nineteenth century;
the left half [7] was discovered in the early 1950s and purchased by the
Metropolitan Museum. A smaller central section is missing.

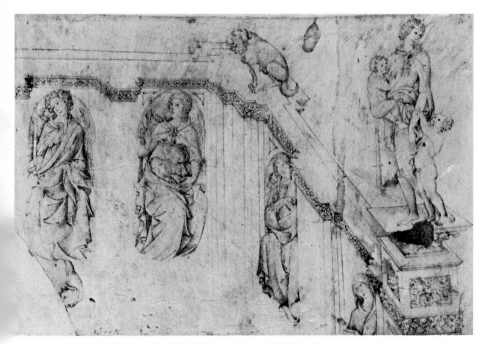

8. Design for Fonte Gaia, right half, 1409. Jacopo della Quercia

Quercia scholars have investigated the problems offered by this regained drawing. The project as represented in the drawing does not quite agree with the fountain as executed. We need not go into this side of the question. What I want to establish is this: first, this drawing was made for the patron and had the validity of a legal document. Secondly, in yet another case, the sculptural decoration of the main portal of S. Petronio in Bologna (1425), Quercia prepared a small-scale drawing 'with his own hand' and signed it. From this sketch a painter produced a full-sized mural for the benefit of the committee in charge. So in this case we know of a sketch that Quercia may have made with a double purpose in mind, as a study for himself and, at the same time, as a basis for the enlargement that was to be submitted to his patrons. Thirdly, in none of the Quercia documents is there talk of a model. Clearly, his way of preparing his works was still close to the medieval tradition – despite the fact that his later work (mainly in S. Petronio) was so progressive, so powerful and personal, that even Michelangelo was deeply impressed by it.

From the early years of the fifteenth century I want once again to turn to the end of the century and to Leonardo. Some of you may know the famous draft of a letter in which he, then in Florence, in his thirtieth year, offered his services to Ludovico il Moro, Duke of Milan. Among many things that he was capable of doing, he writes: 'I can also execute sculpture in marble, bronze, or clay and also painting, in which my work will stand comparison with anyone else's, whoever he may be.' Moreover, he promised he would be able to carry out the equestrian monument of the Duke's father, Francesco Sforza, that had been planned for a number of years.

Leonardo went to Milan and went to work on the Sforza monument. It was to be an enormous bronze work, more than double the size of Donatello's Gattamelata. In 1493 the huge clay model of the horse (without the rider) was publicly exhibited, but was never cast. In 1499 the French invaded Milan under the Italian General Giacomo Trivulzio – deadly enemy of the Sforza. The Sforza dynasty was swept away. Leonardo's model was damaged by soldiers and eventually destroyed. Leonardo returned to Florence. In 1506 he was again in Milan, and soon accepted Trivulzio's commission for his tomb that was to be topped by a life-size equestrian statue. Only drawings and some thoughts jotted down by Leonardo bear witness to his projects of the two monuments and to how he intended to proceed. Briefly, he began by planning the Sforza monument with a rearing horse and a figure in restless movement. Some original drawings and four engravings after lost drawings illustrate this stage [9].

9. Study for the Sforza Monument, *c.* 1482. Leonardo

The balancing of this horse would have presented a vast problem. Leonardo abandoned this project and now planned a quietly pacing horse. Many studies for this new project are in existence. Among them are his studies of the anatomy, muscles and proportions of horses based on his research carried out in the Duke's stables. Studies in proportion of man and animal took on a central position. The changed character of such studies may be illustrated by comparing Leonardo's drawing of a man's head [10] with a page from Villard de Honnecourt's Album (see figure 2, page 37). The medieval artist tends to impose a pre-established geometrical norm upon his imagery, whereas the Renaissance artist tends to extract a metrical norm from the natural phenomena he observes.

10. Profile of a man's head and other studies for the Sforza Monument, c. 1482. Leonardo

A splendid drawing at Windsor (12321) [11] is mainly concerned with
the study of the horse's chest muscles. Another Windsor drawing (12343)
[12] gives an idea of the final design of the monument, shown once again
in full side view. In the designs for the much later, also unexecuted, Tri-
vulzio Monument Leonardo again wavered between the two solutions,
the rearing and the walking horse [13]. The lowest drawing on figure
13 seems to combine both types: the incipient movement of rearing is
brought to a halt by the rider.

Leonardo's drawings can teach us a great deal about the meticulous
way in which a great Renaissance artist prepared his sculptural work.
But they teach us much more than generalities. On one of the horse draw-

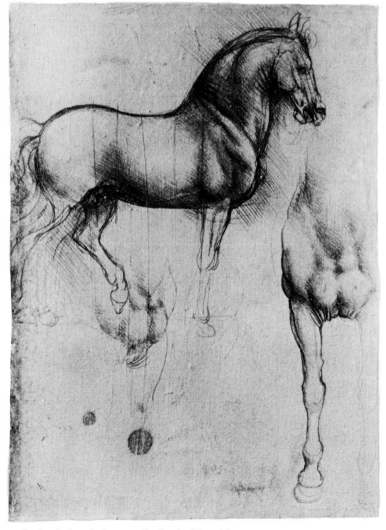

11. Study of a horse's chest muscles for the Sforza Monument,
c. 1482. Leonardo

12. Final study for the Sforza Monument, *c.* 1482. Leonardo

ings at Windsor (12350) Leonardo noted: 'In order to be able to handle
the large model prepare it by making a small model.' And in another place
he wrote: 'You like seeing a model. It will be useful to you and me and
also to those who are interested in my usefulness.' By combining this
information with the evidence of the drawings we are getting a picture
of sculptural procedure established at the time. The sculptor begins with
drawings, studies from nature and compositional sketches. The next step
is the small model in clay, wax or terracotta. This model serves him
as much as the patron. Next he proceeds to the large model, correspond-
ing in size to the execution in stone and in all essentials to the small pre-
paratory model. We can learn more. We have seen that all preparatory
drawings for the two monuments represent the horse in simple profile
views. Leonardo abandoned this kind of representation when he was not
concerned with statuary. In the Windsor drawing 12331 [14] he studied
animals in motion (e.g. a group of St George and the Dragon appears
from all sides and in all possible views). It has been suggested that this
and other drawings formed part of a projected treatise on the movement
of animals. They and similar studies, dating from about 1510, could
scarcely be more different from those for the Trivulzio tomb belonging
to the same period.

I think the explanation for the character of the drawings for the eques-
trian monuments is to be found in one of Leonardo's thoughtful notes
about sculpture:

13. Sketches for the Trivulzio Monument, *c.* 1510. Leonardo

14. St George and the Dragon and animal studies, *c.* 1510. Leonardo

The sculptor says that he cannot make a figure without at the same time making an infinite number of drawings owing to the infinite number of outlines which are continuous quantities. We answer that this infinite number can be reduced to two half-figures, one of the back view and the other of the front. If these two halves are well proportioned they will together make up the figure in the round, and if all their parts are in the proper relief they will of themselves and without further work correspond to the infinite number of outlines which the sculptor says he must draw.

It would seem that in agreement with this passage Leonardo restricted himself to a study of the two profile views of his equestrian monuments.

5

MICHELANGELO

Leonardo da Vinci clarified his thoughts on paper. To this idiosyncrasy we owe what is probably the most bulky and the most precious collection of notes a great genius has ever handed down to posterity. Often Leonardo returned again and again to a problem that moved him and he made ever new attempts to commit to writing the precise meaning he was struggling with. Even though many of his notes were jotted down spontaneously, at the back of his mind he was always aiming at a publishable form. He planned writing treatises on everything under the sun; in fact, he wanted to cover the entire encyclopedia of knowledge he himself was expanding immensely all the time. Some of his treatises reached, or were later organized to reach, final shape, such as his treatises on painting, on architecture, on anatomy, on the flight of birds, and on the nature of water; we know that he planned books on the science of mechanics and its practical application, on weights, on the anatomy of the horse, and so on.

What is now generally known as his *Treatise on Painting* is in actual fact a compilation of excerpts made about 1550 (i.e. thirty years after Leonardo's death) from various Leonardo manuscripts. This compilation is extant in the *Vatican Codex Urbinas Latinus 1270*, a manuscript on which all the later printed editions of the *Treatise on Painting* depend.

The first part of this manuscript contains the *Paragone* comparing painting with poetry, music and sculpture. Many of Leonardo's surviving notes on sculpture are contained in this chapter, but this material is rather scanty. I think one has, justifiably, to ask whether he ever planned a special treatise on sculpture. So far as I can see Leonardo scholars have not discussed this point. It seems to me inherently improbable that he would have planned treatises on painting and architecture and not, like Alberti, also one on sculpture. In addition, some of his notes definitely indicate

the tenor of a treatise in the making. Moreover, Cellini mentions that in about 1540 (i.e. about twenty years after Leonardo's death) he bought a book copied from Leonardo on 'Sculpture, Painting, and Architecture' and that he later lent the book to Sebastiano Serlio who used it for his own treatise on architecture. The Cellini-owned manuscript has not yet been traced and there is no saying how much material on sculpture it might have contained.

I have already (p. 98) quoted the passage in which Leonardo propounded the theory that the sculptor has only to consider the front and back views; if they are correctly proportioned, they will fit together and supply a satisfactory figure in the round. This was Leonardo's answer to the sculptor's opinion that a figure had an infinite number of outlines and that the sculptor would have to draw them all. There is another passage among Leonardo's notes where he phrases this idea in considerable detail: 'the sculptor' – he says – 'in completing his work has to draw many outlines for each figure in the round so that the figure should look well from every aspect.' This idea is expanded and during this discussion Leonardo explains that the sculptor 'has to look from above and below, bending down and raising himself' in order to estimate whether all the shapes are right and he concludes: 'The usual and proper way for the sculptor to bring his works to completion is to proceed by an accurate study of all the outlines of the body's shapes from all sides.'

The sculptor's viewpoint here so clearly expressed by Leonardo can only have been Leonardo's own penetrating thoughts on problems no one else had seriously considered at that time. The demand of going around the figure, of looking at it from every side and angle, from above and below, et cetera, so as to establish satisfactory contours – this demand was logically incontestable, but the time for its fulfilment had not yet come: it came two generations later under considerably changed conditions, as we shall have occasion to find out.

Once again Leonardo stated his logical break through with great determination: 'For making a figure in the round the sculptor need only execute two views, one of the front and one of the back. There is no need to take as many views as there are aspects, of which there are an infinite number . . .' That this was, in fact, the opinion he held when he turned from theory to practice we were able to confirm with the evidence of his studies of the equestrian monuments, which he always rendered in full profile (the two profile views of an equestrian monument may be regarded as its front and back aspects).

Before leaving Leonardo, I would like to point out that his notes contain other revolutionary observations, especially on the influence of light on the effect of works of sculpture. He observed, for instance, that if the

light strikes them from below they appear absolutely distorted. To us, in the age of photography, this is no revelation. Wrongly-lit photographs of pieces of sculpture may distort them to such an extent that they often become almost unrecognizable. It was only during the seventeenth century that Leonardo's observations bore fruit. It was then that sculptors, particularly Bernini, fully recognized the importance of conducted light and tried to ensure that their works would be seen under the conditions of light for which they had been created.

There are other observations by Leonardo that were not taken up again until the seventeenth century. I mean, for instance, the profound recognition that without nature's 'contribution of shadows more or less deep and of lights more or less bright the work would appear all of one tone like a plane surface'. He also realized that sculpture exposed to a concentrated indoor light from above is infinitely more effective than its exposure to the diffused open air light or to light of the same intensity all round.

While Leonardo was thus musing over the principles governing sculptural activity, Michelangelo – twenty-three years his junior – was creating his juvenilia. The two men knew each other, probably rather well, for in 1503 they had worked side by side in the Great Council Chamber of the Palazzo della Signoria (Palazzo Vecchio) in Florence, Leonardo on the cartoon of the Battle of Anghiari and Michelangelo on that of the Battle of Cascina. They were geniuses of such different character that no one ever doubted that they loathed each other. There may be some truth in their notorious encounter near the church of S. Trinita in Florence, reported by a reliable early-sixteenth-century writer. Friends were discussing a passage of Dante and they invited the passing Leonardo to voice an opinion. At that moment Michelangelo was coming by and Leonardo said 'Michelangelo will be able to tell you what it means'. (Michelangelo had the reputation of being a connoisseur of Dante.) Michelangelo felt mocked and shouted 'Nay, do thou explain it thyself, horse-modeller that thou art – who, unable to cast a statue in bronze, was forced with shame to give up the attempt.'

Whether this story be true or not, the deep contrast between them is obvious to anyone who is familiar with their personalities, their thoughts and work. Leonardo, a detached sceptic, urbane but aloof, shunning attachments of any kind; Michelangelo always deeply engaged, but rough in manner, over-sensitive, irritable, uncompromising – as Pope Julius II said to Sebastiano del Piombo: 'He is terrible, as you can see, and one cannot deal with him.' Michelangelo was steeped in Neo-Platonic thought – discernible in his relation to people, in his poetry, and in his work. Michelangelo's humble Neo-Platonism seems geared to a constant

awareness of the gulf between spirit and matter. Here is how he expressed in one of his best known sonnets the relation of the image – the *concetto*, as he says – in the artist's mind to the marble block:

> The best of artists have no thought to show
> What the rough stone in its superfluous shell
> Doth not include; to break the marble spell
> Is all the hand that serves the brain can do.

The idea of the potential containment of the figure in the marble block of which Alberti and Leonardo talked is here given a new pointed dimension. Leonardo had only scorn for the idle speculations of the members of the Florentine Neo-Platonic Academy. He envisaged the universe engulfed in a constant process of destruction and renewal. The problems of the individual soul were of interest only so far as the individual partakes in the cosmic sequence of death and resurrection.

Clearly, Michelangelo's approach to his work cannot be divorced from his philosophical convictions and we should bear this in mind when we get involved in technical subtleties as we will. Michelangelo was very precocious. Within some eight years (between his sixteenth or seventeenth and his twenty-fifth year) he carried out about a dozen sculptural works and commissions, some of them of considerable size, such as the life-size *Bacchus* in the Bargello and the *Pietà* in St Peter's (which is signed and was begun in 1498: he was then twenty-three years old). Shortly after the turn of the century (between 1501 and 1504) he carved the Gigante, the huge statue of David (figure 4, page 87), almost seventeen feet tall from the badly roughed out block that had been lying in the Opera dell'Duomo for almost forty years. There is a sheet of drawings by Michelangelo in the Louvre, Paris, with a large pen and ink sketch of the right arm of the giant marble David and a small sketch of another figure of David that was to be carried out in bronze in 1502. In his own unmistakable hand Michelangelo noted down a few thoughts on the sheet, one of which reads: 'Davicte cholla fromba/e io chollarcho/Michelagniolo', i.e. 'David with his sling and I with my bow Michelangelo'. The first part of the inscription is clear, but the second part ('I with my bow') has elicited half a dozen interpretations, one more unlikely than the other. One has, for instance, taken the bow to be a weapon figuratively directed against Leonardo. I think that old puzzle has recently been resolved once and for all by Charles Seymour of Yale University. He suggested that the bow may refer to the sculptor's hand drill. You will recall the drill with the bow handle that was used by the Greeks and was never forgotten; it was certainly in use in fifteenth-century Florence. According to Seymour the meaning of the inscription would be something like this: 'David had a slingshot for a weapon in his battle with Goliath. I, Michel-

1. *David*, detail, 1501–4. Michelange

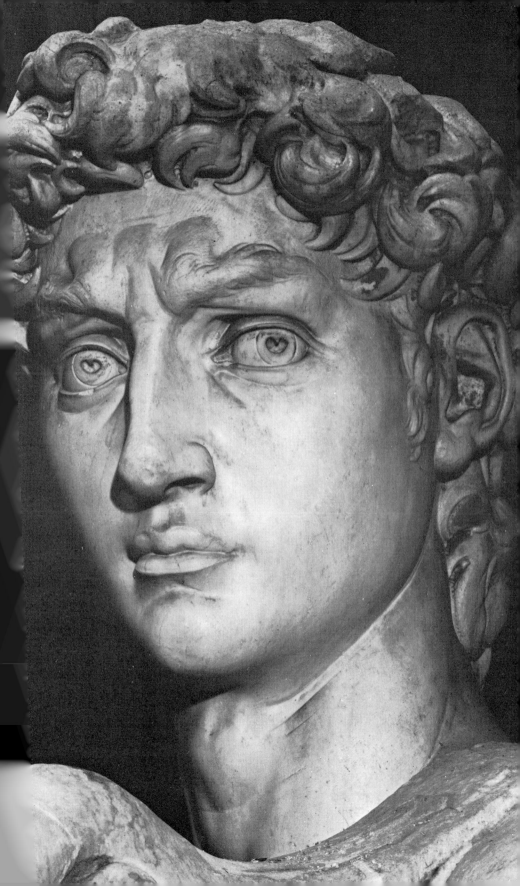

angelo, have a sculptor's drill in my battle with another giant.' From here Seymour ascends to more intricate and subtle interpretations where we need not follow him. The proof of whether Seymour's primary meaning (I, Michelangelo, have a sculptor's drill in my battle with another giant) is correct, was not given by Seymour himself. Did Michelangelo use a drill in carving his giant David? The answer is an emphatic 'Yes'. The drill holes are easily recognizable, especially in the hair [1]. The circular pupils of the eyes are also drill holes. More cannot be said owing to the finished surface of the body on which few tool marks are visible and I would not like to indulge in speculations. But the 'I with my bow' and the discovery of much drill work in the hair of the *David* attunes us to the problem of drill work in Michelangelo's sculptures. The search is soon rewarded. Michelangelo left drill holes standing quite unashamedly in the finished Bargello *Bacchus*, which has to be dated before the *David*, about 1498. Such holes appear mainly in the figure of the Satyr nibbling at the grapes and in the panther's skin on the ground [2].

2. *Bacchus*, detail of Satyr and panther skin, *c*. 1498. Michelangelo

For a time Michelangelo must have worked concurrently on the *Bacchus* and the St Peter's *Pietà* [3], which was however not finished until the end of 1500. It is Michelangelo's most carefully polished work. He must have spent an endless time going over it with abrasives until the figure of Christ took on an almost glossy, enamel-like finish. No drill holes will be found on the surface of this group, but if you study a detail

3. *Pietà*, 1497–1500. Michelangelo

of the head of Christ [4], it cannot escape you that His hair was extensively worked with the drill. Later, no such hair was executed by Michelangelo. The exception is the beard of Moses [5], which cannot have been done without considerable use of the drill. (The *Moses* dates between 1513

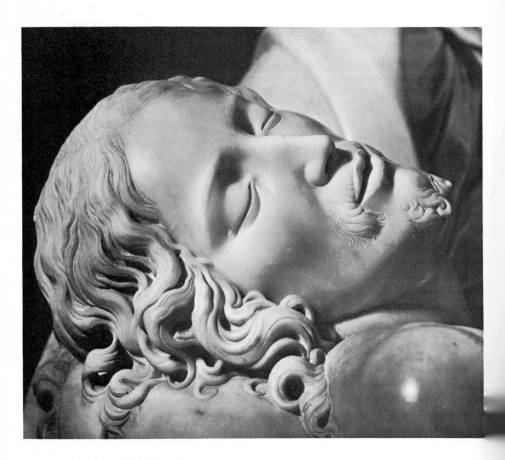

4. *Pietà*, detail. Michelangelo

5 (*opposite*). *Moses*, detail, 1513–16. Michelangelo

6. *Bearded Slave*, detail, 1519–25. Michelangelo

and 1516.) Look, by contrast, at two details of unfinished figures: the head of one of the slaves for the tomb of Julius II [6], dating between 1519 and 1525, and part of the Virgin and Child in the Medici Chapel [7], dating after 1525. In these cases the hair is roughed out and firmly attached to the skull. There would have been no room for drill work.

Careful observation has convinced me that after the completion of the *David* Michelangelo hardly ever used the drill again; i.e. during the long span of sixty years, between 1504 and 1564, the year of his death. He used the drill in his early work, until he was thirty. He first accepted the drill because it was a tool apparently much in use in fifteenth-century Florence.

Proof of this contention is provided by a piece by the Florentine Mino da Fiesole, a most active and interesting classicizing master who also worked in Naples and Rome. His *Last Judgement* belonged to the dismembered monument of Pope Paul II, dating from about 1475, the year Michelangelo was born. The remains of this monument are now in the

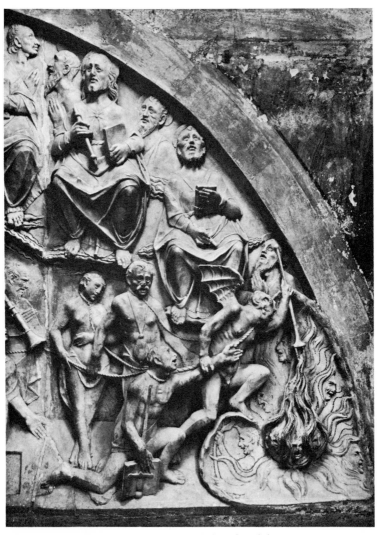

8 and 9 (opposite). Monument of Paul II, details from *Last Judgement*, *c.* 1475. Mino da Fiesole

Vatican Grotte. In the unfinished detail [8 and 9] we see damned souls suffering in hell. A devil pulling a new victim along is seen stoking the flames. Most of the forms inside the mouth of hell – flames, heads and arms – are outlined by long channels of drill holes, one hole next to the other. The design had probably been drawn on the face of the marble and then a studio-hand drilled along its outlines, the safest way of assuring faithfulness to the design in the execution. Incidentally, some archaeologists maintain that this method had already been used in Greece. The next step would have consisted in cutting away the marble separating one drill hole from the next. Abrasives would have finished the job, as we see it finished along the lower edge of the relief. If the

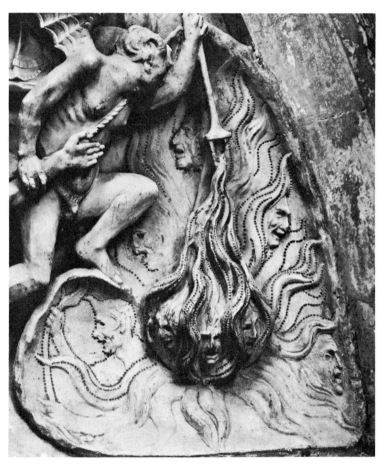

whole mouth of hell were as finished as the leaping flames along the lower edge, it would be entirely impossible to find out how this relief had been executed. With the knowledge of Mino's unfinished relief, invaluable in the context of these studies, one should approach other Quattrocento

sculpture. One is bound to make a dual discovery. Careful investigation leads to the unexpected discovery of drill holes still visible in many finished works such as Desiderio da Settignano's splendid Marsuppini Monument [10] in S. Croce, Florence, dating from the second half of the 1450s. In addition, one is often struck by the draughtsmanlike silhouetting of figures against the ground in reliefs and, whether correct or not, one cannot help associating this kind of visual impression with the procedure we have just studied in action.

In many such cases the drill was used as a short cut to guaranteed reliable results. Of course, Michelangelo must have disapproved of such methods right from the beginning of his career and in the course of time seems to have discarded the use of this corrupting tool almost entirely. It is a curious fact that most of Michelangelo's early works, as long as he used the drill, are finished; the memorable exception being the very early *Battle of Centaurs* of 1491–2, which was done without the use of the drill and anticipates Michelangelo's later technique: in consequence, he later thought that it was his best early work. Most of his later work that was done without the drill remained unfinished. I do not want to make the drill or rather the omission of drill work responsible for this. But his turning away from the drill is an indication of the increasing demands he made on himself as regards technical grasp, solidity and perfection – he needed a technique that would be most appropriate to give life to the imagery he envisaged. It goes without saying that an easier technique would have been less time-consuming and might have allowed the completion of more works.

I have mentioned that Michelangelo was the artist who made more elaborate use of the claw chisel than any artist before or after him. From about 1505 onwards there is a great deal of material that allows us to follow his procedure very closely. I will begin with the so-called *Pitti Tondo* of the Virgin and Child with St John in the background, in the Bargello in Florence [11]. Michelangelo scholars date this work between 1504 and 1508, and good reasons for the earlier as well as the later dating can be adduced. In the ground of the relief we find the roughly parallel (but irregular) striations of the punch, which has here been handled obliquely (this is, you will remember, the so-called mason's stroke). The figures themselves were left in various states of completion. But from a distance the relief may look fairly, or even entirely, finished. This corresponds to the impression one gets before the marble and I am certain that most visitors never notice that it was left unpolished. Closer inspection, however, reveals that three different types of claw chisel marks are discernible [12]. The coarsest claw chisel marks appear on the arm of the Virgin, on various parts of her dress and on the block on which she sits.

Marsuppini Monument, detail, *c.* 1455. Desiderio da Settignano

The Christ Child and the little St John show the marks of a finer claw
chisel. Here you can see, as it were, the tool in action. The entire face
is spun over with the fine parallel grooves produced by the claw. Charac-
teristically, Michelangelo chiselled around the forms, defining them,
modelling them with an extraordinary network of sculpted lines.

11. *Pitti Tondo*, 1504-8. Michelangelo

He worked with the claw chisel as if he were working with pen and
ink on paper. In his drawings too he revealed the pulsating life of the
human body, the life in sinews and skin by going around forms with the
close, parallel lines of his hatching or with cross-hatching. And he
employed the same method with brush and paint, as a study of details
of the Sistine Ceiling would demonstrate. This principle of interpreting
form by means of ever new modelling with clarifying lines – a method
that appeals to rational understanding – rather than by the painterly but
irrational method of working with light and shade (at the exclusion of
clearly definable lines) is eminently Tuscan. And Michelangelo was

12. Detail of

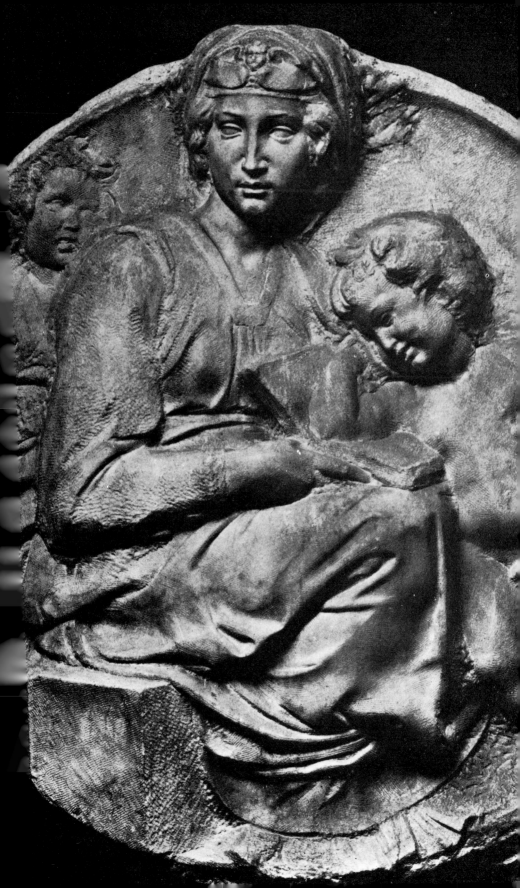

wholly possessed by the inquisitive mind, dedicated to the cogent reasoning that we have come to associate with the Florentine spirit since Dante's days. What I am trying to do may be a hopeless attempt to construe specifically Tuscan roots for Michelangelo's sculptural technique.

To return to the face of St John: in a succeeding phase Michelangelo would have repeated the same process of modelling we see before us, but he would have used a still finer claw chisel until he was satisfied he had reached the final skin. In fact, the head of the Virgin shows the next stage, achieved with a very fine claw chisel. The striations produced by this tool are too fine to be seen from a distance. In any case, the face of the Virgin was ready to be treated with abrasives and all traces of the claw would then have disappeared.

At a first glance, Michelangelo's procedure may seem to have much in common with that of the archaic Greek sculptor whose unfinished statue we studied (figure 6, page 17). In both cases the work is released from the marble block, patiently, layer after layer. But while in both cases the work reaches finality by way of an intense process of uninterrupted creation, the differences are of vital importance. The punch was the legitimate tool for archaic stylization. Michelangelo, on the other hand, could never have realized his lifelike conceptions with even the finest punch work. The claw chisel, however, allowed him to define and redefine natural form, to bring out the subtlest modulations of bodies, muscles, skin and features. But there is more to it. In a sense, Michelangelo's procedure was diametrically opposed to that of the archaic sculptor.

This can be demonstrated by studying his unfinished figure of *St Matthew* in the Accademia in Florence [13]. This figure, about 7 feet high, belongs to the period of the *Pitti Tondo*. It was begun in 1506, the only one of twelve statues of Apostles that were to decorate the pillars of the Cathedral of Florence. Those who have no knowledge of Michelangelo's working method might easily believe that this figure was meant to be a relief. In actual fact, as I have already indicated, this was to be a free-standing, fully three-dimensional statue. It is immediately obvious that Michelangelo did not work around his figure. He attacked the block from one side only. Starting with what he regarded as the front of the marble block, he peeled the figure, as it were, out of the prison of the stone. At the bottom the original block front has been left standing and the right arm is placed along the outermost skin of the lateral face of the block.

The most extraordinary feature of this unfinished figure is surely the fact that the most protruding parts of the body – the knee and thigh of the left leg – are almost finished, while the farther away forms are from the front of the block, the rougher is the state of execution. Everywhere

13. *St Matthew*, begun 1506. Michelange

you can see how Michelangelo first broke through the skin of the block with the trimming hammer. In some areas one finds the marks of a fairly heavy punch which he seems to have used to get quickly into depth. But there is hardly any doubt that in other areas he took up his claw chisels after he had laid down the trimming hammer. Rough as well as fine claw chisel work going over and around the forms in all directions can easily be detected. Nowhere are there any drill holes.

To understand Michelangelo's procedure, I have to recall Vasari's well-known analogy. Imagine a figure in a basin filled with water lying evenly in a horizontal position. If you lifted the figure out of the water, it would slowly emerge, first the most protruding parts, then you would see the figure as if it were a relief and finally it would appear in its three-dimensional roundness. This gives a very clear idea of what I would like to call Michelangelo's relief-like working method. His procedure implies that the work will have one principal view – it is the view (to use Vasari's analogy again) that one will see emerging from the water.

Like the Greek sculptor two thousand years before, Michelangelo drew his figure on the front of the block, but then (in contrast to the archaic sculptor) controlled his design by pushing it back, step by step, into the depth of the stone, always from the ideal frontal position. Vasari, to whose idea I shall return, mirrors to a considerable extent the opinions of his adored master, Michelangelo, who was thirty-six years his senior. Vasari surely reflects Michelangelo's thoughts when he writes:

> Those artists who are in a hurry to get on, and who ... rashly hew away the marble in front and at the back have no means afterwards of drawing back in case of need. Many errors in statues spring from this impatience of the artist to see the round figure emerge out of the block at once, so that often an error is committed that can only be remedied by joining on pieces ... This patching is after the fashion of cobblers and not of competent masters ... and is ugly and despicable and deserves the greatest blame.

But in his later work Michelangelo occasionally also applied his relief-like method to one or both of the lateral faces of the block. Two of the unfinished so-called Captives for the tomb of Julius II [14, 15] (dating as some believe between 1513 and 1516 and according to others between 1519 and 1520 or even later) may serve as examples. In both cases, two outside walls of the block are still standing and a great deal of work remained to be done. Some scholars believe that the roughing out of these figures was done by assistants. This may well have been the case, but they worked under the closest supervision and had mastered Michelangelo's technique.

The left leg of the Captive usually called *Atlas* [14], has been carved out of the front of the block and the right leg appears in the front of

14. *Atlas, c.* 1513–20. Michelangelo

15. *Awakening Captive, c.* 1513–20. Michelangelo

the lateral face of the block. That face presents a perfectly coordinated view. You will notice that the roughed-out head and the left arm are almost level with the front of the block. Beholders without a knowledge of Michelangelo's method believed that Michelangelo wanted this Captive to bite his own arm. This is, of course, sheer nonsense. The side view would show very clearly the large piece of unworked marble in the area of the head. It is evident that the entire depth of the block had remained untouched because Michelangelo wanted to thrust the head

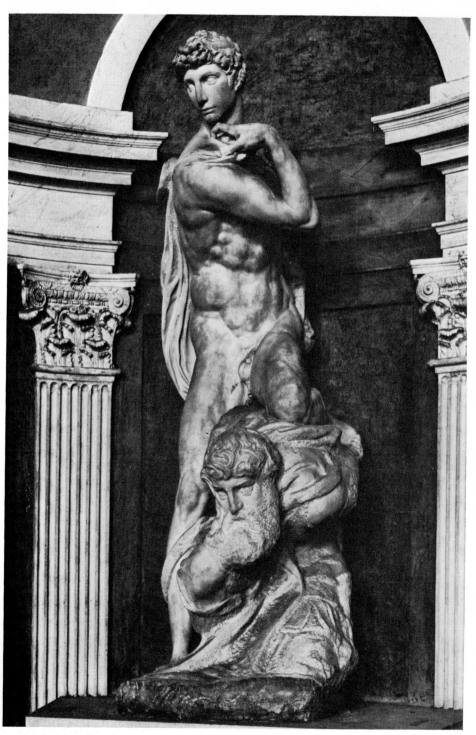

16. *Victory*, early 1530s. Michelangelo

much further back. There is no saying how often he would have remo-
delled the head, each time penetrating into a deeper layer with his modell-
ing claw-chisel work. This method of working into depth by constant
modelling assured complete coordination of all the parts of the body:
we must never forget how complicated the poses of Michelangelo's
figures are and how easy it would have been for a less alert and meticulous
artist to spoil everything by a single wrong stroke.

The so-called *Awakening Captive* [15] shows the body extended in a
clear frontal view, the right leg crossing the left which is still partly buried
in the mass of the block. The head is thrown back and turned sideways
and cannot be seen by the beholder looking at the principal view. The
head is revealed in the lateral view, which would have provided a beautiful
subsidiary aspect.

I would now like to illustrate the same problem with a group that was
approaching completion, the so-called *Victory* [16] now exhibited in the
Palazzo Vecchio in Florence, but originally also planned for the tomb
of Julius II, though at a later phase than the other Captives. The group
was probably carved in the early 1530s. It displays two equally valid
views. We may note in passing that the movement and counter-move-
ment of the youthful Victor's body produces contrapostal torsions of a
kind that earned this type of figure the name *figura serpentinata* among
contemporaries – a serpentine figure, which writers of the time compared
with leaping flames. I think that Michelangelo's *Victory* had an incalcul-
able influence on sculpture of the mid- and late-sixteenth century.

A study of details reveals work with the trimming hammer or punch
in the beard of the Vanquished and the striations of a fairly rough claw
chisel in his face. The face and hair of the Victor are farther advanced
[17]. Here a fine claw chisel can easily be detected. On the cheeks the
criss-crossing of the tool has produced an infinite number of tiny projec-
tions, baffling to those who do not know Michelangelo's technical pro-
cedure.

17. *Victory*, detail. Michelangelo

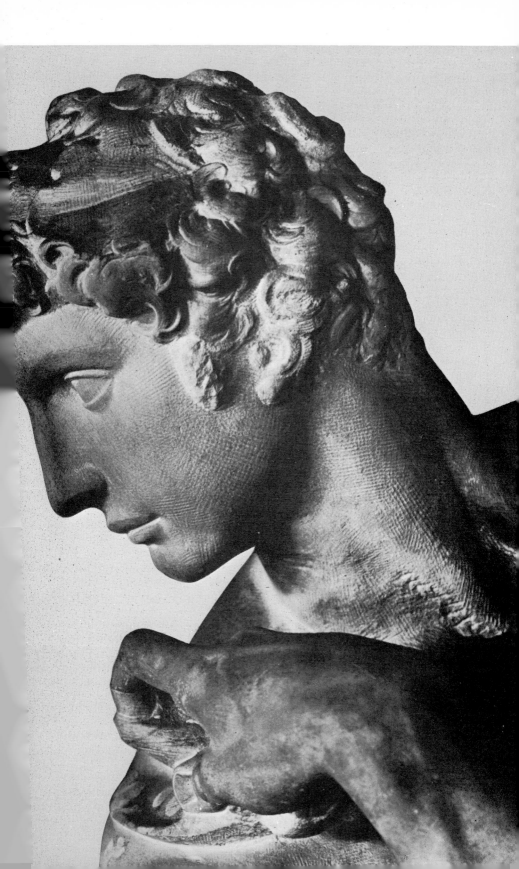

19. Detail of 18

I want to end this description of Michelangelo's working method with a brief discussion of his last *tour de force*, the *Pietà Rondanini* [18], so-called from the Roman palace in which the group was housed for almost four hundred years; it is now in the Castello Sforzesco in Milan. In the mid-1550s Michelangelo had worked at an over-life-size *Pietà*, which remained standing around in his Roman studio far advanced though not entirely finished. Then, shortly before his death, he was dissatisfied with this group and decided to transform it considerably. The result of the change is the present *Pietà Rondanini*. Long gone is the classical beauty of the St Peter's *Pietà*, long gone the titanic power of the *Captives* and the assurance expressed in the *Victory*. Here two unsubstantial, ethereal bodies seem to merge. When he conceived this group Michelangelo's end was approaching, and he knew it. Yet a week before his death, in his eighty-ninth year, he was still seen working on the group.

Scholars have successfully attempted to reconstruct the earlier *Pietà*, before the transformation. Some drawings at Oxford and, above all, the condition of the present *Pietà* allow definite conclusions. The finished legs of Christ belong to the earlier version; the same is true of the severed right arm, which belonged to a more substantial, more palpable torso. Moreover, a detail of the upper part of the group [19] shows that the present face of the Virgin was carved out of the lower part of a larger head that looked up instead of down. Of the earlier version the crown

of the head, the left eye and the bridge of the nose are still recognisable. The detail also shows how Michelangelo had reduced the physical bulk of the previous version with powerful long strokes with a heavy punch; it also shows the work of the claw chisel in the faces of Christ and the first and second Virgin. Michelangelo transformed that earlier *Pietà* without any help. Friends who saw him working in his last years marvelled at his undiminished strength. He also surely decided on this transformation, and carried it through, without any supporting material. He translated an inner vision directly into stone. It is miraculous that he carried a precise image about within him, that he judged correctly the potentialities of the older *Pietà* and went straight to work with punch and claw chisel. No one else had ever achieved a similar mastery of working in stone. No wonder that long before his death Michelangelo had earned the epithet *divino* and that he exerted the most profound influence on other sculptors, on the entire profession of artists and even on his whole epoch.

6

MICHELANGELO, CELLINI, VASARI

When in 1547 Benedetto Varchi, a distinguished Florentine historian and man of letters who knew everyone and had his fingers in every fashionable pie, tried to settle the old *Paragone*, the question of the relative merits of painting and sculpture, by inviting the most prominent Florentine artists to send him written statements, he found cooperative victims in Cellini, Bronzino, Francesco da Sangallo and others. Michelangelo's answer was polite though brief and he did not entirely hide his annoyance with this kind of time-consuming intellectual parlour game. 'Such disputes take up more time than the execution of figures', he wrote. He made, however, a statement that is of particular interest, although I doubt that you will regard it as a great revelation. 'By sculpture I mean that which is done by subtracting (*per forza di levare*): that which is done by adding (*per via di porre* – namely modelling) resembles painting.' We are familiar with this concept. You may recall that Alberti had made a similar differentiation between sculpting and modelling, and there is also Leonardo's dictum that 'The sculptor always takes off from the same block.' But no one had expressed the difference between sculpting and modelling with Michelangelo's terse finality. If a man of his prestige coins such an epigrammatic sentence on a matter of vital concern to sculptors, it is not easily forgotten. Indeed, Michelangelo's phrase coloured the mode of thought about sculpture down to the twentieth century.

One might be inclined to think that Michelangelo dismissed the painterly occupation of the modeller as unworthy of a serious sculptor. But nothing could be farther from the truth. The fact is, that unintentionally and almost paradoxically he promoted modelling and paved the way for a revolution that came about even before his death.

It would be entirely wrong to believe that he fell prey to a frenzied, incalculable creative fury. Although he was the most dedicated, most obsessed artist imaginable, there never was an unpremeditated move in his work. As a rule he prepared his sculptures with meticulous care. He clarified his thought in pen and ink sketches and black and red chalk drawings, and proceeded from there to small models in wax or clay. Such models were a controlling support: they had, as a rule, a dual function; first, they helped to clarify or solidify his ideas and, secondly, they could be used for consultation while work on the marble was in progress.

Michelangelo did not invent this method. You may recall that the method originated in the fifteenth century and that a few late-fifteenth-century preparatory models are extant, such as Verrocchio's model in the Victoria and Albert Museum for the Forteguerri monument at Pistoia, dating from 1475 [figure 6, page 89]. Two points are worthy of our attention: first, by comparison to the small number of fifteenth-century models that have come to us, the number of Michelangelo's original models, though not large, is remarkable. Moreover, Michelangelo's models look different from the rather finished models of the fifteenth century. They are real sketches in wax or clay. They introduced a new category into the history of modern sculpture, that of the spirited, rapid notation of an idea in three-dimensional form. However, opinions of scholars regarding the authenticity of many Michelangelo models are at variance.

Vasari reports (and there is no reason not to trust him) that Michelangelo made a wax model in preparation for his giant *David*. Most scholars wanted to recognize this model in a statuette in the Casa Buonarroti in Florence, which is modelled in sun-baked clay covered with a thin layer of dark wax. But this rather meticulously executed figure has comparatively little in common with the *David* and I agree with recent opinions that suggest it is the work of Michelangelo's follower Vincenzo Danti. More problematical is the torso of a wax model, also in the Casa Buonarroti, that is probably related to one of the Captives for the tomb of Julius II. There are scholars who also doubt the authenticity of this spirited model. I cannot go along with this view. Some have even questioned the authenticity of the little red wax model [1] in the Victoria and Albert Museum. It is certainly an original preparatory study for the so-called *Youthful Captive*. The correspondence between the model and the

marble is extremely close and it seems likely that this is the model used by an assistant when helping Michelangelo to block out the figure.

A clay model in the Casa Buonarroti [2], twice the size of the model in the Victoria and Albert is another piece that has been universally accepted. It was usually regarded as a model for a giant *Hercules and Cacus* to be placed in front of the Palazzo Vecchio and eventually executed by Baccio Bandinelli, but Professor Johannes Wilde proposed (I believe to most scholars' satisfaction) that these two men, interlocked in a deadly

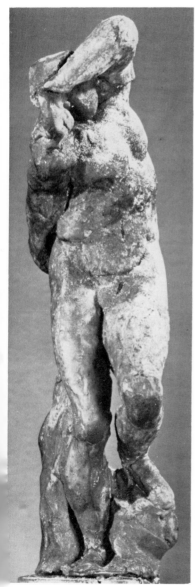

. Wax model for *Youthful Captive*, 1520. Michelangelo

2. Clay model probably for *Hercules and Cacus*, c. 1528. Michelangelo

struggle, were meant to be a counterpart to the *Victory* group, to be placed in corresponding niches of the Julius tomb. A recent reconstruction of the lower tier of Michelangelo's revised tomb project of 1532 conveys an idea of what Michelangelo had planned.

The last original clay model that I want to show represents an attenuated female body in a pose not unlike that of the *Victory* [3]. Style, technique and even size closely conform to the model of the two fighting

3. Clay model of female torso, 1533. Michelangelo

men nearby, in the Casa Buonarroti. With the head this splendid piece would have measured about 16 inches, like the model of the fighting men. Both models are sketches in light sun-baked clay and still reveal Michelangelo's finger marks. But the female model cannot have belonged to the planning of the tomb of Julius II. The model has been associated – I think correctly – with a letter Michelangelo wrote on 15 October 1533 in which he said: 'Tomorrow night I will have finished two small models which I am making for Tribolo.' These models were to serve for statues of Heaven and Earth, to be executed by Tribolo for the niches on both sides of Giuliano de'Medici in the Medici Chapel.

We can stay in the Medici Chapel for the next move. Between 1524 and 1526 Michelangelo made large clay models, i.e. models of the size of the execution, for eight figures of the chapel, among them four river-gods which were to rest on the ground at each side of the sarcophagi. One of the models of the river-gods [4] has survived as a fragment (its

4. Clay model of river-god, 1524–6. Michelangelo

present length is almost 6 feet) and can now be seen in the Academy in Florence. This is rather a surprise. We have no records of large models having been made for other works by Michelangelo. One has to ask oneself why Michelangelo needed them in this case. From all we have learned about his technique we can state most emphatically that any mechanical transfer from the model to the marble was out of the question. Although we have ample documentation for the Medici Chapel, there is no document that would enlighten us on Michelangelo's reason for a departure from his usual preparatory technique. So we are left guessing. It is likely

that Michelangelo used this method to help his assistants who were employed for the blocking out of the figures. In addition, he may have wanted to make his final intentions known, once and for all. The plans for the decoration of the chapel ripened slowly from 1520 onwards and although they reached a certain finality between 1524 and 1526 many of the figures were not worked until 1531. In the end the chapel remained unfinished.

But the matter of large models cannot rest here. I have to introduce two of Michelangelo's friends, Vasari and Cellini, both immensely dedicated to him and both equally keen on learning all they could about his works and working procedure: the one, Vasari, widely known, through his *Lives of the Artists*, celebrated and venerated as the true father of the history of art, a gifted painter, a great impresario, and a man of shining intelligence; the other, Cellini, probably the most gifted sculptor, bronze-caster, and goldsmith between Michelangelo's and Giambologna's generation, a great rascal and a jack-of-all-trades, who is well known through his colourful and controversial autobiography. Vasari introduced his *Lives* with lengthy chapters expounding general considerations on architecture, sculpture and painting; this Introduction was first published in the 1550 edition of the *Lives* and expanded in the second edition of 1568. In the same year, 1568, Cellini published two highly competent, technical treatises, one on goldsmiths' work and one on sculpture (*I Trattati dell' oreficeria e della scultura*). Both works, Vasari's and Cellini's, are indications of a kind of watershed between old and new methods. Both authors have heard Michelangelo make peremptory statements, and recommended procedures. Let us see what they tell us.

According to Vasari, 'Sculptors, when they wish to work a figure in marble usually make a model for it in clay or wax or plaster ... about a foot high, more or less, according to what is found convenient.' He then explains that the wax may be applied over an armature of wood or of iron wires. The armature is still common practice nowadays (in any case, with traditionalists among sculptors); but Vasari explains that a wax model can also be built up little by little without an armature. Fingers are used to give the model the utmost finish. The next step: 'When these small models are finished, the artist has to make another model as large as the actual figure intended to be executed in marble.' Vasari sprinkles all his information with a great deal of purely technical advice. For instance, we are told that: 'To ensure that the large clay model shall support itself and the clay not crack, the artist must take some soft cuttings of cloth or some horse hair, and mix this with the clay to render it tenacious and not liable to split.' In all surviving cases (they are few), we find such or similar materials added to the clay.

Vasari then gives detailed advice on how the transference of the full- sized model to the marble block should be accomplished. His method is not too different from that described by Alberti over a hundred years before, but he insists that the artist in transferring the measurements from the model to the marble has to start with the most projecting parts and, step by step, go into the depth of the block, just as Michelango did.

Finally, in discussing the sculptor's tools, he emphasizes the importance of the *gradina*, the Italian word for the toothed or claw chisel: 'with this,' he says, 'sculptors go all over the figure, gently chiselling it ... and treating it in such a manner that the notches or teeth of the tool give the stone a wonderful grace.' This is a fine description of Michelangelo's claw chisel procedure.

Cellini's text contains a confirmation of Vasari's exposition, but being a sculptor himself he reports with greater expertise and is also more explicit about Michelangelo. A good master, he tells us, if he wants to execute a marble figure well, has to make a small model of at least two *palmi*, which is just about the size of Michelangelo's clay models. He then talks about the full-sized model and recommends a relatively simple pointing off method of transference, a method basically still indebted to Alberti. Thereafter we get a piece of most interesting information. Cellini writes that 'many excellent masters have boldly attacked the marble with their tools as soon as they had finished the little model ... Among the best modern sculptors,' he says, 'the great Donatello adopted this method in his works.'

It is good to get the confirmation to which we had been led by observation and analysis: full-sized models were still unknown in the Quattrocento. Cellini carries on, 'Michelangelo had experience of both methods, i.e. of carving statues alike from the small and the big model, and at the end, convinced of their respective advantages and disadvantages adopted the second method [of the full-sized model]. This we have seen with our own eyes in the Sacristy of S. Lorenzo.' What Cellini calls the Sacristy of S. Lorenzo is, of course, what we now call the Medici Chapel. So, he had seen the impressive array of large models in the chapel and drew the obvious, but fallacious, conclusion that Michelangelo had been converted to this method for good. As we have seen, the Medici Chapel situation was exceptional and there is no indication that Michelangelo ever repeated the same procedure. But owing to voices like Cellini's it was given the sanction of the greatest name, 'the marvellous Michelangelo', as Cellini called him.

Cellini's further information is of immense value to us. When one is satisfied (he says) with the large model, one should take a piece of charcoal and draw the principal view of the statue on the marble block and care

134

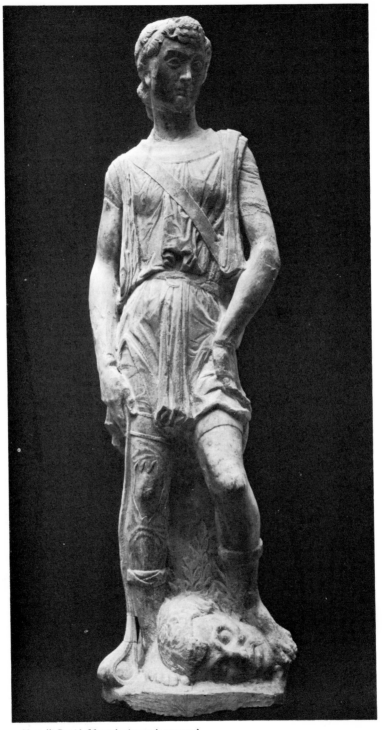

5. *Martelli David*, fifteenth-sixteenth century?

6 (*opposite*). *Martelli David*, detail of head of Goliath

must be taken to do this well; for he who fails in this respect, may run into difficulties when he uses his chisels. To continue: 'The best method ever was that used by the great Michelangelo: after having drawn the principal view on the block, one begins to remove the marble from this side as if one were making a relief and in this way, step by step, one brings to light the whole figure.'

Finally, Cellini explains how Michelangelo used his chisels and points out (if I interpret a difficult passage correctly) that he produced a kind of cross-hatching as if he were making a drawing. Sculptors without Michelangelo's discipline and patience, who try to work fast and attack the marble block here and there, end up by making irreparable blunders.

The stage is now set to find out how Michelangelo's legacy was administered. But before turning away from this great master, I feel I have to touch upon three problems. The first question: is there such a thing as Michelangelo's technique *avant la lettre*? Are there pre-Michelangelo pieces that show his technique? I am convinced that the answer is in the negative. But there is at least one great Quattrocento marble that would seem to be an exception, the life-size so-called *Martelli David* [5] in the National Gallery of Art in Washington. This statue has a venerable pedigree (leading back to the fifteenth-century Casa Martelli in Florence) and an equally venerable attribution to Donatello (going back to Vasari). Recently art historians have felt that Vasari, writing one hundred years after the event, made a mistake. The figure was newly attributed, first to Antonio Rossellino, and finally, to Bernardo Rossellino. I cannot delve into this learned discussion. What induces me to show you this work is its unfinished condition [6]. In the heads of David and Goliath, the hands and legs of David, and elsewhere tool marks are clearly visible and these show the characteristic claw chisel work that we associate with Michelangelo. What is the explanation? I agree with a few critics who believe that

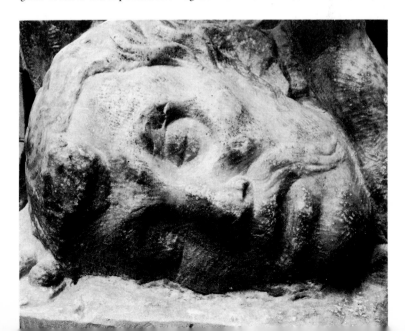

the statue had originally been finished, but that for reasons we do not know revisions were deemed necessary. To my mind this is proved by the fact that the claw chisel marks are always in layers deeper than the finished surface. This, of course, proves (at least to me) that an overall later revision was discontinued. There are areas, for instance in the arm, where it is quite evident that the claw chisel broke into parts that had been finished. I would therefore maintain that this early-fifteenth-century statue was worked over by a master of the Michelangelo succession, say in the mid-sixteenth century. It seems to me that herein lies the real art-historical problem of this important work.

Let me add that in spite of a careful study of unfinished Quattrocento and early Cinquecento pieces I have never come across anything like it at that time. To juxtapose a few pieces to the *Martelli David*, all in the Washington National Gallery: Desiderio da Settignano's unfinished bust, the so-called *Marietta Strozzi* [7], dating from the early 1460s,

7. *Marietta Strozzi*, after 1460. Desiderio da Settignano

reveals in the unfinished parts – the arms and the hair – traces of the trim-
ming hammer and the punch, but not of the claw chisel. Or take the
Virgin and Child with Saints and Donors [8], a relief of about 1520 by
the rare Venetian sculptor Pyrgoteles. The left side of the relief is not
entirely finished. The broad long marks in the face of the donor are easily
recognizable as strokes of the flat chisel [9].

8. *Virgin and Child with Saints and Donors*, c. 1520. Pyrgoteles

9. *Virgin and Child with Saints and Donors*, detail of a donor. Pyrgoteles

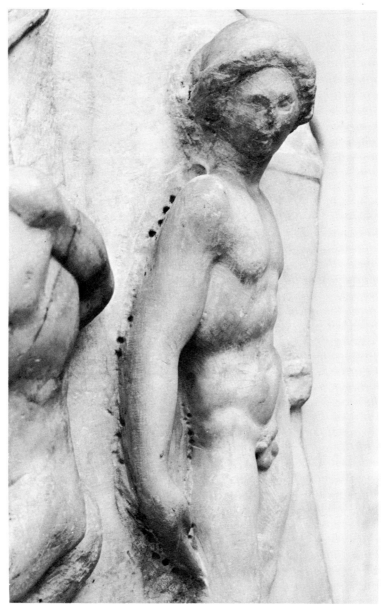

10. *Apollo and Marsyas*, detail of Apollo. Michelangelo follower

Even the little, once famous relief representing *Apollo and Marsyas* [10]
(after an ancient cameo) – famous because until fairly recently this relief
was unanimously accepted as an early work of Michelangelo – shows
neither Michelangelo's technique nor his spirit. The details of the un-
finished Apollo indicate that the sculptor made ample and rather clumsy

use of the drill. We are reminded of the marking of contours by drill work in the Mino da Fiesole *Last Judgement* that we studied [figure 8, page 110]. This relief leads me on to my next question, namely the contribution made by assistants or pupils to Michelangelo's authentic work.

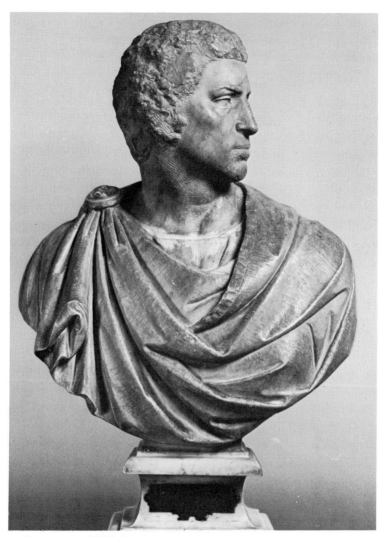

11. *Brutus*, 1539-40? Michelangelo

My first example is the bust of *Brutus*, now in the Bargello [11]. In January 1537 Lorenzino de'Medici had murdered his hated cousin, Duke Alessandro de'Medici. The deed was carried out as a deliberate return to the ancient prototype of tyrannicide: Lorenzino regarded himself as a new Brutus and the Florentine republican exiles felt that Lorenzino's

act of liberating Florence from despotism was in line of succession to the murder of Caesar. It was Michelangelo's friend Donato Giannotti, a Florentine exile, who prevailed upon Michelangelo to carve a bust of Brutus for Cardinal Ridolfi, one of the leaders of the opposition against the Medici.

The bust was not meant to be a portrait. But we might perhaps say that we can see in it a splendid symbol of republican virtues, despite the fact that it was never finished. The hair remained in an early state of preparation: it was worked with a heavy punch, apparently handled at right angles and a small unworked area above the temple still shows the skin of the block [12]. The face is beautifully modelled by the cross-hatching done with a fine claw chisel. A slightly coarser claw chisel can be recognized in the area of the chin, the ear and the neck.

Further down the neck this clear, determined stroke that furrows the marble distinctly gives way to a flat surface produced by characteristic flat chisel marks. The neck under the chin looks somewhat confused.

12. Detail of 11

13. *Pietà*, 1547–5
Michelangelo and Tiberio Calcag

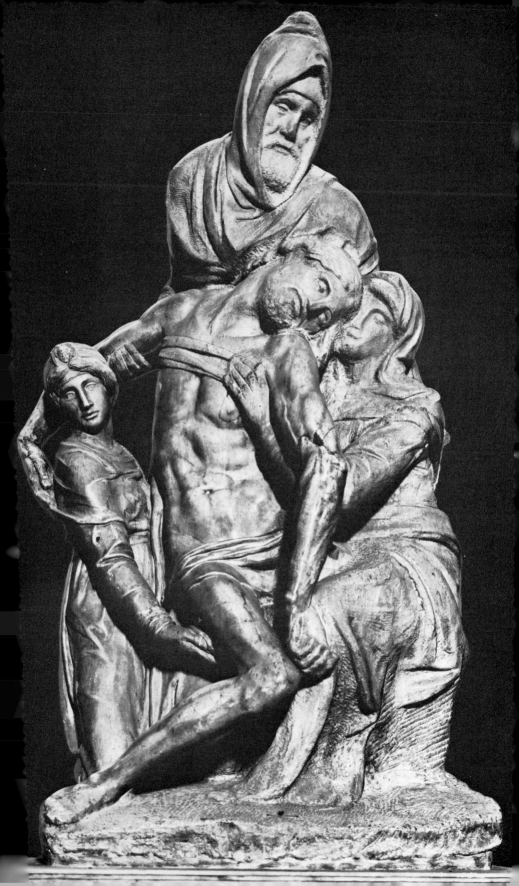

Here the two types of work meet and the flat strokes partly overlay the claw marks. The entire lower part of the bust, i.e. the body with drapery, has been worked with the flat chisel.

We know that Michelangelo's assistant, Tiberio Calcagni, had a hand in this bust. And it is not difficult to separate the two hands: all the flat chisel work from the neck down is Calcagni's contribution. He did not dare to wield the claw chisel and compete with his master. He probably resisted the attempt, fearing that he might spoil the bust. Fortunately, he had sufficient respect and admiration for Michelangelo's wonderful surface treatment to leave it entirely untouched. Nowhere else do we get a chance of comparing so closely Michelangelo's masterly technique, that assured the most intense inner life and the most vigorous surface texture, with the flat and fumbling effort of a follower.

Perhaps my second example, the *Pietà* in the Cathedral of Florence [13], is as revealing as the *Brutus*. Michelangelo began this large group that stands almost 9½ feet high, at the age of about 75. He abandoned it unfinished a few years later, in about 1555, when the marble turned out to be faulty. In a fit of rage he mutilated the group and it seems that on this occasion the figure of Christ lost its left leg and left arm; the arm was salvaged and put back. It was again the faithful Calcagni who restored the group and gave it a superficial finish. His hand can be discovered in various parts of the work – in the hand of Nicodemus, the neck and hair of Christ [14] and elsewhere, but the awkward reworking of the Mary Magdalen is his main, and rather unfortunate, contribution. Her lifeless face and the leathery quality of her dress contrast most strongly with the moving participation expressed in the faces of the Virgin and, above all, of Nicodemus as well as with the warm surface that almost seems to breathe.

Originally, Michelangelo had wanted this *Pietà* to decorate his tomb. According to Vasari (and he ought to have known) the head of Nicodemus was a self-portrait – an idealized one, needless to say. The contributions of Michelangelo's collaborators appear to be revealing foils against which to experience the consummate quality of the work of genius.

The last problem I want briefly to touch upon is what the Italians call Michelangelo's *non finito*, the unfinished character of his works. The literature on the reasons for his *non finito* has grown enormously in the last thirty years and contains many contrasting ideas stretching from the likely to the probable and the nonsensical. The author of the latest two-volume work on *Michelangelo the Sculptor*, Martin Weinberger, denies the existence of the problem altogether. He claims that Michelangelo would have loved to finish his works if his patrons (usually popes) had not forced him to switch from one enormous task to the other and that

14. Detail of 13

in some cases, such as the Florentine *Pietà*, technical circumstances pre-
vented completion. Michelangelo's letters are full of complaints about
disturbing interferences. Out of many other passages let me quote one
from a letter written by him on 14 October 1525. In a rather bitter mood
he writes: 'I should not be treated with the disregard which I see inflicted
upon me, for it works powerfully within me. I have not been allowed
for months now to do what I wanted to do; a man cannot work one thing
with his hands and another with his brain, particularly in marble.' When
you read such a passage, you may feel that Weinberger's position is sound,
but I think it is perhaps a trifle too level-headed.

 While it is true that such works as the *Matthew* of 1506 or the *Captives*
of the Julius Tomb remained unfinished because of the cancelling or
changing of projects beyond Michelangelo's control, there are a number
of others – e.g. the *Pitti Tondo* in the Bargello, the *Brutus*, the *Pietà* that
preceded the *Rondanini* – which do not fall into the same category. We

have to face the fact that first with Leonardo (who never finished anything) and then with Michelangelo the *non finito* enters an unknown phase. We can be absolutely certain that medieval works, if unfinished, remained incomplete for external reasons. But when we come to Leonardo and Michelangelo, internal as well as external causes may have prevented completion.

So far as we can see, never before had a tension existed between the conception and the execution of a work. But now doubt in the validity of worldly art, self-criticism, dissatisfaction with the imperfect realization of the inner image, the gulf between mind and matter and – in Michelangelo's case – between the purity of the Platonic idea and the baseness of its material realization prevented these masters from finishing their works. For the kind of thought that often moved Michelangelo and drove him close to desperation, I want to give you one example. In a letter of October 1542 addressed to his friend Luigi del Riccio, he wrote: 'Painting and Sculpture, labour and good faith, have been my ruin and I go continually from bad to worse. Better would it have been for me if I set myself to making matches in my youth! I should not be in such distress of mind.' The *non finito*, born from the new self-awareness and self-analysis of Renaissance man must not be mixed up with the impressionist *non finito* as practised in the nineteenth century by Rodin and others. Later I shall try to define the utterly different mentality that lies behind Michelangelo's and Rodin's *non finito*.

We can now turn to the question of how Michelangelo's legacy was administered. There were a few pupils and followers, among them above all Vincenzo Danti, Tribolo and Pierino da Vinci, who took up Michelangelo's claw chisel technique in some of their works. But this was a subordinate episode in the history of sculpture that need not detain us. In order to see the events of the second half of the sixteenth century in clear perspective, it seems to me best to return first to Benedetto Varchi's inquiry of 1547 to which I have referred before. Next to Michelangelo, the most important of Varchi's correspondents was Cellini. Let us see what he wrote twenty years before his treatise: 'The greatest art', he said, 'among the arts based on design is sculpture. It is seven times greater than painting because a statue must have eight views which should all be of equal quality.' This, he goes on to explain, is so difficult that a sculptor not sufficiently dedicated to his art will be satisfied with one or two views. This type of sculptor lacks the patience to proceed carefully from the principal view; he will attack also the six less important views and in this way 'put his statue out of tune'. By contrast, the excellent Michelangelo (Cellini continues) carefully observed what the stone

demanded (he means, by applying his relief-like method) and in this way contributed to the greatness of sculpture as an art.

The implication of this passage is very interesting: Cellini obviously takes it for granted that Michelangelo's procedure led not only to one principal view, but in addition to many more coordinated views, to eight altogether according to his theory. Another correspondent, the painter Bronzino, still took up the old position, which you may recall from Leonardo, that the more physical effort is involved in the performing of an art, the more mechanical it is. In this respect sculpture is inferior to painting. On the other hand, sculpture is more delightful than painting, because a figure can be seen from all sides. Thus, multi-faciality (to use a term I introduced in the first lecture) is also of the greatest importance for Bronzino.

In his treatise, the sculptor Francesco da Sangallo discussed the same problems at great length. He explains that the painter who has to paint a nude only represents one view of it; he never has to think of the side and back views. Everyone knows that a nude hardly ever presents equally good views from every aspect. The painter simply selects the best and most pleasing view and does not have to worry about the side and the back aspects. The sculptor, by contrast, has to take into consideration many viewpoints. It logically follows that sculpture is a more difficult art than painting. In addition, the sculptor's material presents a problem: he has to furnish the marble and the tools to work it with. This statement is followed by a most revealing sentence: if one talks about sculpture, one has to talk about marble, Sangallo says, and not about bronze or any other material, for all materials are inferior to marble. But again and again, in his long exposition he returns to the theme that where the painter is only concerned with one view, the sculptor has to provide many.

This constantly repeated insistence on many or even an infinite number of views is something entirely new in the history of sculpture. Up to this point, the number of views (whether one, two, or four) were largely determined by the way the sculptor handled and worked the marble block, be it the archaic Greek sculptor, the master of Chartres West, or Michelangelo. Now, however, an intellectual problem is posed, a theoretical demand is made, solutions are requested. The history of sculpture has arrived at one of its crossroads.

We will now have to ask how this intellectual problem was tackled, what sculptors made of it. It is easy to predict that the model, the plastic sketch – introduced by Michelangelo – will be given ever greater importance and that in consequence the carver will have to yield to the modeller who works by adding – *per via di porre*, to use Michelangelo's phrase.

1. and 2. *The Rape of the Sabines*, 1579–83. Giovanni Bologna

7

GIOVANNI BOLOGNA, CELLINI

Cellini, Bronzino and Francesco da Sangallo all insisted on the multifaciality (to use this ugly but expressive term) of a sculptural work. Cellini made the seemingly abstruse statement that sculpture is seven times greater than painting, because a painted figure can only present one view, whereas a statue has to have eight views. He does not trouble to explain why a statue should have eight views. But, upon consideration, his statement allows of only one explanation: according to him a statue must present four valid views in the main axes and another four in the diagonal axes.

Twenty-one years after Cellini wrote his letter, at the time he published his *Treatise on Sculpture* in 1568, he was still intensely concerned with the same problem. The most interesting passages are not to be found in the *Treatise* itself, but in a kind of epilogue to it entitled *Sopra l'Arte del Disegno* (On the Art of Design). Here he argues that Michelangelo was the greatest among many great painters, because he was the greatest sculptor ever. To buttress this *non sequitur* he explains that the relief is the true parent of sculpture and that painting is one of sculpture's progenies. For, he continues, painting can only represent one of the eight principal views with which sculpture is concerned.

He then carries on (I am slightly contracting his text without interfering with the meaning):

If a good sculptor *(a valent'uomo)* wants to make a statue, he takes clay or wax and begins to form the front view; but before he settles on it, he constantly raises and lowers the model, he steps forward and backward to see whether all the parts of his figure are right. When he finds that he has satisfactorily resolved the first frontal view, he turns his model to the side, i.e. to one of the four principal views. It often happens that he finds this view lacking in grace, so that he will be forced to change the beautiful front view in order to harmonize it with the new view. The same difficulties he will encounter as he checks the other principal views. In actual fact, a figure offers not only eight aspects, but over forty, for even when turning the model ever so little, a muscle may appear to be too much or too little emphasized. A figure presents the greatest variety imaginable, so that the artist is forced (as I have said) to give up some of the beauty of the primary aspect in order to coordinate it with all the other views. But this is so difficult that one will never find a figure that presents itself equally well from every standpoint.

Cellini winds up his argument by saying that he had often seen Michelangelo painting a life-size figure in the course of a day (this was stretching the truth a trifle, for Cellini cannot have seen Michelangelo working in the Sistine Chapel). When it comes to a figure in marble – he carries on – the difficulties presented by the views as well as by the material make it impossible to execute a similar figure in less than six months.

Cellini made his opinions known on yet another occasion. After Michelangelo's death the fairly newly founded Florentine Academy of Art felt that it owed its great founder-member an appropriate memorial ceremony. Eventually they settled on an enormous catafalque in the church of S. Lorenzo, to be decorated with a large number of allegorical figures. The preparation was in the hands of a high-powered committee to which Cellini belonged. The work of this committee proceeded with constant squabbles, but not until it proposed to place the allegory of Painting rather than the allegory of Sculpture on the right-hand side (i.e. the better side) of the catafalque did a serious break occur. Cellini resigned over this question. He felt moved to expound his viewpoint in a memorandum that was printed in 1564. Once again, he set out to demonstrate the superiority of sculpture over painting. In it he gives a precise summary of the theory I have been quoting. Painting only provides one view. The sculptor also begins with one view in mind. Thereafter he turns the piece bit by bit. This turning lays bare the problems, for the first view may appear as different from a new aspect as the beautiful differs from the ugly. Hence the sculptor has to submit to the enormous trouble of providing a hundred views or more, so as to endeavour to bring about unified views all around.

Taken all in all, these are extraordinary statements and nothing like them had been heard before in the history of sculpture. It is true that

Leonardo had clearly recognized the problem of multi-faciality, but he came to conclusions entirely different from Cellini's. You will remember his verdict: 'There is no need to consider the infinite number of views from an infinite number of aspects ... The infinite number can be reduced to two half-figures,' etc.

By contrast, for Cellini multi-faciality had become an absolutely central problem. Nonetheless, when you get down to it, you discover some inconsistency in the rival claims of the *prima veduta* – the frontal view – the four, eight, forty and hundred views. When he discusses execution in marble his vacillation is even more evident. For you may recall that he emphatically recommends Michelangelo's relief-like procedure as the best method. I have suggested before that he must have taken it for granted that this procedure led to many views of equal value. Historically speaking, Cellini's inconsistency mirrors the opinions of two different periods. He was still tied to the past, mainly through his adored idol Michelangelo and at the same time he became a vigorous mouthpiece of the problems that moved the next generation.

In the course of the second half of the sixteenth century (during the period we now call Mannerist) sculpture with many views of equal importance became fashionable. This is most conspicuous in the work of Giovanni Bologna; he was the Fleming Jean de Boulogne. Born in 1529, he was a generation younger than Cellini; after a couple of years in Rome he settled in Florence in his late twenties and remained there for fifty years, until his death in 1608. His prestige was enormous, particularly after his greatest *tour de force*, the *Rape of the Sabines* [1, 2], under the Loggia dei Lanzi in Florence, created between 1579 and 1583. This group of three figures built up in a swirling movement illustrates most fully and convincingly the new ideal of sculpture with multiple views. The torsions of the bodies round their own axes, the richness of movement and counter-movement, the crossing and overlapping of bodies and limbs – all this is so judiciously done and was so carefully calculated that the beholder is not aware of a primary view – on the contrary, he is faced with ever new questions, ever new revelations, and feels himself magically drawn round the group.

Up to this point, Renaissance sculpture, even Michelangelo's sculpture, required a static beholder – a beholder who would take up a stationary position from which he was able to survey the principal view. In order to exclude any misunderstandings: the stationary position is, of course, an ideal postulate; in actual fact, in front of a statue a spectator usually feels the desire to move, but willynilly and often unconsciously he follows an urge to go back to the position from which he can enjoy

the most comprehensive and most satisfactory view, a position that allows him to see bodies and extremities clearly and harmoniously extended in an ideal frontal plane.

By contrast, an infinite number of views turns the stationary beholder into a kinetic one. When we talk about modern, twentieth-century kinetic sculpture we mean that the sculpture is in motion and is viewed by a beholder who is stationary. Nevertheless, the principle of perpetual motion is the same whether the beholder experiences the sensation of a rotating piece by going around it or whether the piece of sculpture actually moves.

The change from Michelangelo's early figures with one principal view, such as the *St Matthew*, to Giovanni Bologna's groups and figures with multiple views (separated by over seventy years) resulted from a deepgoing re-orientation. The socially elevated sculptor of the later sixteenth century – an advance mainly owed to Michelangelo's unbelievable prestige – refused to be ranked as a mere craftsman and strove to create unimpeded by the material restrictions of the marble block. The physical labour involved in sculpting had always been regarded as degrading. I have quoted more than one such remark and among them an unmistakable statement by Leonardo. The stigma was not easily removed from the profession although the greatest sculptors, Michelangelo and Bernini, regarded the physical labour as a prerogative of the sculptor. Bernini even made a point of receiving Queen Christina of Sweden as a guest in his house in his working dress, and it is reported that the perceptive Queen immediately grasped the message of this demonstration.

Sculptors of the second half of the sixteenth century got more and more used to thinking in terms of the small wax or clay model. The advanced sculptors of the time took up the lead given by Michelangelo, and expressed their thoughts in the form of rapid sketch models, or, to use the Italian term, in *bozzetti*. In no other way could statues with multiple views be evolved. The sculptor had to do, and did, exactly what Cellini described: he would hold the little model in his hand, turn it in all directions, look at it from above and below, and introduce all the adjustments necessary without regard to Michelangelo's reminder:

> The greatest artist has no form conceived
> Which in a marble block lies not confined ...

So, in the middle of the sixteenth century a process set in, in the course of which the modeller (the artist who handled wax and clay) became the sculptor and the original sculptor (the one who worked the stone) was eventually turned into a mere craftsman or technician. A gulf opened between invention and execution. But let me emphasize that the process,

though relentless, was very slow and not without many reversals; in the seventeenth and eighteenth centuries there were, of course, a great number of sculptors who were brilliant experts in working the marble and capable of unheard-of technical exploits in this medium.

Before carrying on I have to point out that the old problem of physical exertion over work took on a somewhat new aspect in the sixteenth century. As the century wore on, anything that smacked of sustained hard work and laborious execution became anathema, in whatever field of occupation. To understand this attitude, we have to turn to Baldassare Castiglione's *Cortegiano*, a book that appeared in 1528 and had an immeasurable success throughout the length and breadth of Europe. Castiglione pictured as one of the foremost virtues of the courtier or gentleman what he called *sprezzatura* – an easy deportment, a facility, felicity, and *savoir faire* in all affairs, a scorn of plodding away on any job whatsoever. You see that Castiglione formed the established notion of the gentleman as a well-bred person of wealth and leisure who, although being an amateur, was yet immensely and effortlessly capable of carrying out anything he touched. No wonder that this concept soon penetrated into the history of art. Vasari, himself an exemplary gentleman–artist of the new type, created the image of Raphael as the prototype of felicitous affability, as a marvel of grace, learning, beauty, modesty and excellent demeanour. This new type felt that a laborious process of execution maimed the freshness and vitality of the first conception. In his edition of 1550 Vasari had made the memorable observation that 'many painters ... achieve in the first sketch of their work, as though guided by a sort of fire of inspiration ... a certain measure of boldness; but afterwards, in finishing it, the boldness vanishes.'

The same applies, of course, to sculpture. We find here an awareness of the spontaneity of creation and an intellectual willingness to penetrate into the unchartered depth of artistic originality. The Portuguese painter, Francisco de Hollanda, who published a *Treatise on Painting* in 1548, which according to him consists to a large extent of a kind of transcript of discussions held with Michelangelo in Rome between 1538 and 1550, puts the following remarks into Michelangelo's mouth: 'I value highly the work done by a great master even though he may have spent little time over it. Works are not to be judged by the amount of useless labour spent on them but by the worth of the skill and mastery of their author.'

I think we are now prepared to expect *bozzetti* in Giovanni Bologna's surviving work and we do find them. The number is fairly large, but perhaps not as large as it should be, for it is reliably recorded that Giovanni Bologna's first Florentine patron, Bernardo Vecchietti, had a whole room filled with Bologna models. Some very fine ones are in the Victoria

and Albert museum and two of them, both in a fragmentary condition, are rather advanced models for the *Rape of Proserpina*. The smaller one, not quite 5 inches high, represents a transitional stage between a two-figure bronze group, executed for Ottavio Farnese, Duke of Parma, in 1579 and now in the Museum at Capodimonte at Naples, and the three-figure marble of the Loggia dei'Lanzi. The other model, in red wax, over 12 inches high, is a rather finished model in almost complete agreement with the marble and for that reason some scholars regard it as a later reduction of the group.

In contrast to these models there is, also in the Victoria and Albert Museum, a real sketch model by Giovanni Bologna [3]. Again, it is over a foot in height and width, but this time it is a clay sketch which shows all the characteristics of rapid creation, and the sketchy handling goes distinctly beyond what we had found in Michelangelo's models. It is a

3. Clay model for a river-god, *c*. 1580. Giovanni Bologna

model for a river-god, as the water urn and also the traditional pose indicate, and is now generally accepted to represent an early idea for a colossal figure of *Nile* for the garden of the Medici villa (now Villa Demidoff) at Pratolino near Florence. The *Nile* project was superseded by the idea of representing a giant figure of *Apennine*, which was indeed executed, and the change of programme is first evidenced in another clay *bozzetto*

(now in the Bargello in Florence) that shows the same loose surface
texture as the Victoria and Albert Museum model. The *Apennine* dates
from about 1580, from the period of the *Rape of the Sabines.*

Giovanni Bologna's indebtedness to Michelangelo can be traced in
many of his works. His first two years in Italy – in the mid-1550s – he
had spent in Rome, studying Michelangelo's work, above all. Giovanni
Bologna's seventeenth-century biographer, Baldinucci, reports an inci-
dent from that period that may well have occurred. As an old man (Bal-
dinucci tells us) Giovanni Bologna enjoyed relating to his friends how
one day in Rome he had made a model of his own invention and had
finished it, as the saying goes, *coll'alito* (which may be translated: exqui-
sitely fine, as if it were breathing). He showed this beautifully finished
work to the great Michelangelo, who took it in his hand and squashed
it entirely; then he formed it anew with unbelievable skill, but absolutely
different from the one that the young Giovanni Bologna had shown him
and said to him: 'Now first learn to sketch [properly] and then to finish.'
If there is any truth in this story, the young Giovanni Bologna, then in
his early twenties, may have owed his interest in sketch models to this
encounter.

A few years after this event Giovanni Bologna was given a chance to
show his mettle. In 1565, a year after Michelangelo's death, on the
occasion of the wedding festivities of Grand-Duke Francesco de'Medici,
Michelangelo's *Victory* was placed in the large Hall (the Sala del Cinque-
cento) of the Palazzo Vecchio and Giovanni Bologna was commissioned
to produce a counterpart to it, representing *Florence Triumphant Over
Pisa.* He created a splendid mirror image of Michelangelo's group (never-
theless, the changes in style are obvious and very telling).

The small wax model in the Victoria and Albert Museum ($8\frac{3}{4}$ inches
high) [4] already shows Giovanni Bologna's thought far developed, in
any case as far as the movement and the relation of the two figures are
concerned. But there is a considerable lengthening of proportions, even
much beyond the attenuated proportions of Michelangelo's *Victory*.

A second preparatory terracotta model for the group is supposed to
be in a private collection in Florence, but has never been published.
Remains of another terracotta model, the two beautiful, rather finished
heads of the figures, are in the Bargello. For the occasion of the wedding
Giovanni Bologna executed a full-scale, 10-foot-high figure in plaster,
which survives and is now in the Academy in Florence: for the monumen-
tal scale Bologna adjusted the Mannerist proportions of the early wax
model and harmonized them with the proportions of the *Victory*.

A few years later Francesco de'Medici requested to have the plaster
group executed in marble. The marble version, finished in 1570 and now

4. Wax Model for *Florence Triumphant Over Pisa*,
c. 1565. Giovanni Bologna

in the Bargello [5], corresponds absolutely to the large model in plaster; it has a rather cold and dry surface quality and was executed by studio-hands. So, here we have visual evidence of the whole cycle: more than one *bozzetto*, indicative of the intensity of preparation by Giovanni Bologna himself during the opening phase; then, the full-size model and the marble execution; but Bologna's active interest barely went beyond the *bozzetto* stage. It is a pity that in the rich documentation there is no mention of how the marble was executed. One would expect that some kind of mechanical transfer was used.

5. *Florence Triumphant Over Pisa*, 1570. Giovanni Bologna

6. *Samson and a Philistine, c.* 1568. Giovanni Bologna

Almost immediately after the Florence–Pisa group Giovanni Bologna had another occasion to compete with Michelangelo. In 1566 Francesco de'Medici commissioned him to make a marble group of *Samson and a Philistine* [6] as the crowning feature of a fountain. This work, too, standing almost 7 feet high, is now in the Victoria and Albert Museum. A word about the chequered history of the group: in 1601 it left Florence for Spain as a present of Grand-Duke Ferdinando de'Medici to the Duke of Lerma. The basin found a permanent home in the Royal Gardens at Aranjuez, but the marble group was presented to the Prince of Wales in 1623 and given by him to the Duke of Buckingham and shipped to London; finally, the group came into the possession of Thomas Worsley who put it up in Hovingham Hall, his country house in Yorkshire. From there it reached the Victoria and Albert Museum after the war, in a remarkably good, though slightly weathered condition.

Bologna fashioned this work on two Michelangelo compositions, the Samson and two Philistines, now only known from some bronze casts, and the group of two fighting men (usually, but incorrectly called Hercules and Cacus) known especially from the splendid *bozzetto* in the Casa Buonarroti (figure 2, page 129). I think what Giovanni Bologna tried to do was to change these Michelangelo compositions in such a way that all around the group the views would be equally satisfactory. This work is probably Bologna's first 'kinetic' marble group. It is a mature work, but not yet of the complexity of the three-figure *Rape of the Sabines* of over a decade later.

Another important matter has to be discussed in the context with which I am mainly concerned. We are observing a shift away from Michelangelo's constant awareness of the stone and towards the manipulation of, and concentration on, the *bozzetto*, so that not by chance large numbers of *bozzetti* have come down to us from that time on. The movement of Michelangelo's marble figures always returns on itself: however intricate and contrapostal the composition, it never breaks through the ideal boundary of the block.

To Giovanni Bologna the marble block no longer imposed serious taboos. This can be seen in the *Rape of the Sabines* as well as in other works by him. Zigzagging contours and protruding extremities show that he was willing to, and capable of, freeing himself from the limitations imposed by the stone. By implication this means that the way was open to use more than one block of marble for a figure. You may recall that Vasari (mainly influenced by Michelangelo's ideas) disparaged the joining of pieces and called it patching after the fashion of cobblers, ugly and despicable. On the other hand, we shall find that the greatest sculptor of the next century, Gian Lorenzo Bernini, availed himself of the freedom

opened by Giovanni Bologna and did not mind in the least using a number of pieces of stone for a figure 'after the fashion of cobblers'.

You may perhaps have wondered why, after having quoted Cellini at such length, I did not immediately discuss some of his sculptural works, but went on to Giovanni Bologna. I found it more important to confront you first with the climax which Cellini's interesting ideas were leading up to. But we may now cast a glance back and see what his sculptural work looks like. Cellini was born in 1500 and died in 1571, seven years after Michelangelo. His perennial troubles with the police started when he was 16 and until he was 45 years old he never spent more than five years in any one place. He worked in Rome, Ferrara, Mantua, Padua, and at the court of King François I in Paris and at Fontainebleau. He was Master of the papal mint, founder of artillery in the Castel S. Angelo; he made seals for the Este and splendid jewellery and goldsmiths' work wherever he happened to be. When he returned to his native city in 1545 he had scarcely done any sculptural work. In Florence he enjoyed ducal favour and received the commission for the *Perseus* under the Loggia de'Lanzi, his *chef-d'œuvre*, that kept him busy for almost ten years. During this period he also made a couple of busts and some life-size marble statues. This is practically all, excepting his last work in marble that I want to discuss first.

It is a life-size Crucifix [7] on a black marble cross executed between his sixtieth and sixty-second years. He signed the work: 'Beneventus Cellinus civis florent. faciebat MDLXII'. He made it for himself and wanted to have it placed over his tomb, but Duke Cosimo I bought it and the Duke's son and successor Francesco presented it to King Philip II of Spain. Thus the work ended up in the monastery of the Escorial, where it was always extremely difficult for visitors to see. Moreover, the Crucifix is nude and the monks therefore draped it with a miserable piece of cloth. I think this is the most impressive sculptured Crucifix of the sixteenth century. The interpretation both of the body and the head is extraordinarily personal and the high quality and marvellous precision of carving can perhaps be gathered from the detail of the head [8]. Cellini talks about this work rather movingly in his *Treatise on Sculpture* and describes the difficulties it presented. There cannot be any doubt that Cellini was aiming at technical perfection and that he tried to achieve it by going through the whole process of preparation and execution I have mentioned before. I may add that in his *Treatise* he is also explicit about tools and, among others, discusses two types of drill. One of them, he says, serves for the minutiae and subtleties of hair and clothing. The accomplished drill work in the hair of Christ and also in other parts, for instance along the eyelids, cannot escape you. The drill, out of fashion with Michelangelo, was coming back and was going to stay in use.

7 and 8. Crucifix, 1562. Cell

Impressive as Cellini's Crucifix is, for the problems we are concerned with it is rather negligible owing to the subject matter (a figure of Christ on the Cross does not easily lend itself to experimentation) and also because of its early exile to Spain. Thus it is to the *Perseus* we have to turn for enlightenment. Now, Cellini's *Perseus* is a bronze – in fact the most important one of the mid-sixteenth century.

Bronzes open up, of course, a set of problems quite different from those connected with marble. Above all, the bronze sculptor need not think in terms of the block. He is bound to think in terms of the preparatory models and the casting. It is for this reason that works in bronze have always been freer than works in marble, but they present their own tricky problems. This induced Cellini to regard working in marble as infinitely easier than working in bronze. Cellini had good reasons to make such a remark, for at the time he took on the *Perseus* commission the Florentine Quattrocento tradition of bronze-casting had broken down.

Let us look back for a moment. Greece and Rome had a long-lasting, splendid tradition of bronze-casting and the technique survived into the early Middle Ages. But when in 1329 Andrea Pisano was commissioned with the first bronze door for the Baptistry in Florence, there was no one in the town who knew how to work in bronze. It was necessary to invite a bell-founder from Venice. It was Ghiberti who educated a school of bronze workers in Florence during the half century – from 1403 to 1452 – he needed for his two bronze doors of the Baptistry. During this period he also executed the first post-medieval monumental bronze statues for three niches of the Or San Michele. Even Donatello learned his bronze technique from Ghiberti, to whom he was apprenticed between 1403 and 1406. Verrocchio and Pollaiuolo, on the other hand, were indebted to the great Donatello for their bronze expertise. There was, however, no succession. Cellini had to start right at the beginning. In his autobiography and also in the *Treatise on Sculpture* he gives us a vivid picture of the vicissitudes of his great enterprise. He tells us that the first large bronze he executed was the portrait bust of Duke Cosimo I (now in the Bargello) [9], a work he undertook – as he says – to try out bronze-casting before experimenting with his *Perseus*. The bust, which is double life-size, is the first marvel of the revived Florentine bronze technique. The decorative detail, of incredible finesse, reveals the born goldsmith. A life-size version of the bust (now in San Francisco) in marble is not a fake and may well have been worked in Cellini's studio from his model.

The success of the bust augured well for the *Perseus* [10]. Cellini proceeded with the greatest circumspection both during the preparation of the work and the execution of the cast. Nevertheless, many dramatic inci-

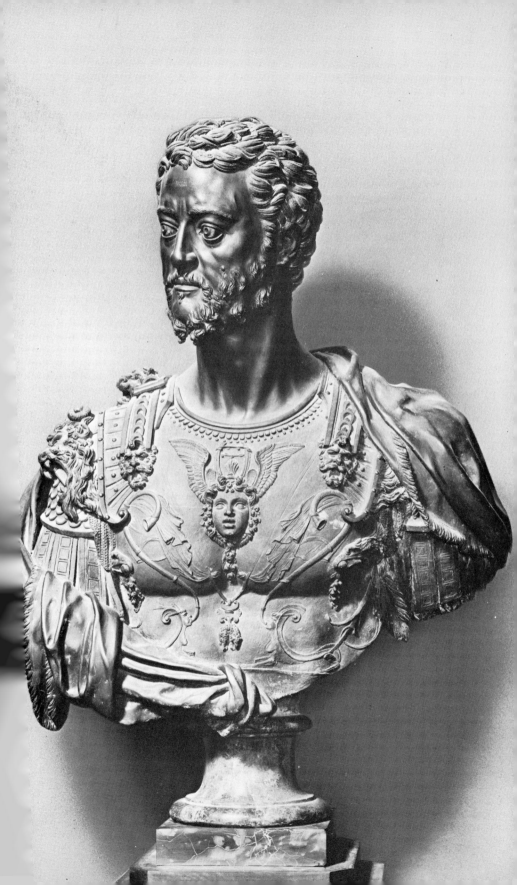

dents occurred about which he talks in his autobiography. As he tells us, he explored Donatello's technique most carefully and I think also used him as a guide in artistic matters. He must have had Donatello's bronze *David* constantly before his mind's eye. Moreover, he probably

11. Bronze cast of model for *Perseus*, *c.* 1545. Cellini

attempted to compete with Donatello's *Judith* across the Piazza. Even today no one can overlook the connection: both groups represent acts of liberation, one is taken from the Bible, the other from mythology (in the sixteenth century the symbolic implications of this parallelism were better understood than today). There are other connections; for instance, the limply hanging arm of the Medusa was fashioned after a similar arm of Holofernes. But such links between Cellini and Donatello apart, a careful study of the *Perseus* reveals that Cellini was aiming at multi-faciality of the group.

He reports that he was engaged for weeks on a wax model; it is preserved in the Bargello and shows the design in an advanced stage. Two models on the same scale as the statue, mentioned by him, are not extant; but a bronze cast of a small model [11] survives in the Bargello that takes up a transitional position between the wax model and the execution. Even without going into details, you will notice that he changed the proportions

12. *Perseus*, detail of mask, Cellini

of *Perseus* and he also added a great deal of masterly detail. But this small
bronze he surely used to test its effectiveness from all sides.

Two details may help to give a feeling for the quality of this work;
the first the fierce mask [12] at the back of Perseus' winged helmet, which
forms an unforgettable unity with Perseus' curled locks; the second is
the head of Medusa. It is of particular interest because fairly recently
a sketch-model for it ($5\frac{1}{2}$ inches high) was acquired by the Victoria and
Albert Museum [13]. Sir John Pope-Hennessy has shown that this model
takes up a position between the Bargello bronze and the execution. This
bronze cast from a model is remarkable in more than one respect: the teeth
are visible between the parted lips, a motif later repeated in the marble
Christ of the Escorial. Even more interesting: the model displays a
ghostly or ghastly expression of pain. In the execution Cellini gave this
head features of classical beauty and perfection without robbing it of its
awe-inspiring quality.

13. Bronze cast of head of Medusa, *c.* 1545, Cellini

It is time to take leave of this fascinating master. He was a wizard who,
both in theory and practice, opened up new horizons. The new bronze
traditions he established in Florence remained alive and Florence virtu-
ally became the world centre of bronze production for the next one
hundred and fifty years. Without him Giovanni Bologna's many great
bronze works such as the *Flying Mercury* would not have been feasible.

8

BERNINI

To assess the effect which the revolutionary development of late-six-teenth-century sculpture had on the following generations, we can do no better than turn to Bernini and see how the greatest sculptor of the seventeenth century administered the legacy whose most versatile heir he was.

Gian Lorenzo Bernini, the son of a Florentine father and Neapolitan mother, was born on 7 December 1598. Already in his early teens he displayed such unbelievable skill as an artist that he attracted the attention of Pope Paul V himself. Even before 1620 he had emerged as the first sculptor in Rome, and from 1623 (after the ascension of Urban VIII to the papal throne) until his death in 1680 he was practically in command of the official art policy of the papacy and wielded a power and influence in artistic matters in Rome as well as throughout Italy and even the rest of Europe that have few if any parallels in the history of western art.

Two contemporary biographies, one written by his son Domenico, the other by the well-informed Filippo Baldinucci, the day-by-day diary written by the Sieur de Chantelou during Bernini's six-month-stay in Paris in 1665, a great many letters, and an endless stream of documents – all this material supplies a wealth of accurate information about Bernini and although he himself had not a theoretical mind and has not left us a lengthy coherent statement of his views, we know more about him than about many a more vociferous artist.

Before going in some detail into Bernini's working procedure, I will briefly try to assess his attitude towards the achievements of the Giovanni Bologna generation. To a large extent Bernini accepted the freedom achieved by the Mannerists: he accepted the freedom from thinking in stone; he refuted the Renaissance limitation dictated by the block form and was prepared to plan figures with zigzagging contours and protruding

extremities. Above all, he was willing, if necessary, to use more than one block of marble for a figure – an idea entirely unthinkable for Michelangelo and his generation.

Bernini did not mind in the least using four pieces of marble for his $14\frac{1}{4}$-foot-high statue of Longinus [1] under the dome of St Peter's (1629-38). The main piece of marble forms the bulk of the body. The raised right arm is a second piece; the cascading drapery on this side a third and the cloak further back on his left side a fourth. As such a figure makes clear, Bernini needed the achievements of the preceding generation, because he wanted to wed his statues to the surrounding space. But in one respect, and a most vital one, he could not follow Giovanni Bologna and others of his generation: he could not accept sculptures with many views. Only on very rare occasions did he conceive works for multiple viewpoints. As a rule this happened when circumstances of location prevented him from controlling the beholder's standpoint.

He could not think in terms of multiple viewpoints for a variety of reasons. Above all, every one of his works represents the climax of an action: for instance, *David* [2], a life-size early work dating from 1623, aims his stone at an imaginary Goliath who must be assumed on the central axis in space, where the beholder has to stand. Goliath is the necessary complement to the figure of David whose action would seem senseless without our postulating the existence of the giant. Thus, the spiritual focus of the statue is outside the statue itself, somewhere in space; in the same space in which we live and move about. Only if we take up the correct position is the great sweep fully effective that goes through the leg and the curve of the body and is counterbalanced by the turn of the head and the arm holding the sling ready for action. No other standpoint reveals the incredible tension in the figure and accounts for its *raison d'être*. This appears nowadays so obvious that it hardly has to be pointed out. Of course, the rich spatial qualities of the *David* and the movement in depth lead to a number of subordinate views which allow us to observe ever new finesses and even otherwise hidden details, but they can never be more than partial views.

I invite you to make another experiment that is perhaps even more revealing than the statue of *David*. In 1620 Bernini carved the *Neptune and Triton* [3], now in the Victoria and Albert Museum, to crown a fishpond in the garden of the Villa Montalto in Rome. We know from old engravings how the group (which incidentally was bought by Sir Joshua Reynolds on speculation and taken to England) was originally placed: it was standing on a balustrade high over the pond in front of a blank wall and was framed at both sides by small fountains. The group was

David, 1623. Bernini

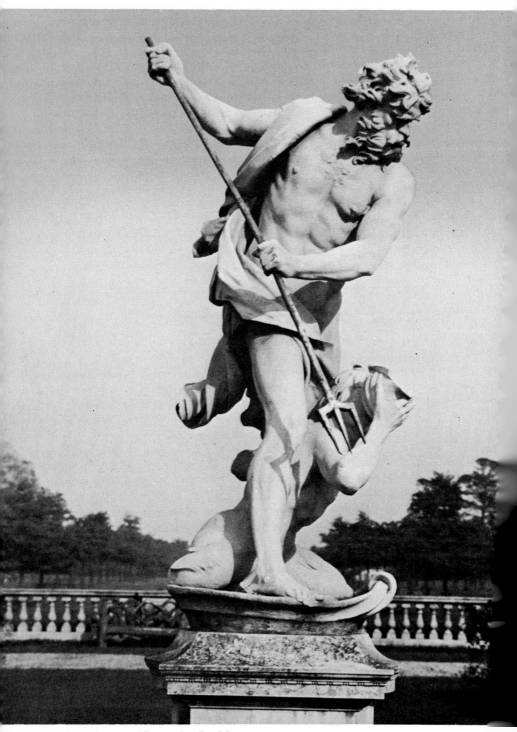

3. *Neptune and Triton*, 1620. Bernini

clearly made for the principal view which is shown in figure 3. This view also offers splendid details. But if you walk round the group you will see that it loses meaning and coherence and the aspect from the back does not make any sense at all. Only in the primary view is the full force of Neptune's action revealed: his thrusting down the trident to pacify the waves (in accordance with an often represented passage from Virgil's *Aeneid*, as I believe, though a text by Ovid has also been suggested as a source of inspiration). It was Bernini's persistent rendering of a transitory moment that made the one-view aspect unavoidable, for the climax of an action can be fully revealed from one aspect alone.

4. Equestrian statue of Constantine, 1654–70. Bernini

Bernini's so-called realism (to which the older art historians dedicated a good deal of scarcely digested verbiage) is very far removed from the realism of nineteenth-century sculpture. The extreme sophistication with which he handled the problem of viewpoints places his realism in a more correct perspective. As time went on Bernini became ever more obsessed with the idea of guiding the beholder's approach and of determining the correct viewpoint. Take the equestrian statue of Constantine [4], a very large marble executed in two phases between 1654 and 1670. The work was placed on the main landing of the Scala Regia, the ceremonial entrance to the Vatican palace not normally accessible to the public. The landing is in the axis of the portico of St Peter's. Huge bronze doors shut off the portico from the Scala Regia, but when they are thrown open (as they are in figure 4) it immediately becomes evident that Bernini designed the high arch containing the equestrian monument and the monument itself with its huge coloured stucco drapery as a focal point on the portico axis. The framing devices distinctly assign to you the correct standpoint. These framing devices are particularly telling, since one looks through the containing dark bronze doors into the brightly lit area of the landing.

The Altieri Chapel in S. Francesco a Ripa with the over life-size marble of the *Blessed Lodovica Albertoni* [5] may serve as a second example. This is a late work, executed between 1671 and 1674. The correct position is the aspect from the nave of the church. Walking along the nave, the Altieri Chapel suddenly comes into view. The beholder stops and sees through the barely lit chapel the dying Blessed Lodovica bathed in magic light. A sequence of arches lead on to the altar recess and any move to right or left would immediately upset the marvellous balance of a pictorial entity.

Despite their *tableau vivant* character such works as the *Constantine* and the *Lodovica Albertoni* are still vigorously three-dimensional and vigorously 'alive'; they are neither reliefs nor in fact relegated to a limited space. Like the *David* and the *Neptune and Triton* they still share our space continuum, but at the same time they are far removed from us: they appear strange, visionary, unapproachable, like apparitions from another world.

In both cases, but particularly in that of the *Lodovica Albertoni*, the directed light contributes decisively to the unrealistic effect of the work. To use directed light, the source of which is hidden from the beholder, was one of Bernini's great inventions. By contrast to the calm, diffused light Renaissance artists used, directed light seems transient, impermanent. Directed light supports the beholder's sensation of the transience of the scene represented. One realizes that the moment of divine 'illumination' passes as it comes. With his directed light Bernini had

5. *Blessed Lodovica Albertoni*, 1671–4. Bernini

found a way to bring home to the faithful an intensified experience of the supra-natural.

The first time Bernini experimented with concealed light was in the Cappella Raimondi in S. Pietro in Montorio, which can be dated between 1642 and 1646 [6]. The chapel is the first large unit in which sculpture and architecture are entirely coordinated; and here, for the first time,

6. Raimondi Chapel, *c.* 1642–6. Bernini

there is a concealed window that throws a beam of light on the altar with the relief of S. Francis' ecstasy. Incidentally, all the sculptural decoration of this important chapel is by Bernini's pupils.

The lesson of this chapel he applied soon after in the Cornaro Chapel in S. Maria della Vittoria, executed between 1646 and 1652. The chapel contains what is perhaps Bernini's most famous work, the group of *St*

7. *St Teresa and the Angel*, 1646–52. Bernini

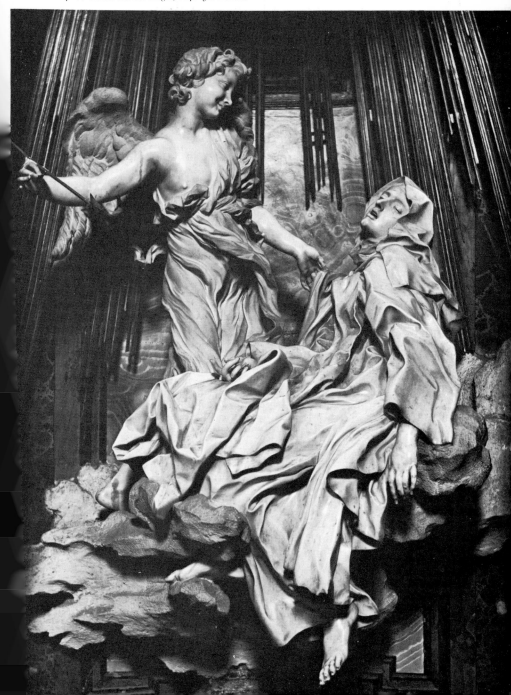

8. Cathedra in St Peter's, Rome, 1656–66. Bernini

Teresa and the Angel [7]. Here the light falling through a window of yellow glass, hidden behind the pediment, supports the visionary character of the scene, the Saint's mystical union with Christ, which takes place in an imaginary realm on a large cloud, magically suspended in mid-air before an iridescent alabaster background.

The Cathedra of St Peter [8], erected in the apse of the basilica during the decade 1656 to 1666, was Bernini's most extensive sculptural work

9. Aquatint after lost design for Cathedra

and, at the same time, the work that carried the greatest symbolic impact. Here a window as well as the transitions from flat to full relief and then to free-standing figures penetrating far into space form part of an indivisible whole. High above the ground hovers the chair of St Peter, and the greatest Latin and Greek Fathers – Sts Augustine, Ambrose, Athanasius and John Chrysostom who supported Rome's claim to universality – appear at the sides of the Cathedra. They carry it symbolically rather than actually. Without any further discussion of the symbolic content of this work, it is clear that this most important altar of the Catholic church asserts the primacy of the papacy and is a visually unequalled apotheosis of the Church Triumphant.

The Vatican can boast that it always had a most elaborate archival department: the documents for the Cathedra fill a published volume of several hundred pages. In addition, some fascinating visual material survives that helps to illuminate the history of this great work. I therefore want to use the Cathedra for some preliminary observations on Bernini's working procedure.

Bernini's first design was a relatively modest affair. The design I am showing in an aquatint is not the first, but already represents an increase in scale [9]. All the elements of the final design are to be found here: the window with the Holy Dove, the wreath of angels and *putti*, the Cathedra itself with sculptural decoration, the two *putti* carrying the papal insignia, and the four church fathers. But the whole project fits comfortably between the columns that belonged to the architectural setting; the design is relatively self-contained and hardly juts out into space. Between March 1658 and April 1660 a few of Bernini's assistants carried out full-scale models of the figures and these were placed in a wooden model of structural parts put up *in situ*. Considering the enormous dimensions of St Peter's it appeared that the scale was too small. Outsiders such as the painter Andrea Sacchi also made this criticism. A *bozzetto* by Bernini for the chair [10], now in the Detroit Institute of Art, was probably made in preparation for the model stage of 1660.

Rather too hastily, Bernini had started casting some bronzes shortly before the model was set up; once under way, the process could not be interrupted and these bronzes were later incorporated among the Glory of Angels and treated as if they were stuccoes like the rest. Between 1660 and 1661 Bernini decided to enlarge the scale of the design still further and this time very considerably. In preparation for this change he made rapid sketches that showed the Cathedra seen through the framing columns of the Baldacchino, which he had himself erected under the dome of St Peter's between 1624 and 1633. These sketches illuminate Bernini's intentions well, and supply a convincing commentary to the

10. *Bozzetto* for Throne of St Peter, 1658–60. Bernini

problem I have been discussing: even the Cathedra was planned for a framed principal view; it was conceived as a colourful sculptured picture of enormous dimensions. A number of large chalk drawings, now in the Museum at Leipzig, attest to the great care with which Bernini worked out every detail of the composition.

After the final scale had been settled, new large models became necessary. They were executed in 1661. By a lucky chance some fragments of these models survive, among others the far over-life-size heads of the

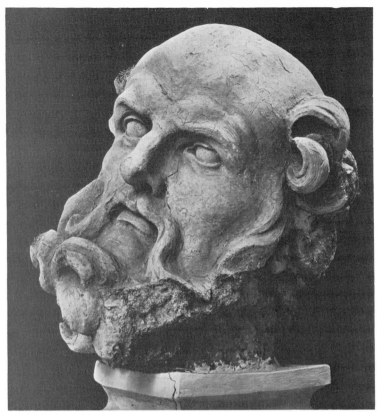

11. Model for head of St Athanasius, 1661. Bernini

Greek church fathers [11]. Such models are extremely rare, for not only are they made of easily perishable material, but also there was no reason to keep them once the work had been completed. These models were then covered by piecemoulds in plaster in preparation for the casting process. The casting of such enormous pieces is a difficult and complicated enterprise and although Bernini had the services of an experienced founder, the first cast of the St Augustine was a failure, and the second cast was only partly successful. The cleaning and gilding of all the bronzes dragged on to the end of 1665. On 17 January 1666 the work was unveiled.

I would like to conclude this brief survey with a few observations that will lead us on. First, to carry out such a work needed an enormous organization. In addition to an army of subordinate helpers, about thirty-five collaborators, some of them high-class sculptors in their own right, were engaged on the execution. This opens up the question of how such workshops operated. As a rule young men in their early teens who wanted to become artists were apprenticed to a painter or sculptor; this was

rooted in the medieval tradition and lived on for many centuries. Often the establishment was small and would operate with few young men. But sculptors with very large commissions always needed a large staff, not only of apprentices but also of responsible, mature personnel. Ghiberti, for instance, had to take on no less than twenty-one assistants after 1407, at the time of the first bronze door of the Florentine Baptistery; Donatello's contract for the high altar in S. Antonio in Padua mentions 'four sculptors and disciples'. Later the number grew. In addition, he had to employ bronze-casters, goldsmiths, stonecutters, masons, and painters who did not belong to his workshop. Riemenschneider had an exceptionally large workshop in Germany. In about 1500, several journeymen and thirteen apprentices made up his establishment. None of these organizations can compare with Bernini's in size and complexity. As a young man, in the beginning of the 1620s, he began with one studio-hand. In 1624, with his first large commission, the Baldacchino in St Peter's, he had to press his whole family into service and, in addition, employed seven assistants. Some of these stayed with him for years, others worked on their own and re-entered his service as and when they were needed.

The great extension of the studio came in the mid-1640s following the commission given him by Pope Innocent X to decorate the pilasters of the chapels and the nave of St Peter's with a lively sculptural cycle of ideal portrait busts of the first thirty-eight martyr popes and with huge *putti* carrying the papal insignia. For the execution of this enormous enterprise he had to rely on the support of no less than thirty-nine sculptors. This meant that almost every respectable sculptor in Rome was working for him. As time went on, the organization became more and more streamlined. In a very late work such as the Tomb of Pope Alexander VII in St Peter's, carried out between 1671 and 1678, the division of labour went very far. He himself actively participated less and less in the work. Often he only made sketches, drawings, and small models. Yet many of such works present an unbroken stylistic unity, because even his high-class assistants scarcely indulged in personal idiosyncracies: they were no more than so many hands multiplying his own. Thus, in a critical study of Bernini's work one would have to differentiate between works designed by him and executed by his own hand; those to a greater or lesser extent carried out by him; others where he firmly held the reins but contributed little or nothing to the execution, and finally those works for which he did no more than a few preliminary sketches.

Let me add to the set-up of his workshop, that not only did it attract Romans and a steady stream of Italians from other cities, particularly from the north of Italy, but also many artists from all over Europe. Thus, to mention only a few, the Englishman Nicholas Stone the Younger, the

12. Tomb of Urban VIII, 1628–47. Bernini

Frenchman Puget, and the German Permoser laid there the foundation for their future work. Owing to the gigantic commissions the church had to offer and to the immense authority of the papal artist, his studio had become a worldwide attraction. Whoever came in contact with him could not resist his spell. So it was by direct transmission – experience in the studio – that Bernini's style was disseminated throughout Italy and Europe.

My next point, which will take us even farther afield, is the important question of polychromy to which I have occasionally referred. The Cathedra presents a good starting point for discussion. One's first impression in front of the Cathedra is an intensely chromatic one: the beholder is struck by the interplay of multi-coloured marble, dark and gilt bronze, gilt stucco, and the yellow light spreading from the oval window. The compositional principle behind the use of colour here is obvious: the colour lightens and becomes ever more visionary the closer figures and objects are to the heavenly region.

It would be mistaken to associate such dazzling polychrome splendour with the love of the Baroque age for colourful magnificence. Multi-coloured decorations of monuments and whole chapels became fashionable in the Rome of Pope Sixtus V, towards the end of the sixteenth century. Much of the coloured marble that was used was taken from ancient buildings; an unmistakable symbolic hint that pagan Rome had finally been superseded by Christian Rome. Moreover, in Counter-Reformation circles there was a neo-medieval demand for the use of the most glamorous materials, because – it was argued – since the church was the image of heaven on earth, there ought to be no limit to the splendour displayed in the house of God.

Bernini had imbibed such ideas in his youth and, I think, the point need not be driven home that in a work like the Cathedra the polychromy has a supra-natural meaning and should not be mixed up with realistic use of colours. Polychromy was extremely important to Bernini, but never for the purpose of producing a life-like appearance through colour. He employed polychrome settings and the alliance of bronze and marble figures as much for the articulation, emphasis, and differentiation of meaning as for the unrealistic pictorial impression of his compositions. For example, in the tomb of Urban VIII (1628–47) [12] the entire central portion is of dark, partly gilded bronze: the sarcophagus, the life-like figure of Death, and the papal statue, i.e. all the parts directly connected with the deceased. Unlike these parts with their magic colour and light effects, the white marble allegories of Charity and Justice have a sensual and appealing surface texture and a distinctly this-worldly quality. But it would have been abhorrent to Bernini to use colour on marble sculpture or compose a figure of differently coloured marbles.

The Greeks invariably painted at least parts of their marble sculpture, above all the dress, hair and eyes. Rome introduced uncoloured, white marble and this was perhaps one of the most important or, in any case, most effective contributions of Rome to the history of sculpture. It is fair to say that it was in Rome and not in Greece that classical sculpture was born. Medieval sculpture was once again polychrome, but the link with the uncoloured marbles of ancient Rome was never entirely broken. The dawn of the Renaissance and the re-assertion of criteria valued in ancient Rome led to an interesting dichotomy in the history of sculpture. Sculpture aiming high, or created for a discerning audience, for the great and learned, imitated the uncoloured marbles of Rome, whereas poly-chromy was almost exclusively reserved for popular works made of cheap materials.

I think once the point has been made, its correctness is strikingly obvious. To imagine Michelangelo's Medici tombs polychrome would seem a joke in bad taste, an almost sacrilegious idea. On the other hand, there are a good many polychrome terracotta pieces in public galleries and often exalted names are given to these works. Usually, though not always, such pieces are workshop productions, repetitions of an un-painted key piece in marble made by the head of the workshop for a patron. The cheap terracotta repetitions were made from a form taken from the original. Such terracottas served the private devotion of Floren-tine burghers and were to be found in every middle-class household. Polychromy made them appealing and extremely lively.

If I am correct, then it would be unlikely that a realistically painted terracotta portrait of Lorenzo the Magnificent until recently attributed to Verrocchio could really have been made by Verrocchio for the Medici prince himself. During the late sixteenth century it became fashionable in Rome and elsewhere to combine white marble heads with coloured (for instance, porphyry) busts, in imitation of a trend in late antique sculpture. The naturalistic element implicit in such works never had any attraction for Bernini. He was probably more critically aware of the prob-lem of colour in sculpture than any sculptor before him.

He always meditated upon the central question of portraiture, namely, how to translate the colours and the complexion of a face into uncoloured marble. He discussed this problem on many occasions when working on the bust of Louis XIV in Paris. He reasoned that 'if a man whitens his hair, his beard, his lips, and his eyebrows and, were it possible, his eyes, even those who see him daily would have difficulty in recognizing him'. He supported this with the observation that a fainting person was hard to recognize because of his pale complexion, so that one often remarked

in such cases 'he does not seem to be himself'. Thus, he said, it was very difficult to achieve resemblance in a marble portrait, which is entirely white. To accomplish resemblance it is sometimes necessary to represent features in marble which are not in the sitter.

Bernini explained this paradox by pointing out that, for instance,

in order to represent the bluish colour which people have round their eyes, the place where it is to be seen has to be hollowed out, so as to achieve the effect of this colour and to compensate in this way for the weakness of sculpture which can only give one colour to matter. Adherence to the living model therefore is not identical with imitation.

From the sculptor's point of view, the most difficult part of the human head (and perhaps even of the entire human figure) to render in sculptural form is the eye. Throughout the entire history of sculpture the eye has always presented the greatest problem in the modelling of a head. This is, of course, due to the fact that, of all the parts of the human body, the eye alone has a design in it that exists only in terms of colour and not of shape: the iris and the pupil.

The representation of iris and pupil by sculptural means is a comparatively late, and, in any case, most sophisticated device. When you come to think of it, it does appear strange that in early Greek art, when the human body was submitted to stringent archaic rules, the eye was represented absolutely realistically, with coloured pupil and iris. Take the bronze chariot-driver at Delphi; he has eyes made of glass, the eyeballs are white, the irises brown, and the pupils black. The life in the eyes is so striking that one tends to overlook the archaism of the features. In Greek stone heads the eyeball is usually given as a simple convex form, on which the iris and pupil were painted, but the colour has almost invariably disappeared. When I introduced the problem of polychromy (see p. 25) I discussed the early classical piece in the Acropolis Museum, dating between 490 and 480 BC which goes under the name of *The Blond Boy* from the colour of the hair: there the paint of the eyeballs is still fairly well preserved [figure 12, page 25].

Not until the Hellenistic period was a way found of representing the eye by purely sculptural means. Sculptors then indicated the iris by a circle cut out of the eyeball, and the pupil either as one or two small holes in the centre. The shadow produced by the holes gives the effect of the dark pupil and the little ridge between them stands out clearly and is reminiscent of the dash of light that enlivens the human eye. Since in real life this spot of light shifts with a person's angle of vision, the ridge enabled the sculptor to fix the direction of the look. You now see why I called this translation of colour into plastic form highly sophisti-

cated. The Romans accepted the Hellenistic sculptured eye at certain *187* periods, while at others they preferred the simple Greek eyeball; since they had abandoned polychromy, they left the eyeball unpainted.

Now one of the interesting points of the Renaissance and post-Renaissance treatment of the eye is that one and the same sculptor would make use both of the simple convex and the sculptured eye, in other words, he would avail himself of the two methods of treating the eye which had developed in Rome over a long period of time. Michelangelo used the sculptured eye for his *David* [figure 1, page 103], where he wanted the stare in the eye to be fixed and determined. The same applies to his *Moses*; but in his Madonnas and his statues in the Medici Chapel he left the eyeball unworked. Similarly, in his portraits and heroic figures Bernini supported the expression of determination and will power by the chiselled eye [13], while retaining the blank eyeball for some of his saints and for his allegorical figures. In this context it is interesting that during a distinctly classicizing moment in the mid-1630s he also gave his portraits the blank eyeball [14].

14. Bust of Thomas Baker, detail, 1630s. Bernini

The Greek eye, in its finished painted form, gave enormous vigour to a head. The Italian sculptors found the blank unpainted eyeball suitable for the expression of general ideas such as sensibility and compassion, where a gaze into space rather than a fixed look was required: this was certainly suitable for and expressive of many themes of Christian iconography. But the sculptured eye was of the greatest importance when Bernini aspired to a truly royal gaze, as in the bust of Louis XIV [figure 1, page 13] which he wanted to look as if the king was about to give a command to one of his generals. Two months before its completion Bernini marked the iris on the eyeballs with black chalk. When asked what these marks meant, he said: 'When the work is finished, I shall use the chisel on the black marks, and the resulting shadow will represent the pupils of the eye.' So during the working process Bernini went back for a time to the realistic archaic device of colouring the eye. Later on, he adjusted the black marks several times, finally during the last sitting in the presence of the King. After the correction, Bernini declared the bust finished; the carving of the iris and pupil was to be done in the studio. Bernini's first and last concern was for the look, and its firmness and determination is, in fact, one of the most striking features of this bust.

9

BERNINI,
BOUCHARDON,
PIGALLE

One aspect of Bernini's work, his sketch models, or *bozzetti*, I have not so far discussed. They are of great importance not only as remarkable works of art in their own right, but also as phenomena in an historical sequence that we have followed from a Quattrocento model by Verrocchio to Michelangelo's sketch models and on to those by Giovanni Bologna – a historical sequence that leads on via Bernini to Rodin.

The *bozzetto* assumed a central position within the creative process. We know that Bernini handled clay with unbelievable dexterity and rapidity. It was the material in which he expressed his ideas without a moment's hesitation. So it does not seem mere chance that many of his models survive (I have not made a count, but there should be well over thirty) – however, quantitatively this can only be a tiny fraction of what, owing to his vivid imagination, he created in such profusion. We get an idea of the numberless models that must have crowded Bernini's studio (as they later crowded Rodin's) from Sandrart's report that Bernini showed him no less than twenty-two small models for his *Longinus* (the German painter and art historian Joachim von Sandrart lived in Rome between 1628 and 1635; he was a shrewd and reliable observer and recorder). Of these twenty-two models only one survives; it is now in the Fogg Art Museum of Harvard University, which owns the largest number of Bernini *bozzetti* in the world.* If there was an intention to

*They were left to the Museum by a nineteenth-century American collector, who bought them at a time when nobody was interested and cleared the Italian market. In fact, our

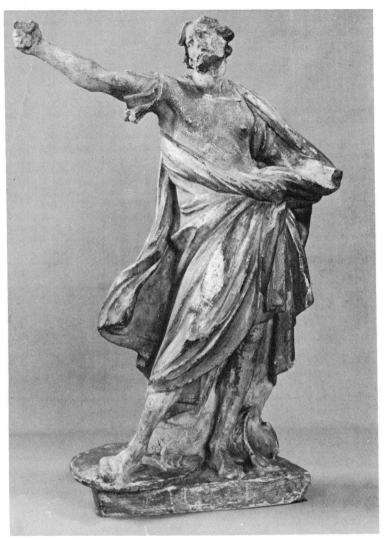

1. Terracotta model for *Longinus*. Bernini

preserve clay models, they were baked in the oven (i.e. they became terra-cottas) and often received a coat of paint both for aesthetic reasons and for further protection.

The *Longinus bozzetto* [1] too has an old polychrome patina (unfortun-ately, I have found in museums a kind of mania for ridding *bozzetti* of

appreciation of such models is of fairly recent date. I vividly remember that at my first visit to the Fogg a few decades ago I still found all the Bernini models hidden away in a store-room. The Director did not dare to exhibit them!

their old paint and this often leaves them with a rather awkward, slick
surface).

Despite the loss of twenty-one models, the one that remains helps to reconstruct some of the pre-history of the *Longinus*. You will notice that the attitude of the model approaches that of the marble. Above all, the revolutionary pose of the arms with the spread-eagled gesture is very close to the final one. But a more detailed study reveals that the stance of the model is different from the execution in an important respect: here the figure's left leg carries the weight of the body, while the right leg moves freely. This is the traditional classical stance. In the marble the tension is heightened by the unclassical device of resting the weight of the body equally on both legs. Moreover, in the *bozzetto* the drapery is comparatively calm and the basic motif of the vertical folds over the weighted leg and the curved swing of folds over the free leg was again closely fashioned on classical statues. Little of this remains in the marble. Here the drapery seems to fan out from a nodal point under the arm on the right-hand side, and the overwhelming motif of the great cataract of the mantle, on the left, seems to participate in, and be expressive of, the paroxysm of devotion shown in the features and the arms.

Thus, briefly, the relation between the *bozzetto* and the execution illustrates a decisive moving away from relatively classical beginnings towards a non-classical, entirely personal, emotionally charged style. This is typical of Bernini's procedure. Whenever we have a chance to check, we find that in grappling with a new commission, Bernini started with a classical figure at the back of his mind. But as the process of his preparatory work developed, he was, step by step, carried away from the spirit and the form of his classical prototype.

In his early work (and less clearly in later works) the reference to antiquity can still be traced in the execution. Let me only remind you of Bernini's *David* and the antique so-called *Borghese Warrior* (at that time in the Borghese Collection and now in the Louvre), or the head of the Apollo from the *Apollo and Daphne* group in the Borghese Gallery, and that of the *Apollo Belvedere*.

When in Paris in 1665, Bernini was asked to address the students of the newly founded French Academy. His famous address there sounds so conservative that some modern critics maintained that he advanced academic ideas in order to please his hosts. Nothing could be farther from the truth. Like all good Italians, Bernini saw in Raphael the supreme artist and in company with most Italian artists from the fifteenth century on he regarded the authority of classical art as unchallengeable. I think it came from the heart, when he told the students, 'In my early youth I drew a great deal from classical figures; and when I was in difficulties

2. Engraving after Bellori of Antinous

3. Study for an angel on Ponte S. Angelo. Bernini

with my first statue, I turned to the *Antinous* [2] as to the oracle.' He was talking about a figure in the Vatican Collections, in actual fact a Mercury, that in his day was very much studied. This figure haunted him

even late in life, after his return from Paris. A nude study [3] for one of the angels for Ponte S. Angelo shows that, despite the changed proportions, he still had the Antinous on his mind. So, in accordance with his theoretical views he began, rationally and objectively, using if possible a venerated antique work; not until his idea had developed did he give way to imaginative and subjective impulses. He then worked himself into a state of controlled frenzy in which he regarded himself (as he emphasized more than once) as the tool of God's grace, and in this state created in rapid succession his numberless sketches and clay models.

In the case of the bust of Louis XIV [figure 1, page 13) we can check each preparatory step. Some of them are so interesting that they have to be mentioned here. Even before the commission for the bust had been confirmed Bernini started making clay models in order to study the general attitude of the bust without regard to likeness. Shortly after the King had commissioned him, he went to see him at St Germain. On this and a number of subsequent visits he sketched the King while he played tennis or presided over cabinet meetings. He argued that the unique character of a man is not revealed in an artificial, self-conscious pose, but only when he follows his usual occupation. He wanted to see his sitter move about, for – he said – movement brings out all those qualities which are his and his alone.

Unfortunately, none of the rapid sketches made of the King has so far come to light, but we can form an idea of what they must have been like. A sketch has survived [4] for the bust of Cardinal Scipione Borghese, executed more than thirty years earlier : one may call it a speaking likeness of the sitter; the eye is sparkling and the mouth is about to open. Remarkably, the same liveliness emanates from the marble bust of the Cardinal.

Bernini conversed often and freely about his ways of maintaining the freshness of his sketches in his finished works. He explained that he made the spontaneous sketches of the King in order to imbue himself with the King's features, but he would never use his sketches while working on the marble. To work from sketches would mean referring neither to nature nor to the idea of it which he had formed in his mind, but to an abstraction, and his comment on this point was: 'I don't want to copy myself but to create an original.'

The preparatory work of the sketches and of the clay models served two different purposes. The sketches familiarized him with the individual features of the King, while the clay models clarified what he called 'his general idea'. The general idea was concerned with the visual expression of such conceptions as grandeur, nobility, heroism and majesty. The expression of these notions was dependent on the pose and the turn of the head, on the arrangement of the drapery, etc. and all this was to a

4. Sketch for portrait of Cardinal Scipione Borghese. Bernini

certain extent distinct from portraying the individual features of the King.

The first clay model was at hand the day after Bernini had been commissioned. We know that the clay models took him eighteen days in all, and this indicates that he studied the pose in one clay model after another until he was satisfied that he had found the clearest formula for

his idea of heroism and majesty. In this particular case no full-size model corresponding to the size of the marble bust was necessary. The rough blocking out of the marble was in the hands of Bernini's trusted assistant, Giulio Cartari. Then Bernini himself took over and carved the bust in about forty working days. He worked the marble directly, without referring to the sketches or models. But the King sat for him, thirteen times in all, and in the course of these sittings Bernini worked on one part of the face after another, directly on the marble – a most daring thing which only few artists could and can venture to do.

The part played by the clay models was of the utmost importance for Bernini. He argued that if the general idea (or, we might say, the concept embodied in the bust) is trivial, then the best detail will also appear trivial; in the beginning resemblance is less important than the general expression that constitutes the central problem of a portrait. The details, however, can only be satisfactorily rendered by subsequent work done directly from the live model.

I now want to supplement what we have learned from the preparatory work for the bust of Louis XIV by turning to the Angels for Ponte S. Angelo, because a fairly large series of models for them have survived. First, I have to summarize briefly the story of this commission. In the autumn of 1667 Pope Clement IX decided to embellish the Ponte S. Angelo, the old bridge over which one reached St Peter's and the Vatican from the city. Ten over-life-size marble angels meditating over the Instruments of the Passion were to be placed on the bridge. Bernini was to direct the enterprise and the most prominent Roman sculptors were invited to participate. In the event, twelve angels were executed. The two carved by Bernini himself [5, 6] (with some assistance, however) were never placed on the bridge; when the Pope saw them in Bernini's studio he requested that works of such quality should not be exposed to the inclemencies of the weather. They were subsequently taken to the church of S. Andrea delle Fratte, where they have remained to this day. This made two replacement copies for the bridge necessary, but one of them was to a large extent secretly carried out by Bernini himself. This figure, which is still *in situ*, is not a copy but a new creation. Thus we may expect preparatory studies by Bernini not only for the two angels in the Fratte but also for the later angel on the bridge.

The two marbles in the Fratte do not represent a complementary pair; the emphasis is rather on contrasts in expression, proportion, and the treatment of garments. The *Angel with the Crown of Thorns* [5] is rather massive and combines the wind-blown drapery (which Bernini had previously used for angels of the Cathedra) with the boldly projecting arch of drapery that echoes the shape of the crown and almost bisects the body.

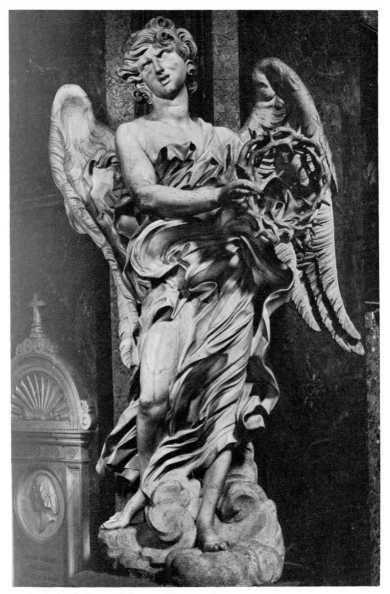

5. *Angel with the Crown of Thorns*, 1668–9. Bernini

The other angel, who is holding the Superscription [6], displays a highly emotional, almost neurotic state of mind, has extremely slender proportions, and is fittingly dressed in a garment with folds that break, crumble and roll up in nervous patterns.

The attitudes of the heads and the arms look as if the angels formed balanced counterparts, but this is not true for the legs: in both cases the

6. *Angel with the Superscription*, 1667. Bernini

left leg carries the weight and the right leg is free moving. This results in a disquieting asymmetry, for one angel is holding his symbol over the free leg, the other over the weighted leg. Now, the *bozzetti* leave no doubt that Bernini first planned these angels as a complementary pair. In a *bozzetto* of the *Angel with the Superscription* [7] (in the Palazzo Venezia, Rome) and a study of the *Angel with the Crown* [8] (in the Fogg Museum

of Art, Harvard) the figures of the angels are entirely complementary: they are both holding their symbol over the free-moving leg.

At this stage Bernini wanted to dress those angels in comparatively unruffled, chiffon-like garments like that of the Palazzo Venezia *bozzeto*. A rapid sketch in Leipzig shows that this also applies to the Angel with

7. *Bozzetto* for
Angel with the Superscription, Bernini

8. *Bozzetto* for
Angel with the Crown of Thorns, Bernini

the Crown. But then the heraldic symmetry begins to break down. The garments were given stronger accents far removed from any classical prototypes. By further stages bilateral symmetry was turned into the turbulent contrasts we found in the marbles.

When planning the second *Angel with the Superscription* on the bridge Bernini was no longer thinking in terms of a dual creation. So in this

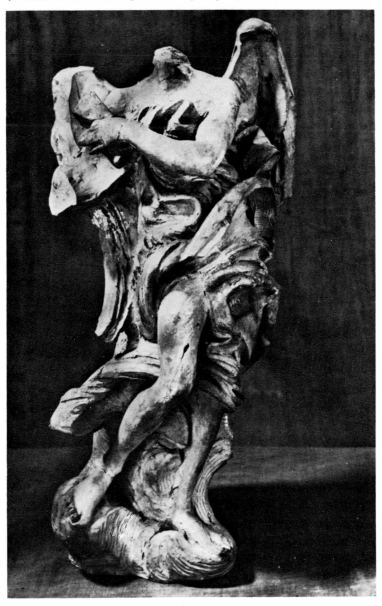

work he combined features from both earlier angels. We can follow up their growth in two *bozzetti*, one of them in Leningrad [9].

It was in the process of producing one sketchy clay model after another at tremendous speed that Bernini left behind the well-trodden paths and found his new, fresh and exciting solutions to many old problems. Although he worked the marble with an ease and accomplishment only

matched by Michelangelo, although he was one of the greatest carvers there ever was, he had none of the old-fashioned relationship to, or veneration of, the marble block – between him and Michelangelo there would have been some difficulty of understanding, for Bernini regarded it as one of his greatest achievements to have made marble as flexible as wax.

To these remarks I only want to add that Bernini's *bozzetti* have a wonderful surface quality. With few exceptions they are extremely sketchy, an indication of the relentless hurry that drove him on. One real-

10. Monument to Countess Matilda, 1633–7. Bernini

izes how his nimble fingers tried to keep pace with the images that crowded in upon him. He worked with a fine-tooth chisel and his thumbs, and tool and finger marks often appear side by side in his *bozzetti*. One even finds these marks in one or two bronzes, a definite proof that the casts were made after a terracotta *bozzetto* by his hand. I want to conclude the study of Bernini with the illustration of such a case. At the instigation of Pope Urban VIII Bernini erected a tomb in St Peter's for the Countess Matilda [10], that twelfth-century benefactress of the papacy who had brought about the submission of the German Emperor Henry IV to Pope

11. Bronze of Countess Matilda. Bernini

Gregory VII at Canossa. Bernini interpreted Matilda as a personification of the papacy, holding the keys of St Peter in her left hand and supporting the papal tiara with her left arm, while wielding the baton of temporal power in her extended right. Five bronzes of this figure have become known in recent years [11]; they are all 16 inches high and were certainly cast from the same form. In such a case the question arises, of course, whether the bronzes are later reductions of the over-life-size marble (this would be a normal occurrence) or whether they derive from a model preparatory to the marble figure. There are overwhelming reasons to assume that these bronzes were made from a form taken from a *bozzetto*. Even a cursory examination shows that the bronzes do not entirely conform with the marble. The proportions of the bronzes are more attenuated, there are minor differences in the arrangement of Matilda's dress and mantle, and so forth. We know from a document in which Bernini specified his contribution to the tomb that, among many other things, he made small models of all the figures of the tomb and it was probably his final model of the Countess that served for the bronzes. All the bronzes show the marks of the fine-tooth chisel, most conspicuously in the lower part of the back [12]. Higher up, he seems to have smoothed the chisel marks

12. Bronze of Countess Matilda, detail of back. Bernini

with his thumb in order to produce a broad concave fold all the length
of the back, between the collar and the tool marks. So the new type of
sketch model may, on occasions, even influence the surface texture of
bronzes. A careful examination of seemingly insignificant details is neces-
sary, if one wants a small bronze to yield its secrets.

In 1666 the French Academy in Rome was founded. Shortly before
that date Bernini had returned from Paris and since the King had
promised him a pension (which after some prodding on Bernini's part
was paid out more or less regularly) Colbert felt that the old master might
as well do something for his money by keeping an eye on the new Institu-
tion and its students. In a letter of 30 December 1669 Bernini promised
Colbert that he would let the students of the Academy work on the marble
of the monumental equestrian statue of Louis XIV that he was carrying
out at that moment [13]. When this ill-fated work, which occupied the
aged master from 1669 to 1677, reached Paris in 1685 (five years after
Bernini's death) Louis was so dissatisfied that he was only prevented from
breaking it up by having it banned to the farthest corner of the gardens.

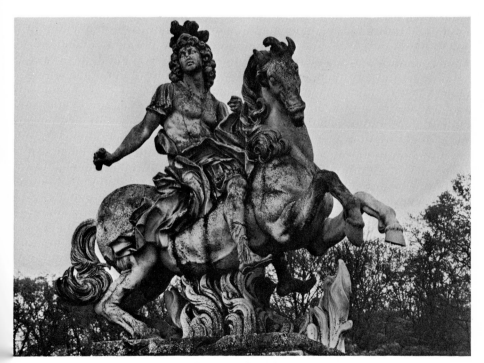

13. Equestrian statue of Louis XIV, 1669–77. Bernini

at Versailles, where it still stands, and having it changed into a Marcus
Curtius. Girardon accomplished this thankless task.

Taste was changing; France was in the ascendancy at the expense of Rome and in Rome herself French influence increased rapidly. Owing to the existence of the Academy, French sculptors now flocked to Rome, often not only to study but to stay. Many became thoroughly acclimatized and received important commissions, others returned to France without ever forgetting their Roman experience during their formative years. Despite the French penchant for antique statuary, they now opened their minds to the conquests of Bernini and understood him. The Abbé François Raguenet, a historian, and a member of the Académie française, published a book in 1700 entitled *The Monuments of Rome or Descriptions of the Most Beautiful Works*. He singled out the works of Bernini particularly for his choice of the transitory moment and the handling of texture in his statues: 'He treated marble with such tenderness that it would appear to be wax or even the flesh itself.' How close this is to Bernini's intention and how Frenchmen profited from such recognition throughout the eighteenth century! But in many respects they went their own way.

Some rather scattered observations will, I hope, clarify some aspects of eighteenth-century sculpture. I will concentrate on three sculptors who seem to me of special interest. The first and oldest of the group is Edmé Bouchardon. He was born in 1698 (exactly a hundred years after Bernini) and died in 1762. He studied under Guillaume Coustou, the nephew of Coysevox. He went to Rome in 1723 and stayed there for nine years. During the last five years of his stay he was so well known that he was given commission after commission. In 1730 he was even asked to make a bust of the reigning Pope Clement XII, of which both the large model and the marble execution have survived (in the De Young Memorial Museum, S. Francisco and Galleria Corsini, Florence). In 1732 he returned to Paris where ceaseless activity awaited him. Three of his works stand out: the Fontaine de Grenelle, executed between 1739 and 1745 (well known to every visitor to Paris), his *Cupid* in the Louvre, and his equestrian statue of Louis XV for the Place de la Concorde, destroyed during the Revolution.

I shall leave the Fontaine de Grenelle aside and turn immediately to the marble *Cupid* [14], who is carving his bow out of Hercules' club. Bouchardon received the commission in 1740; he began work in 1745 and executed the marble between 1747 and 1750. The figure was inspired by classical cupids Bouchardon had seen in Rome such as the *Cupid Stringing his Bow*, now in the Louvre (a Roman copy of a Greek work of the second half of the fourth century BC), or a similar one with restored arms, now in the British Museum.

I am mentioning these antiques as foils against which to see Bouchardon's real problem. For the great French sculptors of the eighteenth cen-

14. *Cupid*, 1747–50. Bouchardon

tury it was again an axiom that a figure must have innumerable views. Falconet, a sculptor whom I am going to discuss later, almost seemed to echo Cellini by writing: 'If the sculptor has well rendered one view of his work, he has only fulfilled one part of his operation. For his work has as many viewpoints as there are points in the space surrounding it.'

In accordance with this principle, French sculptors of the period studied their model from all aspects in the pose of their intended piece of sculpture.

Bouchardon was a great and tireless draughtsman, but his drawings do not show the inspirational fire of a Bernini. They are meticulous and honest statements, resulting from a solid academic education. Fortunately, a good many of his drawings survive. One characteristic sheet shows six studies of the live model in the nude in the attitude of the marble. Obviously, the model remained stationary; Bouchardon walked around it and drew all these profiles – they satisfied him. We know that the nude studies had been preceded by a sketch model; they were followed by a 2-foot *bozzetto*, and this in turn by a full-size $5\frac{1}{2}$-foot model.

Bernini's pictorial one-view concept had no attraction for Bouchardon and others. They went back to the principles that had inspired late-sixteenth-century Mannerists. In fact, a Mannerist note is traceable in much eighteenth-century sculpture, and not only in France. I may add that reversions to Mannerist works and ideas can also be found in eighteenth-century painting and architecture. The multi-faciality of the figure of Cupid is not an isolated occurrence in Bouchardon's work. There are in the Louvre no less than 399 drawings for the destroyed monument of Louis XV. Once again Bouchardon studied a model shown in the same position, from various angles. He applied the same method to the horse and not only to the whole figure of the horse but also to parts, the head, the legs and hooves, and the belly.

The second sculptor I want briefly to discuss is Jean-Baptiste Pigalle, who was born in 1714 and died in 1785. He is perhaps less well known than either Bouchardon or Falconet, but is – in my view – an artist of the very first order. Born into a family of stonemasons, his beginnings were very modest. Jean-Baptiste Lemoyne, a great teacher and the educator of a whole generation of sculptors, accepted him to his studio. At that time the young man was far from brilliant (Diderot baptized him the *'mulet de la sculpture'*). He did not win a Rome prize, but managed to get there anyway and stayed for three years from 1736 to 1739. On his return journey he stayed in Lyons for a year and a half. Although we know little about his Rome and Lyons period, there can be no doubt that Rome made him. It was there that he began to realize his rich potentialities. In 1744 he was elected a member of the Academy; his presentation piece was a *Mercury* to which I shall turn presently. Thereafter he was taken up by Louis XV and Madame de Pompadour. In 1752 he was made Professor at the Academy; in 1777 he was appointed *Recteur*, and in 1785, the year of his death, the greatest honour, that of the Chancellorship, was bestowed upon him.

15. *Mercury Fastening his Wings*, terracotta model, *c.* 1739. Pigalle

The *Mercury Fastening his Wings* [15] established Pigalle's reputation. In all likelihood the splendid terracotta model, now in the Metropolitan Museum, was done in Rome. The piece is an immensely clever transposition of classical reminiscences. In a sense it has three focuses, which is entirely unclassical and also entirely un-Berniniesque. One focus is the outward glance: Mercury is observing a situation that requires his participation and induces him to get ready for action. The thought of Raphael's Mercury in the Farnesina is never far from one's mind and

it may indeed have been that impression that stimulated Pigalle to try his hand at the theme. The second focus is the automatic action of fixing the wing. It needs no attention on the part of the god, but there is an intense plastic concentration to the spot where the god dresses, Olympian fashion. Two arms and a leg unite at this nodal point. The third focus is the other foot, placed far back with the sole of the foot raised in such a way that we have the sensation that Mercury will sprint away in a split-second. Thus we find here compositional and psychological relationships of great complexity and stimulating variety, and the sculptural rendering is so satisfactory and convincing that Frenchmen have always regarded this figure as one of the high-points of eighteenth-century sculpture. Voltaire in his *Siècle de Louis XIV* only mentions two sculptures under the reign of Louis XV and one is Pigalle's *Mercury*.

It was this figure that Pigalle executed in marble in 1744 as his reception piece for the Academy. This piece, now in the Louvre, is rather more of a statuette: it is only 23 inches high. Figure 16 shows the marble from a slightly different viewpoint than the terracotta and proves that the organization of the figure's attitude and movement was dictated by the wish to produce a work with an infinite number of views. The sculptural problem was identical to that of Bouchardon's contemporary *Cupid*. At the request of Louis XV Pigalle produced a large marble version (of more than 6 feet) in 1748 as a companion piece to a Venus of about equal size. Both pieces were sent by Louis XV as a present to the Prussian King Frederick the Great and were first exhibited in the park of Sanssouci until they were transferred to the Berlin Museum.

I now want to discuss an entirely different aspect of Pigalle's art. In April 1770 a group of *philosophes*, among them Diderot, Grimm, d'Alembert, Marmontel, dined at Madame Necker's and decided that the time had come to erect a marble statue of Voltaire and collect the money for it by public subscription. Pigalle had been approached a few days before. During this historic dinner his maquette (now in the Museum at Orléans) was produced and discussed. Two things are remarkable about this model. First, it is a typical sketch model that carries on the tradition with which we have been concerned. But Pigalle takes us a step further: one has visions of things to come, of Carpeaux and Rodin. Even more exciting is Voltaire's nakedness. I think no one had ever before considered erecting a monument to a writer who was still alive. But to envisage him in the nude had the making of a world-shaking scandal. Such a conception needed courage, stamina, taste, tact, and freedom from conventions. The idea was of course Diderot's, but Pigalle made it his own, lock, stock and barrel. At the dinner there were some muffled protests. However, Diderot and Pigalle were adamant.

16. *Mercury Fastening his Wings*, 1744. Pigalle

Pigalle promised to go to Ferney as soon as possible in order to make Voltaire's portrait. Voltaire sent a spirited and amusing note to Madame Necker asking her why Pigalle should come and model his face – because for that one should have a face! In his case at the age of seventy-six and just recuperating from an illness it would be difficult to guess where the face was, and so forth. Voltaire had expected an apotheosis and was shocked when he learned that he was to appear naked. He was terribly

afraid of being exposed to ridicule. Worse still, it became known that Pigalle had an old soldier of the Seven-Year War pose for Voltaire's nude body. No attempts at persuasion, no protests of the majority of subscribers had the slightest success: Pigalle was absolutely bent on heroic nakedness – a foretaste of the Revolution and of the Empire. The marble was finished in 1776 and had, of course, a terrible press. His contemporaries objected to the nudity and the unattractive nudity of an old man, a *squelette vivant*, at that. Later, the neo-classicists could not stomach the figure's realism. No one was willing to put up the work. For a time it was tucked away in a great-nephew's château in the country. At last it was put up in a dark corner of the *Bibliothèque de l' Institut* and is still standing there in a corridor. Rodin was perhaps the only person capable of appreciating the qualities of this work. In any case, his Monument to Victor Hugo, with the poet in the nude, seems to be in direct line of descent from Pigalle and, incidentally, encountered difficulties no less severe than Pigalle's.

Another terracotta model by Pigalle is even closer to Rodin [17]. It was made for a Monument to Louis XV and is now in the Museum of Orléans. The statue of the King, represented in somewhat fanciful Roman costume, was begun in 1756 and unveiled in 1765 in the Place Royal at Rheims. At the foot of the statue there were two bronze figures personifying unusual allegories, namely the 'Sweetness of Government' and the 'Happiness of the People' under a monarch who preferred the blessings of peace to the laurels of victory. This new type of pacifist pre-Revolution allegory was quite in vogue at that moment. Falconet and Houdon, who had also imbibed the spirit of the Encyclopedists, interpreted public monuments in similar terms. Like all French royal monuments, Pigalle's too was destroyed during the Revolution. But strangely enough, the vandals passed by the two allegories, which are still in existence. Maybe they realized that these allegories were creations in their own spirit. While he was working on the monument, Pigalle wrote a letter to Voltaire (23 July 1763) in which he said that he owed to Voltaire's writing the idea of replacing the old type of slaves in chains at the foot of royal monuments by his new type (as he says) of emblematic figures. The 'Happiness of the People' is represented by a happy burgher ('*citoyen*') who enjoys perfect tranquillity in the midst of all sorts of riches. So, since Pigalle's days, this figure has always been known as *le citoyen*.

The model clearly reveals how it was rapidly built up with lumps of moist clay. The appearance of such a model transcends the possibilities of a Giovanni Bologna or a Bernini. It is a splendid illustration of Michelangelo's definition of modelling as that 'which is done by adding'.

17. Terracotta model for Monument to Louis XV, *c.* 1756–65. Pigalle

We have reached the period of the Revolution and a study of Falconet, the third French sculptor I want to discuss, will bring us into even closer contact with the thought of Diderot and the Encyclopedists.

1. *Menacing Cupid*, 1758. Falconet

FALCONET, WINCKELMANN, CANOVA, SCHADOW

Etienne-Maurice Falconet (1716–91) is scarcely better known outside France than Pigalle. These two sculptors were almost exact contemporaries, Falconet being two years younger. They had certain experiences in common. Like Pigalle, Falconet came from a family of simple artisans and had only a smattering of formal education. Like Pigalle, he was apprenticed to Lemoyne and since he entered Lemoyne's studio in about 1734 and stayed with him until 1745 the two young men were co-students for at least two years (Pigalle went to Italy in 1736).

Of course their paths crossed later on, but then they were rivals rather than friends. By contrast to Pigalle, Falconet was an extremely difficult person, self-centred, self-righteous, argumentative, violent in his sallies against people and opinions with which he disagreed. His career was painfully slow; not until 1754 was he elected a member of the Academy; seven years later he was made Professor in the Academy. He never received a major commission from the Crown. But owing to Madame de Pompadour's patronage he was made Director of the sculpture *atelier* of the Sèvres *Manufacture de Porcelaine*, a position that he held from 1757 till 1766. During this period he created charming models for porcelain figurines and delightful small-scale rococo figures such as the *Menacing Cupid* of 1758 [1]. Statuettes like these are among the most gracefully

accomplished works of the eighteenth century. I hardly have to mention that all these works present an endless number of views, in accordance with his opinion that the sculptor's 'work has to have as many viewpoints as there are points in the space surrounding it'.

At the same period (between 1753 and 1766) he also had a commission for monumental sculpture, the decoration with eight statues of two chapels in the church of S. Roch in Paris. Of these, the figure of *Christ in Agony* [2] is the only survivor. It has been noticed that this figure was strongly influenced by Bernini's *Teresa*. Louis Réau, in his basic monograph of Falconet wrote: 'The head of Jesus who gives himself up, eyes closed, mouth half open, hands drooping with fingers hanging limply ... all is copied or transposed from the S. Teresa. Falconet ... is here still a faithful disciple of Bernini.' This is well observed, but a trifle overstated: transposition rather than copying is the keyword. Bernini's work, vibrating with emotion, has been toned down, simplified, rationalized; the climax of ecstasy has been replaced by physical and emotional exhaustion. But the fact remains that Bernini was still the great challenge when sculpture of monumental scale was planned.

This quarrelsome, unsocial man was an extraordinary person with an unusual mind. He was a great intellectual power; among sculptors he was unique in the eighteenth century. When he was about 30 he began to steep himself in learning. He learned Latin, Italian, and some Greek and must have become a fairly accomplished classical scholar, for he translated and annotated Pliny. His contemporary reading was broad and critical. A glance at his collected works published by himself in six volumes in 1781 gives the impression of an immensely alert man, sure of himself and his cause, who did not mind crossing swords with one and all. The dead (fortunately for him) could not answer. He tried to show that Phidias' celebrated works – the statues of Zeus and Athena in their respective temples at Olympia and Athens – cannot possibly have been beautiful; that Cicero was not a connoisseur in painting and sculpture. He attacked Lord Shaftesbury (long since dead) for the printed directions given to the Neapolitan painter Paolo de Matteis for the production of a painting depicting *Hercules at the Cross-Roads*; he attacked Daniel Webb, the author of *An Inquiry into the Beauties of Painting*. He had literary feuds with Mengs and others, and criticized in published essays such men as the Comte de Caylus, Lessing, the famous Italian Count Algarotti, and even Voltaire, to mention only some well-known names.

Falconet's greatest asset was his close friendship with Diderot; it lasted for a number of years, but ended in a break. Their correspondence, from 1765 to 1773, is very important both for Diderot's and Falconet's

2. *Christ in Agony*, 1753–66. Falconet

thought. But interesting as the problems they were concerned with are (such as to what extent works of art are created with an eye on posterity) they can be disregarded in our context. Suffice it to say that Falconet identified himself with Enlightenment thought and Enlightenment procedure. He eagerly read the writings of the *philosophes*, particularly of Voltaire, but did not actively contribute to their debate about religion, political organizations, society, education, and so forth. His exclusive pursuits were the arts and in approaching them he rejected metaphysics and abstract aesthetics and proceeded by an empirical method of investigation and by demonstration. Like the *philosophes* he was anti-authoritarian and critical of tradition. 'We live in the century of light (*de la lumière*);' he exclaimed 'at least in the century in which it is not regarded as a crime to seek it boldly.'

In his attempt to release the artist from the burden of authority, he turned against the antiquomania and struck out against the submission to wrong classical standards. His main *bête noir* was the equestrian statue of Marcus Aurelius on the Capitol. He had a very special interest in a thorough study of the horse of this monument. His fury turned against laymen who pronounce judgements on matters of which they know nothing. Winckelmann is the object of special derision because he had praised Marcus Aurelius' horse, and so Falconet lashed out against the sterile erudition of an antiquarian who would not be able to model the ear of the horse he was judging. In Falconet's opinion, better horses than that of Marcus Aurelius had been made in antiquity; the horse lacks grace and beauty and, in addition, its movement is incorrect. It belongs to a period of artistic decline. In the last part of his *Observations sur la Statue de Marc-Aurèle* he turns against errors spread by such acknowledged critics as Winckelmann, Moses Mendelssohn, the Comte de Caylus, Addison, and others.

The climax of Falconet's career as a sculptor and the fulfilment of his highest aspirations took place in St Petersburg. Owing to Diderot's connections, Falconet was brought to the attention of Catherine II. She admired the men of the Enlightenment. She favoured the idea of commissioning Falconet, for she saw in him *'l'ami de l'âme de Diderot'*. So in 1766 she invited him to come to Russia to make a bronze equestrian monument of Peter the Great [3]. He made a small model for it in the same year. Early in 1768 he began work on the full-scale plaster model, which he completed in 1770. He directed the *cire perdue* casting himself. The cast was completed in 1778; in 1779 Falconet left Russia, before the statue was unveiled.

The result was no doubt one of the greatest equestrian monuments of all time and perhaps the most outstanding sculptural work of the entire

3. Equestrian monument to Peter the Great, 1766–79. Falconet

eighteenth century. It is remarkable that the sculptor of the Sèvres figurines and the rococo statuettes was capable of such monumental grandeur. My lengthy introduction was necessary, I believe, in order to understand the implications of this great masterpiece. No sooner had Falconet received the commission than well-meaning advice was offered to him. The Russian Minister of Fine Arts, Betzki, envisaged a work in the style of and corresponding to, the royal equestrian monuments in Paris. Very firmly Falconet informed the Minister that he was well aware of the proprieties belonging to his subject, and demanded therefore the freedom of action indispensable for a successful artistic enterprise. There were other friendly suggestions, in particular one to take the Marcus Aurelius as a model. Falconet's answer was given in his *Observations sur la Statue de Marc-Aurèle*. Finally, Diderot himself submitted an idea that was less banal than the others. He based his conception on an unexecuted project by Le Brun for an equestrian statue of Louis XIV for the Louvre. Diderot's programme almost reads like a description of the Lebrun project, which is known from some drawings [4]. He wrote:

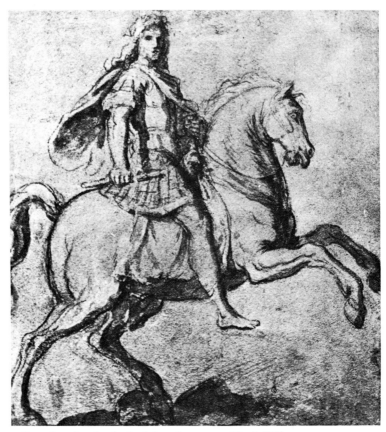

4. Copy after a lost drawing by Lebrun for a statue of Louis XIV

Show your hero climbing the steep rock that serves as base and driving barbarism before him. Make jets of water spout from the crevisses of the rock and collect the water in a rustic and wild basin ... Let barbarism appear with hair half hanging down, half plaited, the body covered by an animal skin, turning her haggard eyes towards your hero and menacing him ... On one side of the monument I want to see the Love of the People with arms lifted towards your legislator, following him with her eyes and with fervent blessings; on the other side there should be the Symbol of the Nation resting on the ground, quietly enjoying well-being, rest and security. These figures placed between the steep mass that surrounds your basin will form a sublime whole and present an interesting spectacle from all sides.

Falconet answered Diderot: 'This monument will be simple. Personifications of Barbarism, of the Love of the People, and of the Nation there will not be. Such figures would perhaps give the monument a more poetical aspect. But when one has reached the age of fifty in my profession, one has to simplify the design in order to achieve the highest goal (*si on veut aller jusqu'au dernier act*).'

Let me add that Peter the Great himself is the subject and the attribute of this monument: it only remains to demonstrate it. 'My Czar does not carry a baton. He is extending his right hand in a gesture of benefaction to his land through which he is riding. He is surmounting the rock, which serves him as base, and which is the emblem of the difficulties he has overcome. Thus, this fatherly hand; thus, this gallop upon the steep rock. Here you have the concept that Peter the Great has offered me.'

The truth of the matter is that, although Falconet could not follow Diderot in conceiving an old-fashioned allegorical monument, he yet owed him the idea of the allegorical rock; and this rock led back, via Le Brun, to Bernini's statue of Louis XIV, which Bernini wanted to have put on precisely such a rock. The decisive break through was Bernini's, namely the idea of replacing the traditional, formal, architectural base by one that would seem to be an organic part of nature. For Bernini the rock had, of course, also an emblematic meaning. It was the steep rock of virtue, the summit of which Louis had reached. Falconet rationalized this concept, but nevertheless he was still in the orbit of Baroque allegory. There is even more to it. In a drawing by Losenko after the plaster model of Falconet's monument one can clearly discern a snake linking the hooves and the tail of the horse. Falconet claimed that he needed this feature to balance the statue, but at the same time the snake was meant to be meaningful: it represents the envy Peter had braved.

Despite such ties with the past, the basic interpretation of the monument is unprecedented: namely, to show the monarch in idealized but homely attire without any martial paraphernalia and without the support of personifications – simply to glorify him as the peaceful benefactor of

his people, riding through his realm, illustrating that part of his career which, in Falconet's words, 'has been most useful to the welfare of humanity'.

So we see how an Enlightenment ideology, the emphasis on the pacific, anti-heroic hero, informs this monument (Voltaire had written to Catherine II 'Legislators have the first place in the temple of glory').

In spite of Falconet's indebtedness to Bernini, he regarded Bernini's equestrian monument as a complete failure: 'one of the worst and most impertinent productions that can be seen in sculpture'. Apart from some rational criticisms, he possibly disliked Bernini for a number of emotionally coloured reasons, one surely being that the fiery temperament of the Italian was alien to him. Compared with Bernini's dynamic High Baroque Falconet's *Peter* almost looks neo-classical. Indeed, an analysis reveals Falconet's rationalist procedure. For instance, the silhouette of the rock follows exactly the silhouette of the horse; in addition, viewed in profile the monument itself fits into a triangular shape which is echoed in the triangle formed by the rock. Falconet commented on these points. 'The gallop of my horse', he said, 'raises the horse's body ten degrees over the horizontal, an elevation corresponding to a gallop in reality. The line of the body of the horse runs parallel to the line of the ground on which the horse gallops; the slant here is also 10 degrees.' Such devices enhanced the impression of simplicity and unity.

The Baroque sculptor to whom Falconet was wholly dedicated was Pierre Puget (1620–94), who had been trained in Rome under Bernini and Cortona and practised thereafter a kind of controlled Italian High Baroque that made his work unacceptable at the Court of Louis XIV. Puget was surely the best French sculptor of his period, and it was the immense vigour of his performance tamed by an insistence on clear silhouette, on strong and simple directions, and on a certain angularity of his compositions that pleased Falconet immensely. 'Who does not notice how the blood circulates in the veins of Puget's Milo,' Falconet exclaimed. The principal master of the *étonnant* Puget, he said, was Nature and this warmed Falconet's heart to such an extent that his first major statue, his reception piece at the Academy, a *Milo of Crotona* (now in the Louvre) [5], testified to his inspiration by Puget's work. He also felt a deep sympathy for Puget as a person. In his time he had been as misjudged and misunderstood as Falconet himself had been. In 1769 he wrote in a letter to Catherine II: 'Puget's character was similar to mine; he could not be appreciated either by stupid or by malicious people.'

This would be a good moment to take leave of this strange genius, but I would like to add a few interesting observations from his *Réflexions sur la sculpture*, written in 1760. For him the act of creation lay in the

5. *Milo of Crotona*, 1754. Falconet

clay model. The relation between model and execution stimulated some illuminating remarks.

Among the difficulties of sculpting there is one, well known and deserving the greatest attention of the artist. This is the impossibility to go back on himself and to make fundamental changes in the whole or in parts of the composition once the marble has been roughed out: a strong reason for deciding on establishing his model and for determining it in such a way that the sculptor can carry out his marble with assurance. That is why, for large works, most sculptors execute their models, or at least sketch models, on the spot where their works shall stand. Because it is there that they can make sure of the right light, of the shadows, and of the correct general impression of the work which, composed in the light of the studio, may be effective enough, but in its proper setting may look very bad indeed.

These are very sound principles, but in fact Falconet here reiterates what had become standard procedure in Bernini's day. As you may recall from the Cathedra, Bernini had made it a rule to put up full-size models on the spot. He went so far as to erect some full-size columns on the Square

of St Peter's during the decisive planning stage. For Falconet the complete reliability of the full-size model was a *sine qua non*, because he needed it for his liberal use of the pointing method.

There is no doubt that this mechanical method of transfer assumed ever greater importance in the course of the eighteenth century. But so far art historians have paid too little attention to these important matters and a great deal of collecting and sifting of documentary material will have to be done before one can make absolutely valid generalizations. Bouchardon, for instance, was rather old-fashioned in his approach to working procedure as a document of 1753 concerning his *Cupid* shows. We are told that the model had been made by an assistant sculptor, helped by a studio-hand, always under the supervision of Bouchardon. Once the figure had been roughed out, Bouchardon never ceased working at it until it was finished. He went over the entire marble and was so scrupulous that he never entrusted his work to those specialists who usually file and polish statues. He did this despite the slowness and boredom of this kind of work, because he feared that they (the specialists) might spoil the contours of the statue. For the same reason Bouchardon reserved to himself all the final drill work, since it is most difficult and risky and, at the same time, gives most liveliness to marble works. So Bouchardon still subscribed to a meticulous craftsmanlike technique. But this was rare.

As guides to the prevalent views of the late-eighteenth and the beginning of the nineteenth centuries I will use three crown witnesses: Winckelmann, Canova, and the German sculptor, Schadow. Johann Joachim Winckelmann (1717–68), the strongest intellectual power in the search for new values through a return to severe classical standards, started his career with the publication in 1755 of his revolutionary essay 'Reflections on the Imitation of Greek Works in Painting and Sculpture'; shortly after its appearance he moved from Dresden to Rome for good. The work contains turns of phrase that have become common property of educated people such as the concept of the 'noble simplicity and calm grandeur' of Greek art, and of a dictum such as 'The only road open to us to become great, nay, if possible, inimitable, is the imitation of the ancients.' But, in addition, we find there observations rarely quoted. He tries to reconstruct the working procedure of Greek sculptors. (With the restricted knowledge at his disposal, this was of course wholly hypothetical.) He contrasts with it the usual method of modern sculptors: a net of horizontal and vertical lines is drawn on the model; the squares these lines form are then repeated on the marble block and in this way parallel points can be determined. But then Winckelmann criticizes the weakness of this procedure and explains that the sculptors of the French Academy in

Rome, who often had to copy ancient statues, developed a different method that has been accepted by many. One fixes over the model and the marble equal rectangular frames on which the same scale is marked and over which plumb lines are hung. The procedure can easily be understood by looking at figure 6. Here calipers of various sizes are used in

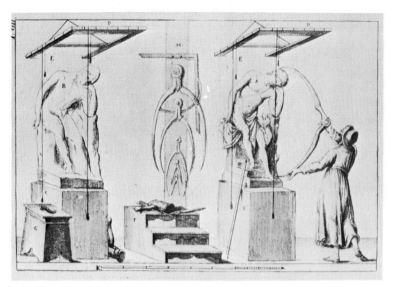

6. Method of copying figures. Francesco Carradori

addition to the other contraption. In fact, this method had long before been anticipated by Alberti and Leonardo and remained in vogue (of course, with considerable technical improvements) to the end of the nineteenth century and beyond; but Winckelmann found this method, too, unsatisfactory and recommended instead what I might call for brevity's sake Michelangelo's 'water-basin' procedure. Winckelmann took Vasari's analogy literally and believed that Michelangelo had placed his model and marble block into basins of water and determined corresponding points by draining the water off gradually. I can save you the trouble of following Winckelmann's most detailed explanation of how this watertight method would unfailingly work. His effort was abortive. Falconet was right: Winckelmann was an antiquarian and not a sculptor.

The problems opened up by Canova are of a somewhat different nature. He was born in Possagno in the Veneto in 1757 and by 1774 had already got his own studio in Venice. In 1781 he settled permanently in Rome and, excepting stays in Vienna, Paris, Naples and London, remained there to his death in 1822. His beginnings were still in a late Baroque tradition and it is amusing that one of his *bozzetti* was long attributed

to Bernini. Even before settling in Rome, he was converted to neo-classical theory and practice. When the French critic and writer Quatremère de Quincy visited Rome in about 1780 and wanted to meet living sculptors and see their works, he found that there was no one except Cavaceppi, the restorer of antiques. Later, Quatremère became Canova's biographer. Twenty-five years after his first visit Rome had once again become a centre of vigorous sculptural activity owing to Canova's presence. The German writer and painter Fernow, who published a little book about Canova in 1806 when the sculptor was at the height of his reputation, tells us that 'in Canova's studio, which comprises a number of large halls, one finds all the sculptural works together that are being done in Rome nowadays'. He gives a vivid description of those rooms, filled with great works of art and ends by saying that all this awakens the impression of a period in which the arts flourished. 'Before one's mind's eye', he says, 'one envisages the workshops of the ancients in which the images of the gods and heroes of the Greeks were created.' I mention all this because one feels that Fernow is impressed by Canova and in sympathy with his work. Now, later in his book Fernow supplies most interesting information about Canova's studio practices and, although we will have to face some contradictions, I want to say at once that in my view there is no reason to cast doubt on Fernow's explicit statements. He tells us that owing to his large commissions Canova was forced to seek much help from his assistants. He himself only makes the models of his works, first small ones in wax, in order to clarify his thought, and later the full-size model in clay. The transfer into marble he leaves entirely to qualified assistants. He only steps in for the master's touch when the execution is far advanced. Nevertheless, in the case of large works this last finish may take him weeks or even months. When doing this kind of work (Fernow carries on) the artist has the laudable habit of having the writings of the ancients read to him in Italian translations. For this purpose he has a special reader among his men. This strange story makes one wonder whether the gentleman-sculptor Canova wanted to elevate in this way the manual toil to a more sublime level. (His older contemporary, Anton Raphael Mengs, was found singing a sonata by Corelli while painting because [as he himself explained] he wanted his picture to be in Corelli's musical style.) The story was certainly true, because Canova himself, in a letter to a Venetian friend, dated 8 February 1794, writes: 'You will say that it is impossible for one who has to work from morning to night like a slave to find time to read. The truth is that I am working the whole day like a slave, but it is also true that almost the whole day I listen to a reader, so that I have now heard all the eight volumes of your Homer edition for the third time.' Fernow also enlightens us about Canova's

treatment of the marble surface. He tells us that Canova was not satisfied
with filing and polishing his works. He tried to soften the dull natural
surface of the marble and give it the appearance of a more flexible
material. For this purpose he stained his statues with soot after he had
worked the last polish to a point where the surface was almost glossy.
In this way he wished to break the brilliant white of the marble and to
bestow upon it a sort of waxen mellowness which must strike every eye
as unpleasant that seeks in statues a pure enjoyment of form.

It seems to me that Fernow explained and expressed something that
many of us have felt in front of some of Canova's work. While acknow-
ledging the excellence of his talent and of his performance (as Fernow
does), one is often irritated by an almost mawkish quality in his work.
So, supported by Fernow's report, one might be inclined to believe that
with Canova the estrangement from thinking in stone had gone a decisive
step further. But now I have to explain what I meant when I talked about
contradictions at the beginning of this argument.

There is no modern monograph on Canova; however, an English art
historian, Hugh Honour, has been preparing one for many years. Upon
inquiry, he informs me that he has 'come to regard Fernow as, in the
terminology of the law courts, a hostile witness'. As a proof he related
to me the history of the Tomb of Pope Clement XIV (now in SS. Apos-
toli, Rome) [7] from Canova's own account book. He began work in April
1783 and had executed *bozzetti* in clay which were cast in plaster by July.
On 11 January 1784 he began the full-scale clay model of the statue of
the Pope which occupied him for forty-five working days ... He then
went on to the allegories, devoting fifty-two days to the Temperance and
fifty-seven to Humility. Later he destroyed the Temperance and made
a second model, which occupied him from 13 December 1784 to March
1785. Roughing out of the marble began early in April. He was then
employing two or three assistants by the day. Work appears to have pro-
ceeded concurrently on the three marbles. The account of man-hours
devoted to the execution reveals that on the marble of the Pope Canova
worked for one hundred days, forty-five of which were devoted to the
face and hands. Three assistants worked on this statue for 192, ninety-
nine and seventeen days each. Surprisingly, Canova gave rather more
time to the allegorical figures – 172 days to the Temperance and 193 days
to Humility.

I think the contradiction is easily resolved: Canova was obviously a
dedicated carver early in his career. But Fernow records the position
twenty years after the execution of the tomb of Clement XIV, when
Canova enjoyed world fame, had to cope with an endless number of
commissions, and was getting old. In Francesco Chiaruttini's aquatint

7. Tomb of Pope Clement XIV, 1783–7. Canova

of Canova's studio [8] we see the full-size models and the marbles of Clement XIV and of Temperance, wooden frames for mechanical transfer above them, and young studio-hands working with drills on the marbles. This may well be a correct rendering of what was to be seen in the studio in 1785.

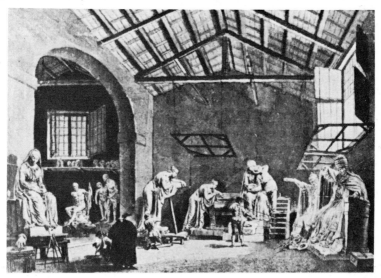

8. Aquatint showing Canova's studio, *c.* 1785. Francesco Chiaruttini

This was the precise period when the young Johann Gottfried Schadow arrived in Rome. He was born in Berlin in 1764 and died in 1850. He stayed two years in Rome, became a friend of Canova, had relations with the artists of the French Academy and spent most of his time studying the ancient works of Rome. During his stay in Rome he made a name for himself and upon his return to Berlin was elected to the Academy and appointed Head of the Court Sculptors' Studio and also Director of all sculptural enterprises of the Office of Works. At that time he employed sixteen studio hands. For over forty years he was flooded with public and private commissions. In the 1830s his eyesight failed and he had to stop sculpting. The last twenty years or so of his life he mainly spent with literary activities. In our context it is of particular interest that Canova paid his studio a visit in 1798 and that Schadow published, in 1802, a paper entitled *The Sculptor's Studio*. The essence of this he had already put down in a letter to a friend. Surely, what he says are reflections upon his Roman experience? I think he essentially described Canova's working procedure, which he made his own.

Drawings, he tells us, are necessary, but not too useful, because they can only show one view. A sketch model has to be made to give form to one's idea. From the sketch model one has to proceed to the finished

9. *Princesses Luise and Friederike*, 1797. Schadow

model. For safety's sake he regards it as advisable to take a plaster cast from the clay model and use the cast for the work of transfer into marble. (This is precisely what Canova did.) He describes the scientific transfer of points from the model (or rather the plaster cast) to the marble by way of rectangular frames and plumb lines, a method illustrated by Carradori's plate [6].

10. *The Three Graces*, 1817. Canova

He also mentions the use of calipers (which Carradori had shown) which are mainly used to determine the exact distance between points. He carries on that the block abounds with as many points as does the sky with stars. One can check the truth of this statement at a visit to the so-called Gypsotheca at Possagno, the Museum at Canova's birthplace, where there are hundreds of his models and plaster casts assembled under one roof: many of the plaster casts look as if they had German measles; these are the points which were transferred on to the marble block.

Finally, Schadow assures us that it would be impossible for one man alone to execute an entire work of marble from beginning to end (Michelangelo would hardly have subscribed to this statement). We are told that at least three people are required: one who is doing the pointing of the marble; a second man, a real artist, who has to carve and drill away what Schadow calls the bark; and for the third person, the master himself, remains the skin, the finishing of the finest details, the last breath, in a word, the animation of the surface.

Despite this rather objectionable procedure, objectionable both from a Renaissance and a modern point of view, Schadow produced much respectable work such as the life-size marble group of the two princesses Luise and Friederike [9]. Luise was the crown-princess of Prussia, and her younger sister Friederike was married to the crown-prince's younger brother. The model of the group was exhibited at the Berlin Academy in 1795; the marble in 1797. It is now in the National Gallery of Berlin's East Zone. Schadow's assistant, Claude Goussaut, was responsible for the exquisite classical dresses and Schadow reserved for himself the execution of the attractive heads, which seem to have been excellent likenesses.

For the composition of his two-figure group Schadow looked back to classical antiquity, such as the *Cupid and Psyche* group in the Capitoline Museum, and perhaps also to the classical trio of the Graces, a theme to which Canova returned twenty years after Schadow's group [10]. Compared with the Canova, Schadow's princesses display (despite their formality) an engaging modesty.

11

THE NINETEENTH CENTURY

RODIN, HILDEBRAND

Long stretches of the first half of the nineteenth century and even of the second half are rather barren, but I am not suggesting that everything was bad. When we think of nineteenth-century sculpture, an endless number of run-of-the-mill public monuments come to mind, dating mainly from the second half of the century, the Garibaldis, the Vittorio Emanueles and their likes – the bane of all European towns. Nevertheless, there was no dearth of gifted sculptors and of high quality work. I recall François Rude (1784–1855), the best French sculptor of the first half of the century, who decorated the Arc de Triomphe in Paris (1836), and his brilliant pupil Jean-Baptiste Carpeaux (1827–75), the precursor of Rodin, whose dramatic *Ugolino and his Sons* [1] made his name, and who is well known to every visitor to Paris from his ecstatic group called *The Dance*, executed 1865–9 for the façade of the Opera and now in the Louvre; or in England the names of John Gibson (1790–1866), a fine classicist, who worked under Canova and Thorvaldsen in Rome and spent most of his life there; of Sir John Steell (1804–91), the foremost Scottish sculptor of the period, and of Alfred Stevens (1817–75), an extraordinarily sensitive artist, who is perhaps not yet sufficiently appreciated.

All these names and many more might be of interest in a balanced history of ninteenth-century sculpture, but that is not my concern. I

1. *Ugolino and his Sons*, 1865–7. Carpeaux

have to diagnose and discuss the new historical constellation that was rich in ideas – a constellation where tradition and revolt combined to open up new and hopeful possibilities and alternatives. In fact, this moment is not too difficult to pin down. As the century drew to its close, the fate of European sculpture had become the responsibility of two men: one name is obvious, Auguste Rodin; the other does not come so easily to mind – I mean Adolf von Hildebrand.

The two were almost exact contemporaries. Rodin's dates are 1840 to 1917; Hildebrand's 1847 to 1921. But this is about the only thing they have in common. In all other respects they represent the greatest possible contrast. The Frenchman Rodin – passionate, aphoristic and ingenious – left no coherent or systematic statement of his views. We can, however,

piece them together, mainly from talks with his friends, and the sum of his statements adds up to a distinctly uniform conception of sculpture. The German Hildebrand, on the other hand, had a philosophical mind and was eager to expound his thought in coherent form. The result was a book, entitled *The Problem of Form*, first published in 1893. Twenty-one years later, at the outbreak of the 1914 war, the book had gone through nine editions. I have no doubt that for the two decisive decades before the First World War it was the most read and most influential book on art, even more so than Clive Bell's *Art* and other such fabulous successes. This is strange, because by no stretch of the imagination can Hildebrand's style be categorized as *belle-lettres*; it is concise, often to the point of dryness; and for that reason it makes fairly heavy reading. It seems that people were looking for just this kind of reliable solidity – truth without embellishment. The book's message was lapped up not only by creative artists, but also had a great influence on students, on the general public, and even on the method of art historians such as Wölfflin. So, by naming Rodin and Hildebrand together on the same level, as it were, I am not at all implying that they were equally important as sculptors. Rodin was a genius, the only one in nineteenth-century sculpture, whereas Hildebrand's sculptural work was mediocre, to put it charitably. Where the one was effective through the impact of his work and his personality, the other triumphed by means of the published word.

But before we explore their different messages in some detail, I want to assure you that there is at least one fine work by Hildebrand in existence that has fortunately survived the last war, namely the Wittelsbach Fountain in Munich [2], begun in 1891. The fountain is sensitively placed before a landscaped background. The basins, the fall and jets of the water, and the sculptural groups are harmoniously coordinated, and the whole

2. Wittelsbach Fountain, begun 1891. Hildebrand

work, organized like a picture extending in a plane, presents a balanced view on the central axis from a certain distance. Even before studying Hildebrand's book, you may have come to the conclusion that he was out to demonstrate here the correctness of his theory. Fortunately, in this case the strict adherence to his theoretical deductions helped in the creation of a superbly composed, attractive, and aesthetically satisfying work.

Rodin's friend, Camille Mauclair, the champion of the Impressionists, published in 1905 the impressions he had gathered during his long acquaintance with the master. I will use him as a starting point for Rodin's approach to sculpture. 'The study of movement [Mauclair writes] has led him to give unlooked-for values to the general outline and to produce works which may be viewed on all sides and which continually show a fresh and balanced aspect that explains the other aspects.' This is immensely interesting, and it is of course correct. The correctness can be buttressed not only by many other statements, but above all by Rodin's works themselves. But, strangely enough, despite the enormous and rapidly growing literature on Rodin, no attempt has been made, so far as I know, to do justice to Rodin and show his works or at least some of them from many sides.

Take, for instance, *The Kiss*, one of his major works. The group was executed in 1886 and exhibited in the Salon of 1898. It is now in the Musée Rodin in Paris; there are other versions, one of them in the Tate Gallery, which is illustrated here [3]. The group is illustrated in every book on Rodin, as a rule from the same photograph that reveals the girl's beautiful back and the graceful line of her body, the counter-movement of arms, and the plastically suggestive triple motif of knees. We even get an idea of the position of the young man's left leg: the girl is resting her left foot on his left foot.

3. *The Kiss*, 1901–4. Rodin

Figures 4 and 5 show the group more from the right. More of her back, her right elbow and his left hand come into view and we see more of the meeting of the faces. The kiss itself is now fully exposed to the beholder and the man's arms take on a new meaning; their parallel

4. and 5. *The Kiss*, 1901–4. Rodin

outward movement (which could not be seen before) forms a kind of protecting cage around the girl. Finally, a view from the other side [6], displays the young man's muscular body and also a previously undisclosed movement of arms: his right arm now parallels her body, while her left arm reveals an immensely tender embrace that could perhaps be guessed but not seen before.

6. *The Kiss*, 1901–4. Rodin

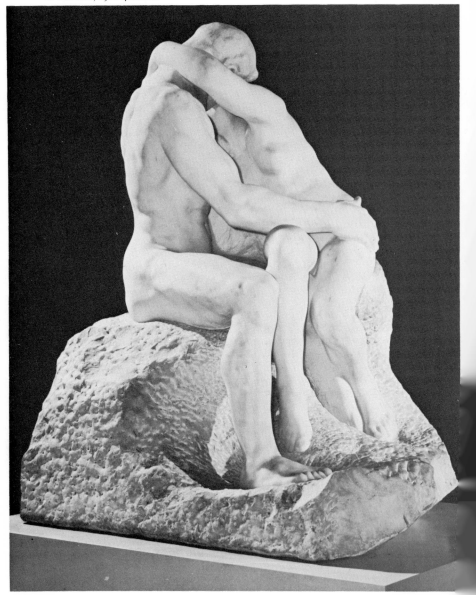

Even though this experiment leaves much to be desired, it is, I hope, visually convincing. We may now continue with Mauclair's observations: 'Rodin made successive sketches of all the faces of his works, going constantly round them so as to obtain a series of views connected in a ring ... He desired that a statue should stand free and should bear looking at from any point; moreover, it should remain in relation with the light and with the surrounding atmosphere.' Such ideas clearly link Rodin to the French sculptors of the eighteenth century and beyond that to the kinetic sculpture devised by late-sixteenth-century artists.

Fortunately, we know more about Rodin's procedure. His friend, Paul Gsell, reported the following: 'His method of work was unusual. Several nude models, male and female, strolled around his studio or relaxed ... Rodin watched them unceasingly ... and when one or the other *gave* a movement which pleased him, asked for the pose to be held. Quickly, he took his clay, and a maquette was soon in being. Then, just as swiftly, he passed on to another which he fashioned in the same way.' Rodin wanted in his sketches and models to capture life in movement. He himself said: 'Different parts of a sculpture represented at successive moments in time give an illusion of actual motion.' It is extraordinary how close in this respect Rodin was to Bernini. You may recall that Bernini sketched Louis XIV during his daily occupation; he observed him long and then, suddenly, like lightning, put on paper a characteristic moment. Rodin too made an endless number of rapid sketches. It sounds unbelievable, but there are about 7,000 in the Musée Rodin. Few of these have so far been published and there are few people, if any, outside the Museum who have been given permission to study them.

Now, let us supplement what we have learned so far from the notes taken by another friend of Rodin's, Dujardin-Beaumetz, who was the Minister of Fine Arts in the early years of this century.

When I start on a figure [Rodin said] I look first at the front, the back, and the two left and right profiles, in other words, I view its outlines from four angles. Then, with clay, I put the rough mass in place ... Next I do ... the profiles seen from a three-quarters angle. Then, rotating my clay and my life-model in turn, I make comparisons and refinements ... Then I turn my stand and that of my model so that I see another outline; I turn again, and am thus led, by stages, to make a complete circuit of the body. I begin again, condensing and refining the outlines more and more [he is always talking about work on the clay model]. Since the human body has an infinite number of outlines, I do as many as I can or consider expedient.

All this sounds as if it had been lifted out of Cellini's treatise. This was, of course, not the case (I shall come back to what Rodin might or might not have known of it), but he was thinking and working in a living tradi-

tion or at least a lingering tradition, and every word of his, every one of his actions shows that his mind was a kind of receptacle in which the experience of the last 300 years seemed mysteriously stored up.

Let us hear how the story continues: 'I place my life-model in the same outlines as my clay and compare them, or, more often, it is I who follow the model by turning my stand.' This is precisely what we could reconstruct as Bouchardon's procedure. It was probably a procedure common in the eighteenth century. In order to get a full picture of Rodin's ideas we must once again return to Mauclair. He reports Rodin as saying: 'To work by the profiles, in depth not by surfaces, always thinking of the few geometrical forms from which all nature proceeds, and to make these eternal forms perceptible in the individual case of the object studied, that is my criterion ... I go so far as to say that cubic truth, not appearance, is the mistress of things.' And this should be supplemented by Rodin's recollections:

In my youth at the beginning of my career the sculptor Constant gave me the following advice: when you do sculptural works in future never perceive forms in the plane, but always in depth ... Always consider a surface as the extremity of a volume, as if it were a smaller or larger point turned in your direction ... This principle was for me remarkably fruitful. I have always applied it when executing figures. Instead of visualizing the different parts of the body as more or less plane surfaces, I imagined them to be projections of internal volumes ... Thus the truth of my figures: instead of being superficial (on the surface only), they seem to grow from inside out, just as life itself.

7. *The Burghers of Calais*, after 1884 Rodin

8. *Balzac*, 1917. Rodin

This conception of sculpture as matter, plastic mass, animated from within and radiating outward had a consequence of special interest in our context. Mauclair reports that Rodin was shocked at the academic method that treated figures or groups as if they were bas-reliefs. 'The spectator must stand in front, at a certain spot, and whatever is behind is accessory: the decorative line produces its effect only from that point ... The academic sculptors treat a piece of sculpture like a picture; it has a right side and a wrong side ...' Thus he firmly repudiated, as he had to, sculpture with one view and with a static beholder. It would seem that Rodin defined his own position with almost clairvoyant lucidity. And he knew exactly what he wanted. That was part of his greatness. It is common knowledge that he was immensely stubborn. He was never afraid of taking on any committee. The *Burghers of Calais* [7] ran into enormous difficulties. He was commissioned in 1884, but it took the better part of a decade until he had battered down all opposition to his new-fangled idea. Only in 1895 was the monument unveiled in Calais. His *Balzac* [8], for which he was commissioned by the progressive *Société des Gens de Lettres* in 1883, had probably the most stormy career; none of the co-actors saw the end, for the bronze was not cast until after Rodin's death and the monument in the Boulevard Raspail was erected only in 1939.

The *Victor Hugo* monument [9] encountered a similar fate. Soon after the great poet's death in 1885, Rodin was invited to make a monument for the Panthéon. He envisaged the pensive poet nude with a string of wildly gesticulating Muses behind him. A monument to a poet in the nude to be erected in a church, even though in a secularized one: impossible. Rodin's design was unanimously rejected. A simpler version without the Muses was eventually executed twenty-four years later (in 1909); it found a home in the gardens of the Palais Royal. Rodin could look back to a great precedent in France – Pigalle's *Voltaire* – for the naked statue of his monument.

Rodin had a magic power of divination, a sure instinct in what direction to go. He knew that the *Balzac* was his greatest work and he said it. It was easy to agree with him in 1930 and after. But who was prepared to accept his judgement in 1898, when the plaster model was shown in the Salon?

His instinct never failed him; but how far did his knowledge go? The living standard of Rodin's family was extremely low, and his home education was nil. At school he was a complete failure and when he left, he was virtually uneducated. He never learned to write grammatically, and he was never able to talk coherently. For many years he earned a precarious livelihood as a simple mason, and he was well over thirty before

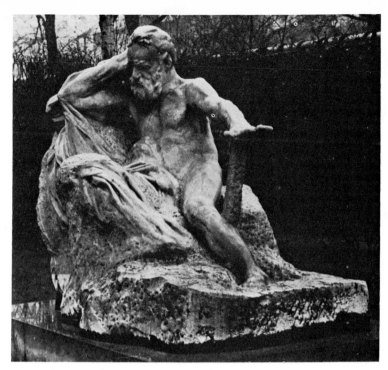

9. *Victor Hugo*, 1909. Rodin

his reputation began to rise. The knowledge he later accumulated was sketchy and casual, and although one always comes across flashes of deep understanding and extraordinary penetration, a good deal of what he said about matters not directly connected with his own work might, if one could hear him on a tape recorder, sound almost feeble-minded today. His saving grace was the aura that surrounded him; it must have been fabulous and to women he was simply irresistible. These considerations are not extraneous to my topic; on the contrary, as you will see. Very occasionally do we come across a voice dissenting from the general capitulation before his greatness. One man who really knew him was the sculptor Antoine Bourdelle (1861–1929), who worked as Rodin's assistant for fourteen years, from 1893 to 1907. He left him, aged 46, when Bourdelle was a major figure in his own right in the Paris art world. Bourdelle said of him: 'He talked a lot and he talked well, but he was ignorant . . .' There is no reason to distrust Bourdelle. In fact, Rodin's ignorance cannot be denied when one turns to a topic central to his creed as an artist: Michelangelo.

Before I say more about this matter, we have to consider Rodin's attitude to marble. Rodin was the arch-modeller in the history of sculpture.

He thought clay, felt clay, handled clay, as we have seen, with unbelievable skill and dedication, but he scarcely worked the stone. In his studio the pointing method was extensively used and sometimes he seemed to have paid so little attention that he allowed figures to leave the studio with the surfaces covered by drill holes remaining from the pointing-up process. In his group of *The Kiss* in the Tate, which is an exact replica, made between 1901 and 1904, of the group of 1886, you will easily distinguish a number of points on the entire surface and, what is even worse, the technical assistant who drilled the points blundered at the back of the young man (see figure 5): in one case he went about an inch under the surface. The little crater is there for all to see; no attempt was made to fill it in or repair it. Most of the execution of Rodin's works was left to assistants; among them were fine artists such as Charles Despiau (1874–1946), who worked for him from 1907 to 1914. After Rodin's death Bourdelle said that he himself had done a considerable number of Rodins. In 1931 Madame Bourdelle told the art dealer René Gimpel that Rodin never touched marble. Thereupon Gimpel telephoned Mademoiselle Cladel (who as an absolute Rodin devotee cannot be regarded as objective) and asked her whether Madame Bourdelle's assertion was correct. Mademoiselle Cladel, who had been a close friend of Rodin's for many years, answered: 'He didn't do all that much to them, but... would apply the mark of his genius to them. His pupils would take the work as far as they could ... he [Rodin] would bend the pupil's will and lift it to the height of his own mind ...' So the issue is pretty clear. But now, let's approach this important matter from another angle.

In 1918 (a year after Rodin's death) Adolf von Hildebrand wrote a paper about Rodin (that remained unpublished at the time) in answer to an article by Wölfflin, in which Wölfflin had talked about Hildebrand's rejection of Rodin. Hildebrand felt that, to a certain extent, he had to correct this impression, for he had the greatest admiration for the vigour and power of Rodin's work; it was like a phenomenon of nature and his criticism should be regarded as if it were applied to a natural event. He assures us that if one had only fragments of Rodin's figures one would have to agree that there was nothing like them since the days of the Greeks or Michelangelo. But if one looks at a whole work such as the monument for Victor Hugo, one is deeply shocked because of the unfathomable lack of knowledge of how to compose a real unit and one is also shocked because of the low level of any architectural (structural) feeling and of a general artistic refinement.

How were such contrasts possible? Hildebrand's answer to his own question was that Rodin, notwithstanding his remarkable vitality and feeling for organic growth, simulated a working procedure that had never

taken place. As Hildebrand put it, any professional will immediately dis- cover that Rodin never worked directly in stone. He misunderstood the character and necessity of the unfinished areas in Michelangelo's work; he imitated them for purely visual effects; in his work the seemingly unfinished areas could never have resulted from a process of direct carving (as in Michelangelo's case). Hildebrand drives his point home over several pages and ends with the rather amusing statement that Rodin did quite naïvely what all the other sculptors of his time did but his fraud was more courageous than that of the others.

Hildebrand was right; he knew what he was talking about. He was certainly more correct than Henry Moore who, in a conversation printed in the fine Catalogue of the recent Rodin Arts Council Exhibition, said: 'I should say that Rodin is the one artist since Michelangelo who has understood Michelangelo best.' Strange that Moore, a born carver, could be misled to make such a statement. We can, however, subscribe to Moore's dictum that Michelangelo was Rodin's 'greatest influence, without any doubt'.

Both Rodin and Hildebrand looked back to Michelangelo with profound admiration. Rodin revered Michelangelo's genius and his titanic performance. He felt himself to be the great master's worthy successor and imitated him so cleverly and successfully that, what are in fact impressionist sensations could be mistaken for the real thing, even by those who should know better. Hildebrand learned an entirely different lesson from Michelangelo. He not only endeavoured to revive Michelangelo's relief-like working procedure, but also advocated emphatically a return to the craftsmanlike Renaissance method of direct carving. He was the first to voice the challenging battlecry 'Back to the stone!' When you look at one of his principal works, however, such as the life-size marble of the *Young Man* in Berlin [10], dating from 1883–4, the disappointment is boundless. Before its deliberately classicizing coolness the name of Michelangelo would never come to mind. So we are faced with the paradoxical situation that the sculptor who misinterpreted Michelangelo was able to catch a good deal of his creative passion while the other who really knew what Michelangelo was trying to achieve, produced works that were divorced from him by an unbridgeable gulf.

Hildebrand is too important a phenomenon to be dealt with so briefly. His father, a liberal university Professor of Economics at Marburg, took an active part in the revolution of 1848 and had to flee to Switzerland; eventually the family settled in Berne. Adolf von Hildebrand grew up in a highly intellectual milieu, but without any contact with the creative arts. His decision to become an artist was not taken lightly. But at twenty, in 1867, he went to Rome with some knowledge of painting and sculpting.

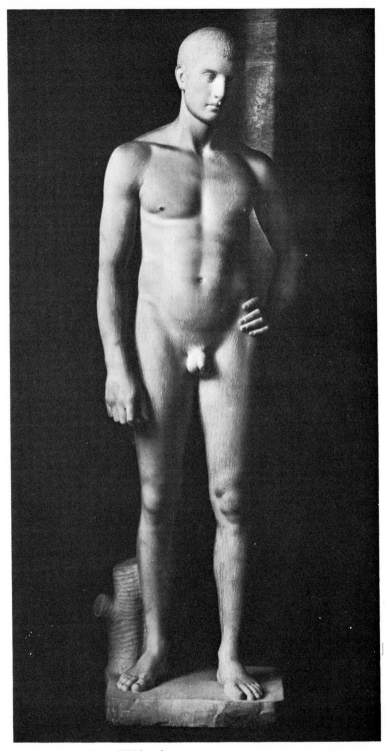

10. *Young Man*, 1883–4. Hildebrand

In Rome he met two people who had a formative influence on his future and even on the work with which we are here mainly concerned, *The Problem of Form*. He met the German painter Hans von Marées, ten years his senior, and the philosopher and art critic Conrad Fiedler (1841–95), and the three were soon linked by close friendship. Marées was the great rejuvenator of German painting in the nineteenth century; he had determined views on art and artistic creation and from all accounts was immensely effective as a talker but left no written statements. His hold over Hildebrand must have been considerable. Fiedler's influence on him is more clearly traceable, because Fiedler produced between about 1870 and 1890 a series of important writings on art, which are now counted among the incunabula of modern art history. The study of Kant and Schopenhauer and of the psychology of perception led him to separate the world of artistic cognition from accidental nature that surrounds us and thereby laid the foundation for a theory of pure artistic vision. Hildebrand carried on where Fiedler left off and attempted to create a phenomenology of form. It is interesting that his work was first conceived in 1888–9 as a long obituary for Marées and that various drafts were handed to Fiedler for criticism. By 1893, at the time of the first edition, *The Problem of Form* had grown into a book independent of its link with Marées.

Hildebrand starts by differentiating between two modes of vision; vision from afar and vision from a near standpoint. The far-vision is the language of art, because one has a simultaneous impression of a whole. Near-vision offers only parts of the objects, which by eye movement we have to perceive in a successive process. He supplemented his recognition of the two modes of vision by a differentiation of what he called 'actual form' and 'perceptual form'. The actual form is the form of an object independent of its changing appearance, while the perceptual form is the one that depends on many changeable aspects such as colour, light, environment and changing viewpoints. The artist's task is the perceptual form.

From here he goes on to discuss the concept of space and its visual expression and concludes that objects at different points in space will be most easily perceived when they are placed in a few clearly separate planes. This leads on to one of the decisive premises of his theory. To bring order into the three-dimensional world that surrounds us, the artist has to organize it in a number of imaginary layers or planes of uniform thickness. According to him such planar relief conception is the only artistic way of ordering things three-dimensionally. We could not be farther removed from Rodin's ideas ('never perceive forms in the plane...')!

Applying all this to sculpture and its working process, he argued that sculpture, no doubt, developed from drawing, first leading to relief by

carving along the contours. Thus sculpture originated from plane images. The sculptor's working procedure has to repeat these stages: the design must be drawn on the flat surface of the block; then layer after layer of stone should be removed from the frontal plane corresponding to Michelangelo's 'water-basin' method. Parts lying in the same plane have to be finished before going on to the next layer. In order to maintain a unified vision, the back of the block should remain standing as long as possible and, in any case, any procedure departing from the deliberate freeing of the figure, layer after layer, would lead to confusion. Thus, Hildebrand buttressed Michelangelo's working procedure with a broad philosophy of perception and form. As one should almost expect, he finally contrasted carving and modelling. The technique of modelling requires an armature and the building up of the clay all around it. By contrast to the carving in stone, this means a denial of a definite standpoint. One cannot therefore advance to an artistic order or spatial conception that is not inherent in the natural object. While he does not deny the value of modelling for the study of nature, he maintains that it cannot lead to a unified conceptual image. A lack of it, you may recall, was one of his major criticisms of Rodin. It is only now that the nature of his criticism becomes entirely intelligible, because according to him Rodin could never have arrived at a unified performance through modelling and via a deceptive working process in stone.

I have already mentioned with what enthusiasm Hildebrand's book was received. Let me add that Wölfflin, apostle of pure vision and of an autonomous history of art, exclaimed in the Preface to his *Classic Art* (1898): 'Hildebrand's book is like a life-giving rain on scorched earth. At last a new way of coming to grips with art, a method ... that leads into depth.' The older generation of art historians who had a penchant for cultural history felt disturbed. Carl Justi, a great man and the author of two volumes on Michelangelo among many other works, talked about 'the collective hypnosis of scholars, sculptors, archaeologists, and philosophers,' imposed by Hildebrand's idea of planes: 'plane sculpture, that sounds like wooden iron,' he said. I am quoting all this because I feel that my brief précis could hardly give an idea of the logical coherence, the originality and vitality of this book. It is a historical fact that, directly or indirectly, twentieth-century sculptors were immensely indebted to Hildebrand.

None of the important sculptors of the first half of the twentieth century could avoid reacting to the work of Rodin and to the principles propounded by Hildebrand. You can be sure that a sculptor who was unaware of these issues had no contact with the vital events of his time and shows it in his work. Let me give you one such example. Sargeant

Jagger, the sculptor of the huge but miserable war memorial monument at Hyde Park Corner, published a book in 1933 entitled *Modelling and Sculpture in the Making*. There is a lot of talk about models in the making but not a single word about sculpture in the making. The book ends by discussing the 'finish' of the surface of the large model which depends, as the author says, 'upon the permanent material in which our statue will be ultimately reproduced'. To take it for granted in 1933 that sculpting was not the sculptor's job, but a purely mechanical, technical operation, sounds almost criminal.

By contrast, all those who mattered took sides. Owing to Rodin and Hildebrand, the old difference between modelling and carving was again acutely felt. Perhaps no one expressed this clearer than Eric Gill in an essay published in 1918: 'I shall assume', he wrote, 'that the word sculpture is the name given to that craft and art by which things are cut out of a solid material, whether in relief or in the round. I shall not use the word as applying to the art and craft of modelling ...' He goes on to explain that things modelled in clay are generally not suitable for carving in stone and concludes: 'modelling ... is a process of addition, whereas carving is a process of subtracting.' Words and spirit are Michelangelo's. I doubt whether they would have been possible without Hildebrand.

1. *The Kiss*, 1908. Brancusi

12

THE
TWENTIETH
CENTURY

I suggested that early-twentieth-century sculptors became again very conscious of the dichotomy between carving and modelling, and as a prelude to a further inquiry I quoted a determined statement by Eric Gill in an essay of 1918. We all know Gill's importance as a renovator of classical script. His sculptural work, however, is now scarcely remembered. But there were incidents in his life as a sculptor which are of special interest in the context of these lectures. Gill's German friend and patron Count Harry Kessler thought that Gill would benefit by working for a time under Maillol in Paris. Now Maillol, who belonged to an older generation (he was twenty years older than Gill – 1861–1944) was a modeller; he employed carvers to transfer his models by means of pointing machines into stone. Gill, by contrast, was only interested in direct carving in stone. He did travel to Paris to start his apprenticeship with Maillol: this was in 1910 when he was 28 years old, but in the middle of the first night there, moved by a sudden impulse, he dashed to the Gare Saint-Lazare and returned to London.

Gill explained his strange behaviour in an apologetic letter to Kessler in which he said: 'What I need to learn is about tools and the uses of tools – the chisel and hammer and what they are capable of doing. I cannot learn that from Maillol. Infinitely better would it be for me to go and apprentice myself to the most skilful and the most ordinary of monumen-

tal masons and learn to hack idiotic angels out of white marble ...' This is a very interesting incident. There is no doubt that among the younger generation of artists the carving fever was spreading. Let me introduce you to an Italian sculptor, Adolfo Wildt, who was rather fashionable between the two wars. Again, I am not going to illustrate any of his works, but will quote from his little book, *L'arte del marmo* (*The Art of the Marble*), that appeared in 1922 and is one of the most concise and characteristic statements of the period.

Wildt makes the point that the modeller has to put up with two different metamorphoses. First, if he only works in terracotta and wants to have his model executed in marble, his concept expressed by him in soft, greasy, dark material will be translated by the man who makes the plaster cast into hard, white, opaque material, i.e. all relationships of light and shade will be changed and implicitly also the spatial effect of the work as well as the specific aura of spirituality that every statue creates around it. The second transformation takes place when a technician transfers the plaster cast into marble. All the forms are mechanically – and one must add – bestially translated into the lively, vibrant, splendid material that absorbs light so that there is again a complete change of all values.

Later, he contrasts Michelangelo's and Canova's working methods and attributes the 'invincible atmosphere of coldness issuing from Canova's works' to the use of the pointing method. Wildt concludes that a sculptor who cannot carve is like a painter who cannot paint. Well and good, but now Wildt recommends his own method of procedure. He explains that a statue should be worked equally from all sides and that no one part should be more advanced than the others. As you see, this is wholly at variance with Michelangelo's and Renaissance procedure; it is, in fact, a return to primitive or archaic methods of carving: you may recall that the unfinished sixth century BC Greek statue [figure 6, page 17] was worked like this. At first one may be astonished to find such a recommendation in a twentieth-century book. On second thoughts one realizes, however, that there is some logic in the recommendation; for Wildt and his contemporaries were not only heirs to the message of the apostle of direct carving, Hildebrand, but also to the bequest of Rodin, the towering genius of the nineteenth century, the giant on and beyond the threshold of the twentieth, who had employed mechanical processes. While the new generation of sculptors had no use for his procedure, they could not escape the impact of his ideas: for them, as for him, sculpture was concerned with mass radiating in all directions.

Take the Russian-American Alexander Archipenko (1887–1964). He arrived in Paris in 1908, at a moment when – as he himself said – Rodin was *à la mode*; he hated the old master: his works reminded him of chewed

bread spit on a base. His own work was entirely unhampered by realistic conventions and yet, in the second and third decade, he created works with an infinite number of equally valid views – which shows unexpectedly the deep-rooted affinity between him and Rodin.

The Rumanian Constantin Brancusi (1876–1957), who settled in Paris in 1904, had an ambivalent attitude towards Rodin. I may add immediately that the same is true of the younger Jacques Lipchitz (1891– 1973); he came from Lithuania to Paris in 1909 and later lived in New York and Italy. Rodin tried to attract Brancusi to his studio, but the young man refused. 'One cannot grow in the shadow of great trees,' he said. But his rejection of Rodin went much deeper; for Brancusi was wholly committed to carving: 'Direct carving is the true road to sculpture,' he exclaimed. The moral weight of his conviction and the single-mindedness with which he followed the path of virtue make him one of the great pillars of the heroic age of modern sculpture. In one of his writings Henry Moore remarked 'since the Gothic, European sculpture had become overgrown with moss, weeds – all sorts of surface excrescences which completely concealed shape ... it has been Brancusi's special mission to get rid of this overgrowth, and to make us once more shape-conscious.'

Shortly after Brancusi had abandoned the then current imitation of nature, he carved *The Kiss* in stone (now in the Philadelphia Museum of Art) [1], probably as a deliberate answer to Rodin's *Kiss*. This was in 1908. Only minimum indications of the two truncated figures (the lower part of the legs is not shown) are incised in the rectangular block. There is no interference with the cubic mass of the stone, and yet the theme is unmistakably stated. In carving this piece archaic procedure was evidently on Brancusi's mind. His *Bird* [2], carved in marble in 1912 (now also in Philadelphia) was to a large extent the result of abrasive processes. He went round and round the form until he had achieved a polished surface of such accomplishment and perfection that the beholder experiences an intense desire to savour this shape in an uninterrupted circuit – and not an iota will interfere with his enjoyment of this form.

I hope you will not regard it as irresponsible on my part if I now juxtapose to Brancusi's *Bird* Rodin's first nude study in clay for his *Balzac* [3]. Even though no person in his senses would want to construct a connection between these two pieces, there is yet in both a similar wish to attain form with an endless number of profiles – form radiating from within. Much later, Brancusi realized how much he owed to Rodin: in 1928 he wrote: 'Without the discoveries of Rodin, my work would have been impossible.' Unlikely as it may seem, Brancusi's *Bird* is in a direct sense indebted to Rodin. The *Bird* is a fragment: it has no feet and, what

is more significant, no head. The discovery that the part can stand for the whole was Rodin's, and Brancusi along with scores of other sculptors accepted the premise. In contrast to Michelangelo, whose unfinished works were unfinished, Rodin created partial figures which are the finished product. This required a new (we might call it, modern) form of self-analysis and introspection, for the artist had to develop a sophisticated control of the act of creation. Now let us turn from Brancusi to

3. Terracotta model for *Balzac*, *c*. 1891–2. Rodin

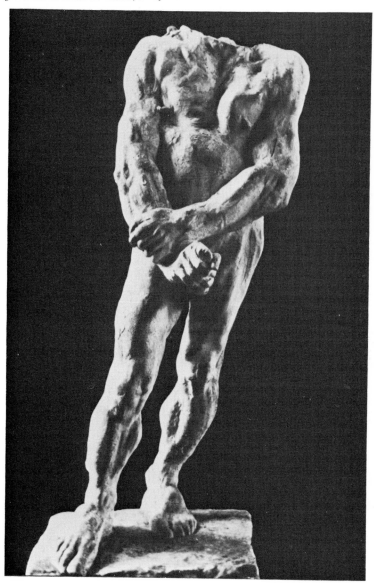

The Bird, 1912. Brancusi

a younger master, Henry Moore (born in 1898). His opinions could easily be mistaken for those of Rodin; for instance, when he writes: 'The sculptor mentally visualizes a complex *form from all round itself*: he knows while he looks at one side what the other side is like; he identifies himself with its centre of gravity, its mass, its weight . . .' Now, Moore is a carver, as determined a carver, one might say, as Brancusi himself. Moore's own words show that he is trying to realize Rodin's ultimate sculptural aims, and he is trying to realize them by means of the craftsmanlike method of direct carving in stone – and in so doing he is, unknowingly, following in Hildebrand's footsteps. Hildebrand's craftsmanlike Renaissance procedure, however, led (as you may recall) to figures with one principal view. Since Brancusi, Moore, and many of their twentieth-century peers are concerned with 'cubic truth' (to use Rodin's phrase), cubic truth that is revealed to the beholder through multiple viewpoints, the Renaissance method of carving could not be employed.

We have already seen Brancusi in 1912 using the procedure recommended ten years later in Wildt's book. It is a fact that if a carver (not a modeller) wants to create form 'visualized from all round itself', he has to work round and round this form in a slow and laborious process, in which abrasives may play an important part. He has to think, moreover, in great, solid and simple forms, for nobody could or can carve direct in stone such works as Giovanni Bologna's *Rape of the Sabines* or Rodin's *Kiss*.

Figures 4a–c illustrate three stages in the working of Moore's *Virgin and Child* for the Church of St Matthew at Northampton, finished in 1944. The work exemplifies what I just said. Different from Michelangelo's relief-like procedure, but corresponding to the work of the archaic craftsman, Moore accomplished one phase after another, always around the entire mass of the stone, exactly as Wildt had described it.

The genuine enthusiasm of twentieth-century sculptors for the works of so-called primitive or early civilizations with their simple, cubic forms was not merely a reaction against the over-strained classical ideology, nor was the new great form (as we see it in Moore's work) merely a reaction against Rodin's Impressionism: one has to state emphatically that the new approach to sculpture was firmly rooted in the European tradition: it came about when genuine carvers re-interpreted the doctrines of the arch-modeller Rodin.

5. *Figure with Raised Arms*, 1956–7. Wotruba

I said that in the early years of this century a real carving fever was breaking out. For the sculptors it was like an ablution, like an act of purification, a moral necessity. It would therefore seem not only worthwhile but also historically correct to survey the situation from that angle. But here I can only add some miscellaneous remarks to impress upon you how widespread the feeling or rather conviction among sculptors was that any renewal was tied up with direct carving. A painter like Modigliani (1884–1920), who came from Leghorn and settled in Paris in 1906, and who was also a distinguished sculptor, declared peremptorily 'The only way to save sculpture is to start carving again.' Or take from a younger generation the American, John Flannagan (1895–1942), who returned to the old concept of the image embedded in the rock, and the even younger Austrian, Fritz Wotruba (*b.* 1907), who was for many years Director of Sculpture of the Vienna Academy. He works with cubic forms organized in such a way that they suggest the disposition of classical stance [5] and may be called schematic twentieth-century illustrations of Hildebrand's views. It was he who re-coined the Renaissance phrase of the figure potentially hidden in the marble block emphatically thus: 'The point of working directly in stone is ... to force the image to emerge clearly and simply.'

Let me conclude this list with the voice of Barbara Hepworth who gave the following message in 1952: 'I refute absolutely the recent tendency to discount the act of carving as being out-of-date or not contemporary. Carving is to me a necessary approach – one facet of the whole idea which will remain valid for all time.' Apart from the common fervent belief in the necessity of carving, twentieth-century carvers had many different messages to convey. This is obvious to anyone who has a superficial knowledge of the sculptural work of the last two generations. I will mention a few additional names and point out some problems, but before doing it, I feel I should return for a minute or two to Maillol (1861–1944) who was a modeller like Rodin. And yet he is always and rightly quoted as the most important French antidote to Rodin. His static, monumental, massive female figures created in the spirit of classical antiquity are well known [6].

Maillol had been trained as a painter; he began, self-taught, to sculpt in the early 1890s and went his own way undaunted. He argued that, unlike Rodin, he was not after character, but after beauty, and he had his own criteria of beauty. He also contrasted his working method to that of Rodin. Instead of starting, as Rodin did, from a pose of a moving model that had caught his fancy, Maillol first clarified his conception in his mind. He was exclusively interested in the structure, the equilibrium of the human, primarily the female body and not, like Rodin, in the move-

ment and fluidity of form. The result, it could be argued, is that the conceptual side of his work came very close to Hildebrand's (I am not talking of quality, of course) and that the principles of his art were those of a carver rather than a modeller. It is for this reason that Eric Gill, despite his opposition to Maillol, could write 'Maillol has a vision which I feel to be very largely my vision.'

The oldest of the small group of carvers I want to mention is the excellent Ernst Barlach (1870–1938), a German Expressionist of great dramatic power. He was primarily a woodcarver [7], but some of his works were cast in bronze such as the *Man Berserk* of 1910 and *The Fugitive* of 1920. He shared with the genuine stone carvers of this period an unfailing feeling for great unifying plastic forms, for the simple, immensely effective silhouette, and it might even be argued that he accepted

6. *The Three Nymphs*, 1930–38. Maillol

Hildebrand's principle of the relief character of three-dimensional sculpture.

While Barlach remained faithful to his style and the North German countryside, his fellow countryman Hans Arp (1887–1966) was completely acclimatized in Paris, became a Frenchman and played a considerable part in the kaleidoscopic changes of modern art – Cubism, Dadaism, Surrealism which he took in his stride. We are here interested in the fact that he became first interested in three-dimensional work in 1930. He himself said about this moment in his career: 'Suddenly ... the body, the form, the supremely perfected work became everything to me. In

8. *Human Concretion*, 1935. Jean Arp

1930 I went back to the activity which the Germans so eloquently call *Hauerei*' (i.e. hewing – what he means is 'direct carving'). The first products were two torsos. Such figures have very impressive, immensely simplified, rhythmically silhouetted forms, closely reminiscent of Brancusi and scarcely uninfluenced by him. Arp continues: after the torsos came the 'concretions'. Concretions he called according to James Thrall Soby 'the curdling of the earth and the heavenly bodies'. I am illustrating the plaster *Human Concretion* [8] of 1935 (repeated in cast stone in 1949)

from the Museum of Modern Art in New York. It is a free shape vaguely
suggesting human forms. Even without such reminiscences, simply as
abstract form, as an evocation according to the law of chance, it has a
most enticing, rich sculptural quality and invites inspection from all sides.

Another piece entitled *Human Lunar Spectral* [9] is in pink limestone
and has been called Arp's most impressive torso. This was carved in 1950
and is now in the Museum of Rio de Janeiro. Albert Elsen, presently the
finest Rodin scholar, believes that he can even fathom connections with
Rodin. However that may be, Elsen reports from personal conversations
that Arp greatly admired the older artist. Despite the deep-going contrast

9. *Human Lunar Spectral*, 1950. Jean Arp

between the two, Elsen tells us that Arp, standing with him in front of Rodin's *Gates of Hell* pointed out the beauty of many of the fragments in the portal. Let me quote Elsen's interesting conclusions: 'There is an exuberance and vitality in Arp's torsos that almost matches Rodin's. Rodin verbally, and occasionally in drawings, analogized his models with clouds, flowers, vases. It remained for Arp to enact in sculpture the spirit of Rodin's metaphors.' I am not going to probe into the truth of this somewhat poetical statement. But that Arp, the dedicated carver and creator of poetical abstract forms, was deeply impressed by Rodin and influenced by him, cannot be doubted.

I could easily name several instances of gifted and well-known American carvers who worked under Brancusi's pervasive influence, but I have to confine myself to mentioning Sidney Geist (*b.* 1914) who also, in 1968, published the best monograph on Brancusi. It is interesting to listen to Geist himself. He was nineteen when he saw a large Brancusi exhibition in New York and admired some of the works shown, but maintained that at that time they did not influence his attitude, 'at least in any way I was conscious of. Brancusi was too far off, a star gleaming in a distant galaxy. Rodin, too, was something I had no way to touch; if Brancusi was ice, this was fire. Much closer to my preoccupations were Lehmbruck and Nadelman. But the work I admired most was Lachaise's early standing figure, *Elevation* ...' It is interesting that Gaston Lachaise, the French–American sculptor (1882–1935), who is well known to every visitor to the Museum of Modern Art in New York, evolved his strongly idiosyncratic personal style by tempering, as it were, Rodin with Brancusi.

But now the time has come to turn to the other side of the coin. It would be wrong to believe that there are no convinced and determined modellers among modern sculptors. I think the most eloquent partisan of modelling was Epstein (1880–1959) and I will therefore let him speak for himself:

> There is apparently something romantic about the idea of the statue imprisoned in the block of stone, man wrestling with nature ... According to the modern view Rodin stands nowhere. He is patronised as a modeller of talent, even of genius, but merely as a modeller ... Personally I find the whole discussion about modelling and carving entirely futile and beside the point. It is the result that matters after all. Of the two, modelling, it could be argued logically ..., seems to me to be the most genuinely creative. It is the creating of something out of of nothing ... In carving the suggestion for the form of the work often comes from the shape of the block. In fact, inspiration is always modified by the material, there is no complete freedom, while in modelling the artist is entirely unfettered by anything save the technical difficulties of his own chosen subject. As I see sculpture, it must not be rigid. It must quiver with life, while carving often leads a man to neglect the flow and rhythm of life.

10. *Bust of Kramer*, 1921. Jacob Epstein

Epstein made other points that, although they are not new to us, are worth repeating: 'In carving there is absolute finality about every movement. It is impossible to rub out and begin again. This fight with the material imposes a constant strain. A sudden flaw or weakness may upset a year's work.' For genuine carvers these were, of course, the challenges that kept them constantly in a heightened state of awareness. Epstein also tells us that he turned to sculpture because of a great desire 'to see things in the round, and to study form in its different aspects from varying angles ...' and this is a point to which he returns several times.

 Epstein's spirited and intelligent defence of modelling came from the heart. He was essentially a modeller stemming in direct line from Rodin,

and in 1942 he even had the courage and wisdom to say that Rodin 'compelled sculpture into a path which it is still following or which has developed out of his fecund example'. His admiration for Rodin was boundless; he called him 'the greatest master of modern times'.

In the loosely modelled surfaces of Epstein's portrait busts [10] we sense the kneading of the clay or wax which he scarcely ever tried to hide or suppress – on the contrary, for him this was the way to make the surface 'quiver with life', as he expressed it. It is therefore not astonishing that Epstein cast his portraits in bronze, for the bronze cast brings out all the finesse of the modeller's art and thus the surface permanently displays the artist's special calligraphy that he had – as it were – written into the soft material of the clay model. Epstein only continued a mode of fashioning portraits we know so well from Rodin and many others who followed him.

For modellers, especially those who were not professional sculptors, bronze casts were, of course, the only way of preserving their inventions. You may recall that the great Daumier (1808–79) turned to modelling in clay before the mid-nineteenth century and achieved a freedom in the handling of the soft material that had no equal at his time. When Degas died in 1917, there were in his studio about 150 models in wax and clay. Many were cracked or damaged (most of those that remain are now in a special room of Paul Mellon's house at Upperville, Virginia). Only seventy-three were fit for casting and some major collections own the whole series. These bronzes are miracles of the modeller's art and it is again the calligraphy of the artist moulding the moist, doughy material that enchants the beholder and that the bronze has preserved for us.

The late Renoir, too, turned to sculpture: the Tate Gallery owns one of his most splendid sculptural works, the life-size kneeling *Washerwoman* of 1917 [11]. At that time Renoir was so crippled with arthritis that he had to use an Italian modeller in addition to the bronze caster. Nevertheless, these works bear the unmistakable marks of his autograph style and can even be recognized as his by those who only know his pictures.

The list of painters who needed modelling as a supplement to their painted work is long. Gauguin and Braque occasionally worked in this medium, and so did Matisse. He was more involved than the others and about seventy bronzes by him are in existence. In 1900 he studied briefly with Bourdelle and was exposed in this way to Rodin's influence. In Matisse's case it is not as easy as in Renoir's to recognize spontaneously a link between his paintings and his sculptures. His *Slave* [12], 3-feet high, probably modelled between 1900 and 1903 and not cast until after 1908, shows what he was after. The rough, flickering, vibrating surface,

1. *The Washerwoman*, 1917. Renoir

12. *The Slave*, 1900–1903. Matisse

handled in Rodin's manner, reveals the skilful modeller. The arms had deliberately been removed so that one can easily take in the ragged outline. The figure illustrates Matisse's dictum: 'The smaller the bit of sculpture, the more the essentials of form must exist.' Moreover, amputation was in vogue, as I have already mentioned, again owing to Rodin's example. In fact, Matisse's *Slave* follows directly out of Rodin: it looks like a revision of Rodin's revolutionary *Walking Man* of 1877, that determinedly striding torso without head and arms.

Finally, I would like to mention at least two Italian modellers, namely Umberto Boccioni (1882–1916), the well-known Futurist artist, and Medardo Rosso. Boccioni was the author of the Futurist painters' mani-

13. *Unique Forms of Continuity in Space*, 1913. Umberto Boccioni

festos of 1910. In 1911–12 he turned to sculpture and on 11 April 1912 published his *Technical Manifesto of Futurist Sculpture*. His own sculpture was first exhibited in Paris in the summer of 1913 and his bronze entitled *Unique Forms of Continuity in Space* [13] is probably his most characteristic surviving work. We may let him speak: 'My sculpture does not offer a series of rigid profiles, immobile silhouettes. Each profile carries in itself a clue to the other profiles ... I propose to make the object live in its surroundings. The great cry: out with the past from Greece to Rodin. Replace the ignominious yoke of tradition by a dynamic continuity of forms, by an extension of sculpture into space, by breaking down the homogeneity of materials,' and so forth.

Upon reflection, looking at the result from the distance of almost sixty years we can see to what extent Boccioni and his Futurist friends were tied to a traditional mode of expression, for basically such a piece is no more and no less than a modeller's exercise. One cannot deny historical interest in this sort of object, because we see reflected in it the serious struggles of a great generation, though we can no longer share the excitement of the pre-First World War avant-garde.

The only sculptor of the older generation whom Boccioni accepted was Medardo Rosso (1858–1928) [14], indeed, an artist of the first rank, and called by Boccioni 'the only great modern sculptor who tried to enlarge the horizon of sculpture by rendering into plastic form the influences of a given environment and the invisible atmospheric links which attach it to the subject'. Rosso also started as a painter and only turned to sculpture in 1883. His favourite medium was wax and he produced with it flickering, throbbing surfaces which seem to merge with their environ-

14. *Conversation in a Garden*, 1893. Medardo Rosso

15. *Walking Woman*, 1912. Archipenko

ment. He was surely influenced by Rodin (from 1884 to 1886 he was in Paris) and this is also shown by his Impressionist preoccupation with light playing on forms. But his work is more fleeting, spectral and ethereal than Rodin's. Moreover, in contrast to Rodin and most modellers he preferred a single viewpoint and a central focus. Rosso's flair for the refinement and delicacy of surfaces survives in the work of Giacomo Manzu (b. 1908), who is probably the leading Italian sculptor of the day.

Even though, artistically speaking, the Futurist experiment was a cul-de-sac, Boccioni's manifesto revealed an intuitive understanding for the contemporary scene. Archipenko, soon after his arrival in Paris in 1908, began making sculptures of transparent materials, incorporating concavities and 'holes'. He gave these matters a great deal of thought and concluded that the customary roles of solid and void must be inverted: 'Traditionally there was a belief that sculpture begins where material touches space. Thus space was understood as a kind of frame around the mass ... I concluded that sculpture may begin when space is encircled by the material.' [15] Boccioni replaced this idea of inversion of solid and void by the concept of interpretation: 'No one can any longer believe that an object ends where another begins.' He continued, there must be 'absolute and complete abolition of definite lines and closed sculpture. We break open the figure and enclose within it the environment ... Thus objects never have finite ends, and they intersect with infinite combinations of sympathetic harmonies and clashing aversions.'

We might conclude that the space age is dawning and henceforth many sculptors are concerned with the relation of mass to space and the meaning of space. The next step is Gabo's *Realist Manifesto* of 1920. It begins: 'We deny volume as the expression of space ... We reject physical mass as a plastic element ... We consider space as a new and absolutely sculptural element, a material substance ... space thus becomes one of sculpture's main attributes.' Next one might turn to Moholy-Nagy's 1922 Manifesto published in *Der Sturm*. He talks about the activation of space by means of a dynamic-constructive system of forces, the replacement of the static principle of art by the dynamic principle of universal life, the creation of freely moving works of art. Such constructivist dreams were later realized in Alexander Calder's mobiles. From here one might move on to Julio Gonzalez (1876–1942) who about 1930 began open-form iron sculpture and explained: 'To project and design in space with the help of new methods, to utilize this space, and to construct with it, as though one were dealing with a newly acquired material – that is all I attempt.' Gonzalez pioneered the use of welded iron. Picasso, Calder, David Smith, Theodore Roszak and many others followed and brought about a new iron age in the 1940s and 1950s.

16. *Cubi XIX*, 1964. David Smith

Let me conclude with some observations by David Smith [16], who was immensely successful and influential and died still young in 1965: 'I do not today recognize the lines drawn between painting and sculpture, aesthetically ... The sculptor is no longer limited to marble, the monolithic concept, and classical fragments. His conception is as free as that of the painter ... There is no conceptual difference between painting and sculpture.' Let's face it: ultimately Smith is protesting against Michelangelo's designation of modelling as a painterly, i.e. non-sculptural activity. Other similar voices are not rare. There is Lipschitz ('I don't see any difference between sculpture and painting'); there are Epstein and Giacometti, and, to crown it all, there is Sartre whose condemnation of the kind of sculpture we have been dealing with is devastating: traditional statues 'fling in your eyes their heavy eternity. But the eternity of stone is synonymous with inertia; it is a forever ... NOW.' This seems to me an appropriate note on which to end my survey. I know that I have given but the merest outline of the new ideas which have been, and still are, so powerfully battling against thoughts which have preoccupied the minds of men over several thousand years and across the whole of Europe; but to do more would have transgressed the limits of the task which I have imposed upon myself.

BIBLIOGRAPHY

Chapter 1: Antiquity

ADAM, S., *The Technique of Greek Sculpture in the Archaic and Classical Periods*, London, 1966
AGARD, W. R., *The Greek Tradition in Sculpture*, Johns Hopkins University Studies (no. 7), 1930
BLÜMEL, C., *Griechische Bildhauer an der Arbeit*, Berlin 1927, 1940 (Engl. trs. *Greek Sculptors at Work*, London, 1955)
BOARDMAN, J., Review of Blümel's 'Greek Sculptors at Work' in *Burlington Magazine*, April 1970
CASSON, S., *The Technique of Early Greek Sculpture*, Oxford, 1933
ETIENNE, H. J., *The Chisel in Greek Sculpture*, Leiden, 1968
GARDNER, E. A., 'Archaeology in Greece', *Journal of Hellenic Studies*, XI, 1890
HOFFMAN, M., *Sculpture Inside and Out*, New York, 1939
MULLER, V., 'A Chronology of Greek Sculpture 400 BC to 40 BC', in *Art Bulletin*, XX, 1938
PUTNAM, B., *The Sculptor's Way*, New York, 1948
ROBINSON, F. H., 'The Tridimensional Problem in Greek Sculpture', *Mem. American Academy in Rome*, VII, 1929
ZORACH, W., *Zorach explains Sculpture: what it means and how it is made*, New York, 1947

Chapter 2: The Middle Ages (Theoretical Foundation; Chartres West)

BECKWITH, J., 'Reculver, Ruthwell and Bewcastle' in: *Kolloquium über frühmittelalterliche Akultur*, ed. V. Milkčič, Mainz, 1969
COLOMBIER, P. DU, *Les chantiers des cathédrales*, Paris, 1953
EGBERT, V. W., *The Medieval Artist at Work*, Princeton, 1967
FRIEDRICH, K., *Die Steinbearbeitung*, Augsburg, 1932
HARVEY, J. H., *The Gothic World*, London, 1950
HUSSON, F., *Les maçons et tailleurs de pièrre*, Paris, 1903
HUTH, H., *Künstler und Werkstatt der Spätgotik*, Augsburg, 1923
KLAPISCH-ZABU, C., *Les Maîtres du marbre: Carrara, 1300–1600*, Paris, 1969
MILANESI, G., *Documenti per la storia dell'arte senese*, Siena, 1854
MORTET, V., *Mélanges d'archéologie*, Paris, 1915
NEUWIRTH, J., *Die Wochenrechnungen und der Betrieb des Prager Dombaues in den Jahren 1372–1378*, Prague, 1890
SALZMAN, L. F., *Building in England down to 1540*, Oxford, 1952
SWARTWOUT, R. E., *The Monastic Craftsman*, Cambridge, 1932
THEOPHILUS, *De Diversis Artibus*, trs. C. R. Dodwell, London, 1961
VÖGE, W., *Die Anfänge des monumentalen Stiles im Mittelalter*, Strassburg, 1894

Chapter 3: The Middle Ages (Chartres, Rheims, Bamberg, Orvieto)

AUBERT, M., *La sculpture française du moyen-âge*, Paris, 1946

EGBERT, V. W., *The Medieval Artist at Work*, Princeton, 1967
HAHNLOSER, H., *Villard de Honnecourt*, Vienna, 1935
HARTIG, O., *Der Bamberger Reiter und sein Geheimnis*, Bamberg, 1939
KELLER, H., 'Die Risse der Orvietaner Domopera', in *Festschrift Wilhelm Pinder*, Leipzig, 1938
KNOOP, D. and JONES, G. P., *The Medieval Mason*, Manchester University Press, 1933
MORPER, J., 'Zur Technik des Bamberger Reiters', in *Belvedere* VI, 1924
SALZMAN, L. F., *Building in England down to 1540*, Oxford, 1952
WHITE, J., 'The Reliefs on the Façade of the Duomo at Orvieto', in *Journal of the Warburg and Courtauld Institutes*, XXII, nos. 3–4, 1959

Chapter 4: The Renaissance (Alberti, Gauricus, Leonardo)

BERTINI, A., 'Il problema del non finito nell'arte di Michelangelo', in: *L'Arte*, 1930
—, 'Ancora sul non finito di Michelangelo', *L'Arte*, 1931
CLARK, K., *Leonardo da Vinci*, London, 1954
GAURICUS, Pomponius, *De Sculptura*, Florence, 1504
HEYDENREICH, L. H., *Leonardo da Vinci*, trs. from the German, London, 1954
JANITSCHEK, H., *Leon Battista Albertis kleinere kunsttheoretische Schriften*, Vienna, 1877
LAVIN, I., 'Bozzetti and Modelli: Notes on Sculptural Procedure from the Early Renaissance to Bernini', in *Akten des Internazionalen Kongresses für Kunstgescgichte*, III, Bonn, 1967
PANOFSKY, E., *The Codex Huygens and Leonardo's Art Theory*, London, 1940
PAROCCHI, A., 'Sul "Della Statua" Albertiana' in *Paragone*, X, 1959
RICHTER, J. P., *The Literary Works of Leonardo da Vinci*, Oxford, 1939
SEYMOUR, C., JR., *Sculpture in Italy 1400–1500*, Harmondsworth, 1966
—, *Tradition and Experiment in Modern Sculpture*, Washington, 1950—, '"Fatto di sua mano". Another Look at the Fonte Gaia Drawing Fragments in London and New York', in *Festschrift Ulrich Middeldorf*, Berlin, 1968
WITTKOWER, R., 'Desiderio da Settignano's St Jerome in the Desert', in *Studies in the History of Art*, National Gallery, Washington DC, 1971–2
WITTKOWER, R. and M., *Born under Saturn: The Character and Conduct of Artists from Antiquity to the French Revolution*, London, 1963

Chapter 5: Michelangelo

LEONARDO DA VINCI, *Treatise on Painting*, trs. A. Philip McMahon, Princeton, 1956
MACLEHOSE, L. S., *Vasari on Technique*, New York, 1960
SEYMOUR, C., JR., *David: a Search for Identity*, Pittsburgh, 1967
—, *Sculpture in Italy, 1400–1500*, Harmondsworth, 1966

Chapter 6: Michelangelo, Cellini, Vasari

CELLINI, BENVENUTO, *The Treatises of Benvenuto Cellini on Goldsmithing and Sculpture*, translated and introduced by C. R. Ashbee, 1888. (New York, 1967)
GANTNER, J., 'Il problema del non finito in Leonardo, Michelangelo e Rodin', in *Atti del Seminario di Storia dell'arte*, Pisa, 1954
GANTNER, J. et al., *Das Unvollendete als künstlerische Form*, Saarbrücken, 1956
HOFFMAN, M., *Sculpture Inside and Out*, New York, 1939
MACLEHOSE, L. S., *Vasari on Technique*, New York, 1960
MILANESI, G., *Documenti sulla storia dell'arte toscana*, Siena, 1878
PERRIG, A., 'Michelangelo Buonarottis letzte Pietà Idee' in *Basler Studien zur Kunstgeschichte*, Bern, 1960
STECHOW, W., 'Joseph of Arimathea or Nicodemus?' in *Festschrift für L. H. Heydenreich*, Munich, 1964
WEINBERGER, M., *Michelangelo the Sculptor*, New York, 1967
WESCHER, P., *La prima idea*, Munich, 1960
WILDE, J., *Michelangelo's Victory*, Charleton Lectures on Art, 36, Oxford, 1954

Chapter 7: Giovanni Bologna, Cellini

PANOFSKY, E., *Studies in Iconology*, New York, 1939 (Paperback 1962)

POPE-HENNESSY, J., *Italian High Renaissance and Baroque Sculpture*, London, 1963
—, *Samson and a Philistine by Giovanni Bologna*, London, 1954
WITTKOWER, R. and M., *The Divine Michelangelo: The Florentine Academy's Homage at his Death in 1564*, London, 1964

Chapter 8: Bernini

BALDINUCCI, F., *Vita di Bernini*, Florence, 1682
BERNINI, DOMENICO, *Vita del Cavalier Gio. Lorenzo Bernino*, Rome, 1713
BRAUER, H. and WITTKOWER, R., *Die Zeichnungen des Gianlorenzo Bernini*, Berlin, 1931 (reprint Collectors Editions, 1969)
CHANTELOU, M. DE, *Journal du voyage du Cav. Bernini en France*, ed. L. Lalanne, Paris, 1885
WITTKOWER, R., *Gian Lorenzo Bernini. The Sculptor of the Roman Baroque*, London, 1966

Chapter 9: Bernini, Bouchardon, Pigalle

CHANTELOU, M. DE, *Journal du voyage du Cav. Bernini en France*, ed. L. Lalanne, Paris, 1885
DIDEROT, D., *Observations sur la sculpture et sur Bouchardon*, 1763 (reprint, J. Assezat, *Œuvres complètes de Diderot*, XIII, Paris, 1876)
LAMI, S., *Dictionnaire des sculpteurs de l'école française au dix-huitième siècle*, Paris, 1910 (On Bouchardon, see also: *Archives de l'art français*, I)
RAGUENET, ABBE FRANÇOIS, *The Monuments of Rome or Descriptions of the Most Beautiful Works*, 1700
RÉAU, L., *J.-B. Pigalle*, Paris, 1950
ROCHEBLAVE, S., *Jean-Baptiste Pigalle*, Paris, 1919
WEBER, G., 'Dessins et maquettes d'Edmé Bouchardon' in *Revue de l'Art*, VI, 1969
WITTKOWER, R., 'The Role of Classical Models in Bernini's and Poussin's Preparatory Work', in *Studies in Western Art, Acts of the Twentieth Congress of the History of Art, 1963*. (Reprint in *Studies in the Italian Baroque, The Collected Essays of R. Wittkower*, II, London, 1975)
—, 'Two Bronzes in the National Gallery' in *Art Bulletin of Victoria*, 1970–71

Chapter 10: Falconet, Winckelmann, Canova, Schadow

CARRADORI, F., *Istruzione elementare per gli studiosi della scultura*, Florence, 1802
CASSIRER, E., *Künstlerbriefe aus dem 19. Jahrhundert*, Berlin, 1919 (for Schadow see p. 46 ff.)
Diderot et Falconet: Le Pour et le Contre, Correspondence polemique sur le Respect de la Posterité ... ed. Yves Benot, Paris, 1958
FALCONET, E. M., *Oeuvres d'Étienne Falconet Statuaire; contenant plusieurs Écrits relatifs aux Beaux Arts ...*, Lausanne, 1781 (6 vols.)
FERNOW, C. L., *Uber den Bildhauer Canova und dessen Werke*, Zürich, 1806
HONOUR, H., 'Canova's Studio Practice–I: The Early Years' in *Burlington Magazine*, March 1972; 'II–1792–1822' in *Burlington Magazine*, April 1972
JUSTI, C., *Winckelmann und seine Zeitgenossen*, Leipzig, 1898
MACKOWSKY, H., *Die Bildwerke Gottfried Schadows*, Berlin, 1951
QUATTREMÈRE DE QUINCEY, M., *Canova et ses ouvrages*, Paris, 1835
RÉAU, L., *Étienne-Maurice Falconet*, Paris, 1922
SCHADOW, J. G., *Aufsätze und Briefe*, ed. E. Hübner, Stuttgart, 1890
—, *Kunstwerke und Kunstansichten*, Berlin, 1849
UHDE-BERNAYS, H., 'Gottfried Schadow an Böttiger' in *Künstlerbriefe über Kunst*, Dresden, 1926
WEINSHENKER, B., *Falconet: His Writings and his Works*, Geneva, 1966
WINCKELMANN, J. J., *Gedanken über die Nachahmung der griechischen Werke in der Malerei Bildhauerkunst*, 1755. (Reprint and ed. in H. Uhde Bernays, *Winckelmanns kleine Schriften ...*, Leipzig, 1913)

Chapter 11: The Nineteenth Century (Rodin, Hildebrand)

Arts Council Exhibition Catalogue on Rodin, London, 1966–7
BOURDELLE, E. A., *La Sculpture et Rodin*, Paris, 1937

BURCKHARDT, C. J., *Rodin und das plastische Problem*, Basel, 1921
CHAMPIGNEULLE, B., *Rodin*, London, 1967
DUJARDIN-BEAUMETZ, H. C. E., *Entretiens avec Rodin* (trs. by A. McGarrell as 'Rodin's Reflections on Art', publ. as ch. 3 in A. E. Elsen's *Auguste Rodin: Readings on his Life and Work*, New York, 1965)
ELSEN, A. E., *Rodin*, New York, 1963
—, *Auguste Rodin, Readings on his Life and Work*, New York, 1965
FAENSEN, H., *Die bildnerische Form. Die Kunstauffassungen Konrad Fiedlers, Adolf von Hildebrands und Hans von Marées*, Berlin, 1965
FERNOW, C. L., *Über den Bildhauer Canova und dessen Werke*, Zürich, 1806
FIEDLER, K., *Schriften zur Kunst*, Munich, 1913–14
GANTNER, J., *Rodin und Michelangelo*, Vienna, 1953
GILL, ERIC, *Sculpture: An Essay on Stonecutting* (with a Preface about God), Ditchling, 1918
GIMPEL, R., *Diary of an Art Dealer*, London, 1966
GSELL, P., *August Rodin. Die Kunst*, Munich, 1925
HILDEBRAND, A. VON, *Das Problem der Form in der bildenden Kunst*, Strassburg, 1893. (Trs. M. Meyer and R. M. Ogden, *The Problem of Form in Painting and Sculpture*, New York, 1907)
A. v. Hildebrand und seine Welt: Briefe und Erinnerungen, ed. E. Sattler, Munich, 1962
HILDEBRAND, A. VON, *Gesammelte Schriften*, Cologne, 1969
—, *Briefwechsel mit Konrad Fiedler*, Dresden, 1927
MAUCLAIR, C., *Rodin on Art*, New York, 1905
NOSTITZ, H. VON, *Rodin in Gesprächen und Briefen*, Dresden, 1927
RODIN, A., *L'Art; Entretiens réunis par Paul Gsell*, Paris, 1911
SCHMITZ, R., *Rodin und die Fiedler-Hildebrandsche Kunsttheory*, Berne, 1929
WÖLFFLIN, H., *Die klassische Kunst. Eine Einführung in die italienische Renaissance*, Munich, 1898 (trs. *Classic Art ...* by P. and L. Murray, London, 1952)

Chapter 12: The Twentieth Century

ARCHIPENKO, A., *Fifty Creative Years*, New York, 1960
ARNASON, H. H., *History of Modern Art*, New York, n.d.
ARP, H., 'On my Way: Poetry and Essays, 1912–1947', in *Documents on Modern Art*, ed. R. Motherwell, New York, 1948
BARR, ALFRED H., JR., *Matisse. His Art and his Public*, New York, 1951
BARR, M. S., *Medardo Rosso*, New York, 1963
DROSS, F., *Ernst Barlach: Leben und Werk in seinen Briefen*, Munich, 1952
ELSEN, A. E., *Rodin*, New York, 1963
—, *The Partial Figure in Modern Sculpture from Rodin to 1969*, Baltimore, 1969
EPSTEIN, JACOB, *Let there be Sculpture*, New York, 1942
—, *An Autobiography*, London, 1963
FRÈRE, H., *Conversations de Maillol*, Geneva, 1956
GEIST, S., *Brancusi; A Study of the Sculptor*, New York, 1968
GIEDION-WELCKER, C., *Constantin Brancusi*, New York, 1959
GILL, ERIC, *Autobiography*, New York, 1941
HAMMACHER, A. M., *The Evolution of Modern Sculpture*, London, 1969
HASKELL, A. L., *The Sculptor Speaks; Jacob Epstein to A. L. Haskell*, New York, 1931
HEPWORTH, BARBARA, *Carvings and Drawings*, London, 1952
HERBERT, R. L., *Modern Artists on Art*, New York, 1964
HUNTER, S., *David Smith*, Exhibition Catalogue, Museum of Modern Art, New York, 1957
JAGGER, C. S., *Modelling and Sculpture in the Making*, London, 1933
JAMES, R. (ed.) *Henry Moore on Sculpture*, London, 1966
READ, H., *The Art of Sculpture* (Bollingen Series XXXV, 3), Princeton University Press, 1969
—, *Henry Moore. A Study of his Life and Work*, New York, 1966
SELZ, J., *Modern Sculpture*, London, 1963
SELZ, P., *Giacometti*, New York, 1965
David Smith by David Smith: Sculpture and Writings, ed. Cleve Gray, London, 1968
SOBY, J. T., *Arp*, Exhibition Catalogue, Museum of Modern Art, New York, 1958
TAYLOR, J., *Futurism* (including Boccioni's 'Manifeste technique de la sculpture futuriste'), New York, 1961
WERNER, A., *Rodin on Art and Artists*, New York, 1957
WILDT, A., *L'arte del marmo*, Milan, 1922

LIST

OF

ILLUSTRATIONS

gello. (Photo: Soprintendenza, Florence); 12. Detail of 11; 13. *St Matthew*, Michelangelo, begun 1506. Marble. Florence, Galleria dell'Accademia. (Photo: Soprintendenza, Florence); 14. *Atlas*, Michelangelo, *c.* 1513–20. Marble. Florence, Galleria dell'Accademia. (Photo: Soprintendenza, Florence); 15. *Awakening Captive*, Michelangelo, *c.* 1513–20. Marble. Florence, Galleria dell'Accademia. (Photo: Alinari); 16. *Victory*, Michelangelo, early 1530s. Marble. Florence Palazzo Vecchio. (Photo: Soprintendenza, Florence); 17. Detail of 16. (Photo: Brogi); 18. *Pietà Rondanini*, Michelangelo, 1555–64. Marble. Milan, Castello Sforzesco. (Photo: Anderson); 19. Detail of 18.

CHAPTER 6: MICHELANGELO, CELLINI, VASARI (pages 127–45) 1. Wax model for *Youthful Captive*, Michelangelo, *c.* 1520. London, Victoria and Albert Museum. (Photo: Museum); 2. Clay model probably for *Hercules and Cacus*, Michelangelo, *c.* 1528. Florence, Casa Buonarotti. (Photo: Alinari); 3. Clay model of female torso, Michelangelo, 1533. Florence, Casa Buonarotti. (Photo: Alinari); 4. Clay model of river-god, Michelangelo, 1524–6. Florence, Galleria dell'Accademia. (Photo: Alinari); 5. *Martelli David*, fifteenth-sixteenth century. Marble. Washington, National Gallery of Art. (Photo: Museum); 6. Detail of 5. (Photo: Museum); 7. *Marietta Strozzi*, Desiderio da Settignano, after 1460. Marble. Washington, National Gallery of Art. (Photo: Museum); 8. *Virgin and Child with Saints and Donors*, Pyrgoteles, *c.* 1520. Marble. Washington, National Gallery of Art. Samuel H. Kress Collection. (Photo: Museum); 9. Detail of 8. (Photo: Museum); 10. *Apollo and Marsyas*, detail, Michelangelo follower. Marble. Washington, National Gallery of Art. (Photo: Museum); 11. *Brutus*, detail, Michelangelo, 1539–40? Marble. Florence, Bargello. (Photo: Soprintendenza, Florence); 12. Detail of 11; 13. *Pietà*, Michelangelo and Tiberio Calcagni, 1547–55. Marble. Florence, Cathedral. (Photo: Anderson); 14. Detail of 13. (Photo: Alinari).

CHAPTER 7: GIOVANNI BOLOGNA, CELLINI (pages 146–65) 1. *The Rape of the Sabines*, Giovanni Bologna, 1579–83. Marble. Florence, Loggia dei Lanzi. (Photo: Alinari); 2. *The Rape of the Sabines*, Giovanni Bologna, 1579–83. Marble, Florence, Loggia di Lanzi. (Photo: Ugo Scaletti, Studio 72); 3. Clay model for a river-god. Giovanni Bologna, *c.* 1580. London, Victoria and Albert Museum; 4. Wax model for *Florence Triumphant Over Pisa*, Giovanni Bologna, *c.* 1565. London, Victoria and Albert Museum. (Photo: Museum); 5. *Florence Triumphant Over Pisa*, Giovanni Bologna, 1570. Marble, Florence, Bargello. (Photo: Brogi); 6. *Samson and a Philistine*, Giovanni Bologna, *c.* 1568. London, Victoria and Albert Museum. (Photo: Royal Academy of Arts); 7. Crucifix, Cellini, 1562. Marble. Escorial, Spain; 8. Detail of 7; 9. *Duke Cosimo I*, Cellini, 1546–8. Bronze. Florence, Bargello. (Photo: Alinari); 10. *Perseus*, Cellini, 1545–54. Bronze. Florence, Loggia dei Lanzi. (Photo: Alinari); 11. Cast of model for Perseus, Cellini, *c.* 1545. Bronze. Florence, Bargello. (Photo: Alinari); 12. *Perseus*, detail of 10. (Photo: Alinari); 13. Head of Medusa, Cellini, *c.* 1545. Bronze. London, Victoria and Albert Museum. (Photo: Museum).

CHAPTER 8: BERNINI (pages 166–88) 1. *Longinus*, Bernini, 1629–38. Marble. Rome, St Peter's. (Photo: Anderson); 2. *David*, Bernini, 1623. Marble. Rome, Galleria Borghese. (Photo: Brogi); 3. *Neptune and Triton*, Bernini, 1620. London, Victoria and Albert Museum; 4. Equestrian statue of Constantine, Bernini, 1654–70. Marble. Rome, Vatican. (Photo: Anderson); 5. *Blessed Lodovica Albertoni*, Bernini, 1671–4. Marble. Rome, Altieri Chapel, S. Francesco a Ripa; 6. Raimondi Chapel, Bernini, *c.* 1642–6. Marble. Rome, S. Pietro in Montorio. (Photo: Gabinetto Fotografico Nazionale, Rome); 7. *St Teresa and the Angel*, Bernini, 1646–52. Marble. Rome, Cornaro Chapel, S. Maria della Vittoria. (Photo: Anderson); 8. Cathedra in St Peter's, Bernini, 1656–66. Rome. (Photo: Leonard von Matt, Buochs, Switzerland); 9. Aquatint after lost design for St Peter's Cathedra. Berlin, Kupferstich Kabinett; 10. *Bozzetto* for Throne of St Peter, Bernini and workshop, 1658–60. Detroit, The Detroit Institute of Arts; 11. Model for head of St Athanasius, Bernini, 1661. Rome, St Peter's Museum. (Photo: Anderson); 12. Tomb of Urban VIII, Bernini, 1628–47. Bronze and marble. Rome, St Peter's. (Photo: Anderson); 13. Bust of Costanza Buonarelli, Bernini, *c.* 1635–6. Marble. Florence, Bargello. (Photo: Alinari); 14. Bust of Thomas Baker, Bernini, detail, 1630s. Marble. London, Victoria and Albert Museum. (Photo: Museum).

CHAPTER 9: BERNINI, BOUCHARDON, PIGALLE (pages 189–211) 1. Model for *Longinus*, Bernini. Terracotta. Cambridge, Massachusetts, The Fogg Museum of Art. (Photo: Museum); 2. *Antinous*, engraving after Bellori from *Le vite de'pittori, scultori ed architetti moderni*, Rome, 1672, p. 457; 3. Study for an angel on Ponte S. Angelo, Bernini. Rome, Galleria Nazionale; 4. Sketch for portrait of Cardinal Scipione Borghese, Bernini. New York, Morgan Library. (Photo: Library); 5. *Angel with the Crown of Thorns*, Bernini, 1668–9. Marble. Rome, S. Andrea delle Fratte. (Photo: Anderson); 6. *Angel with the Superscription*, Bernini, 1667. Marble. Rome, S. Andrea delle Fratte. (Photo: Anderson); 7. *Bozzetto* for *Angel with the Superscription*, Bernini. Terracotta. Rome, Palazzo Venezia. (Photo: Gabinetto Fotografico Nazionale, Rome); 8. *Bozzetto* for *Angel with the Crown of Thorns*,

Bernini. Terracotta. Cambridge, Massachusetts, The Fogg Museum of Art. (Photo: Museum); 9. *Bozzetto* for the second *Angel with the Superscription*, Bernini. Terracotta. Leningrad; 10. Monument to Countess Matilda, Bernini, 1663–7. Marble. Rome, St Peter's. (Photo: Anderson); 11. Bronze cast of Countess Matilda from a model by Bernini. Houston, University of St Thomas Art Gallery. (Photo: Gallery); 12. Detail of 11. (Photo: Gallery); 13. Equestrian statue of Louis XIV, Bernini, 1669–77. Marble. Versailles. (Photo: Giraudon); 14. *Cupid*, Bouchardon, 1747–50. Marble. Paris, Louvre. (Photo: Bulloz); 15. *Mercury Fastening his Wings*, Pigalle, *c.* 1739. Terracotta model. New York, Metropolitan Museum of Art. (Photo: Museum); 16. *Mercury Fastening his Wings*, Pigalle, 1744. Marble. Paris, Louvre. (Photo: Archives Photographiques); 17. Monument to Louis XV, Pigalle, *c.* 1756–65. Terracotta model. Orleans, Musée des Beaux Arts. (Photo: Serge Martin).

CHAPTER 10: FALCONET, WINCKELMANN, CANOVA, SCHADOW (pages 212–30) 1. *Menacing Cupid*, Falconet, 1758. Porcelain. London, Wallace Collection. (Photo: Museum); 2. *Christ in Agony*, Falconet, 1753–66. Marble. Paris, Church of St Roch. (Photo: Giraudon); 3. Equestrian monument to Peter the Great, Falconet, 1766–79. Bronze. Leningrad, Admiralty Square. (Photo: Novosti Press Agency); 4. Statue of Louis XIV, copy after lost drawing by Lebrun. Vienna, Albertina; 5. *Milo of Crotona*, Falconet, 1754. Marble. Paris, Louvre. (Photo: Archives Photographiques); 6. Method of copying figures from Francesco Carradori, *Istruzione elementare per gli studiozi della scultura*, Florence, 1802; 7. Tomb of Pope Clement XIV, Canova, 1783–7. Marble. Rome, SS. Apostoli. (Photo: Anderson); 8. Canova's studio, Francesco Chiaruttini, *c.* 1785. Aquatint; 9. *Princesses Luise and Friederike*, Schadow, 1797. Marble. East Berlin, National Gallery. (Photo: Museum); 10. *The Three Graces*, Canova, 1817. Marble. Leningrad.

CHAPTER 11: THE NINETEENTH CENTURY (RODIN, HILDEBRAND). (pages 231–49) 1. *Ugolino and his Sons*, Carpeaux, 1865–7. Marble. New York, Metropolitan Museum of Art. (Photo: Museum); 2. Wittelsbach Fountain, Hildebrand, 1891. Marble. Munich. (Photo: Zentralinstitut für Kunstgeschichte, Munich); 3. *The Kiss*, Rodin, 1901–4. Marble. London, Tate Gallery. (Photo: Museum); 4. *The Kiss*, Rodin, 1901–4. Marble. London, Tate Gallery. (Photo: Museum); 5. *The Kiss*, Rodin, 1901–4. London, Tate Gallery. (Photo: Museum); 6. *The Kiss*, Rodin, 1901–4. Marble. London, Tate Gallery. (Photo: Museum); 7. *The Burghers of Calais*, Rodin, after 1884. Plaster. Paris, Musée Rodin. (Photo: Museum); 8. *Balzac*, Rodin, 1892–7. Bronze. Paris, Boulevard Raspail. (Photo: E. Sougez); 9. *Victor Hugo*, Rodin, begun 1889. Marble Paris, Palais Royal gardens; 10. *Young Man*, Hildebrand, 1883–4. Marble. Berlin, National Gallery. (Photo: Museum).

CHAPTER 12: THE TWENTIETH CENTURY (pages 250–76) 1. *The Kiss*, Brancusi, 1908. Limestone. Philadelphia Museum of Art. (Photo: Museum); 2. *The Bird*, Brancusi, 1912. Marble. Philadelphia Museum of Art. (Photo: J. Wyatt); 3. *Balzac*, Rodin, *c.* 1891–2. Terracotta model. Paris, Musée Rodin; 4a–c. *Virgin and Child*, Henry Moore, 1943–4. Hornton stone. Northampton, Church of St Matthew. (Photos: Henry Moore); 5. *Figure with Raised Arms*, Wotruba, 1956–7. Bronze. Washington, Hirschhorn Museum. (Photo: Museum); 6. *The Three Nymphs*, Maillol, 1930–38. Bronze. London, Tate Gallery. (Photo: Museum); 7. *The Solitary One*, Barlach, 1911. Oak. Hamburg, Kunsthalle. (Photo: Museum); 8. *Human Concretion*, Jean Arp, 1935. Plaster. New York, Museum of Modern Art. (Photo: Museum); 9. *Human Lunar Spectral*, Jean Arp, 1950. Pink limestone. Rio de Janeiro, Museo de Arte Moderna. (Photo: Museum); 10. *Bust of Jacob Kramer*, Jacob Epstein, 1921. Bronze. London, Tate Gallery. (Photo: Museum); 11. *The Washerwoman*, Renoir, 1917. Bronze. London, Tate Gallery. (Photo: Museum); 12. *The Slave*, Matisse, 1900–1903. Bronze. Baltimore Museum of Art. (Photo: Museum); 13. *Unique Forms of Continuity in Space*, Umberto Boccioni, 1913. Bronze. New York, Museum of Modern Art. (Photo: Museum); 14. *Conversation in a Garden*, Medardo Rosso, 1893. Plaster. Rome, Galleria Nazionale d'Arte Contemporanea); 15. *Walking Woman*, Archipenko, 1912. Bronze. Denver Art Museum, Collection of the Charles Bayly Fund. (Photo: Museum); 16. *Cubi XIX*, David Smith, 1964. Stainless steel. London, Tate Gallery. (Photo: Museum).

INDEX

Mengs, A. R., 224
Michelangelo, 12, 30, 41, 54, 86–7, 101–45, 147
 claw chisel work, 113–16, 126, 122, 133, 140, 142
 drawings, 102, 114, 125, 128
 drill work, 104, 106, 110–11, 113
 followers of, 138–9, 142, 144, 150, 153, 157, 245
 Leonardo and, 101–2
 models, 127–32, 210
 procedure, 118–22, 126, 135, 144–5, 149, 187, 223, 248
 punch work, 113, 118, 126
 trimming hammer and, 118
 unfinished work, 142–3, 255
Milan, 92–6, 125
Mino da Fiesole, 110–11, 139
Modelling, 80–81, 127–8, 145, 148, 150–51, 248–9, 261, 266–8, 276
Models, 89–90, 92, 96, 133, 152–4, 164, 178–80, 206, 224, 255 (see also Bozzetti; Clay models)
Modena Cathedral, 46
Modigliani, A., 261
Moholy-Nagy, 274
Moore, H., 245, 253, 256–9
Multi-faciality, 147–50, 169, 205–8, 214, 234–9, 253, 256, 267
Munich, 233

Nanni di Banco, 86, 88
Northumbrian Renaissance, 33–5
Nudity, 208–10
Nuremberg, 76

Orvieto Cathedral, 38, 63–70

Pacher, M., 76
Painting and sculpture, 127, 144–5, 148, 276
Panofsky, E., 80, 82
Papier mâché, 85
Paris, 70, 214, 231–2
Pasiteles, 30
Paul II Monument, 110–11
Peter the Great, 216–20
Physical labour, 150–51
Picasso, P., 274
Pierino da Vinci, 144
Pigalle, J.-B., 206–11, 213
Pisano, Andrea, 28, 160
Pisano, Giovanni, 65
Pisano, Nicolo, 40
Pistoia Cathedral, 89–90
Plaster casts, 225, 229–30, 242
Pliny, 30, 80
Pointing, 30–32, 81–2, 86, 89, 133, 222, 229–30, 244, 252
Pollaiuolo, A., 160
Polychromy, 25, 46, 48, 52, 62–3, 76, 183–5

Pompadour, Madame de, 213
Pope-Hennessy, Sir J., 165
Porphyry, 184
Portraiture, 184–5, 193–5, 230, 268
Prague Cathedral, 40
Private workshops, 70–71, 74–5
Procedure, see Working procedure
Puget, P., 220–21
Punch, 14, 18
 work, 16–17, 20–23, 29, 52, 68, 137
Pygmalion, 47
Pyrgoteles, 137

Quatremère de Quincy, M., 224
Quercia, Jacopo della, 90–92

Raguenet, Abbé F., 204
Raimondi Chapel, 174–5
Raphael, S., 191, 207
Rasps, 14
Réau, L., 214
Renaissance, 76, 79–98, 149, 167, 184, 187
Renoir, P., 268–9
Reproductions, 85, 184
Reynolds, Sir J., 169
Rheims, 38, 58–9
Ridolfi, Cardinal, 140
Riemenschneider, T., 76, 181
Rodin, A., 144, 189, 210, 232, 234–45
 influence of, 255, 266, 268, 271
 multi-facial work, 234–9, 253
 procedure, 239–40, 244–5, 248, 252
Roman sculpture, 28, 30, 31, 184, 187
Rome, 203–4, 206, 224
Rossellino, A. and B., 135
Rosso, M., 272, 274
Roszak, T., 274
Rouen Cathedral, 41–2
Rude, F., 231
Ruthwell Cross, 33–5

Sacchi, A., 178
S. Croce (Florence), 112–13
St Peter's (Rome), 105, 169, 172, 176–9, 181, 183, 201–2
St Wolfgang, 75–6
Sandrart, J. von, 189
Sangallo, F. da, 145, 147
Sartre, J.-P., 276
Scala Regia, 172
Schadow, J. G., 227–30
Serlio, S., 100
Sèvres ware, 213
Seymour, C., 102–4
Sforza Monument, 92–6
Siena, 91
Single-aspect sculpture, 169–72, 179, 256
Sistine Chapel, 114
Smith, David, 274–6
Soby, J. T., 264